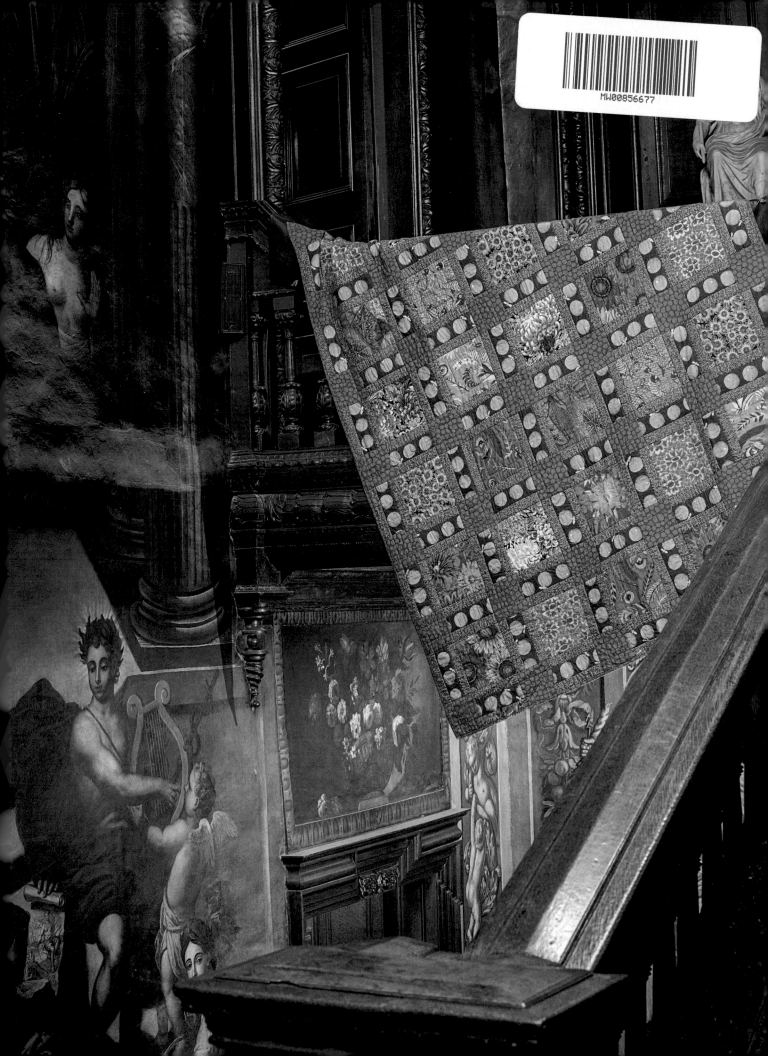

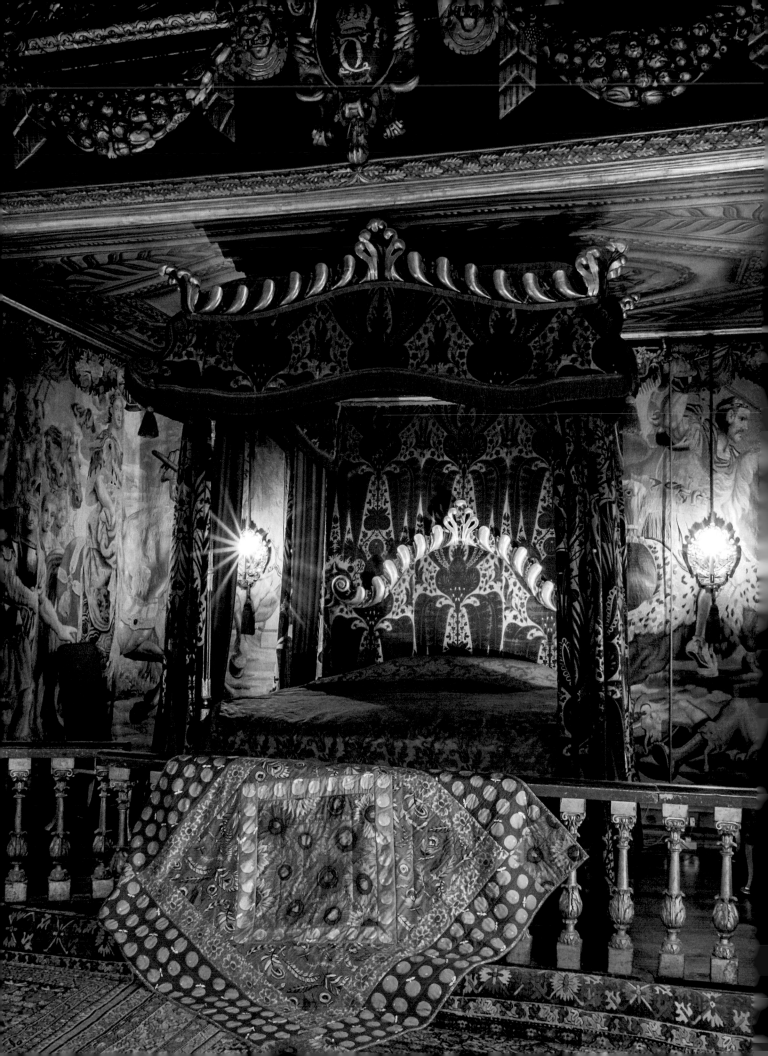

KAFFE FASSETT'S
Quilts in Wales

Designs inspired by a Welsh castle

featuring
Liza Prior Lucy

location photography
Debbie Patterson

The Taunton Press

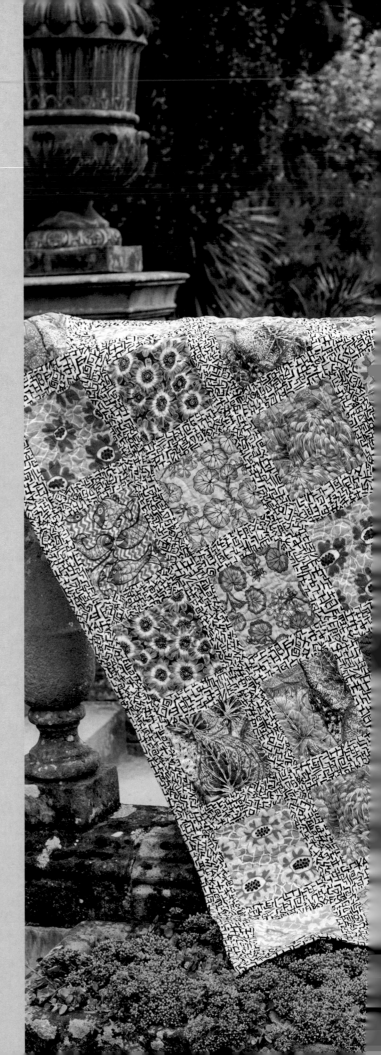

First published in the USA in 2022 by

The Taunton Press
Inspiration for hands-on living®

The Taunton Press, Inc.
63 South Main Street
Newtown, CT 06470
email: tp@taunton.com

Patchwork designs	Kaffe Fassett
	Liza Prior Lucy
Quilt making coordination	Heart Space Studios (UK)
	Liza Prior Lucy (US)
Technical editor	Bundle Backhouse
Designer	Anne Wilson
Art direction/styling	Kaffe Fassett
Location photography	Debbie Patterson
Stills photography	Steven Wooster
Quilt illustrations	Heart Space Studios
Map illustration	Héloïse Wooster
Publishing consultant	Susan Berry (Berry & Co)

Library of Congress Cataloging-in-Publication Data in progress

ISBN 978-1-64155-173-1

Colour reproduction	Pixywalls Limited, London

Printed in China

Page 1: Glowing against the panelling of the gallery at Powis Castle is my *Hot Frames* quilt.
Pages 2–3: The perfect match! My *Saturated Red* quilt with the sumptuous bed hangings at the castle.
Pages 4–5: The subtle tones of my *Cobweb* quilt, draped over a balustrade with the castle gardens beyond.

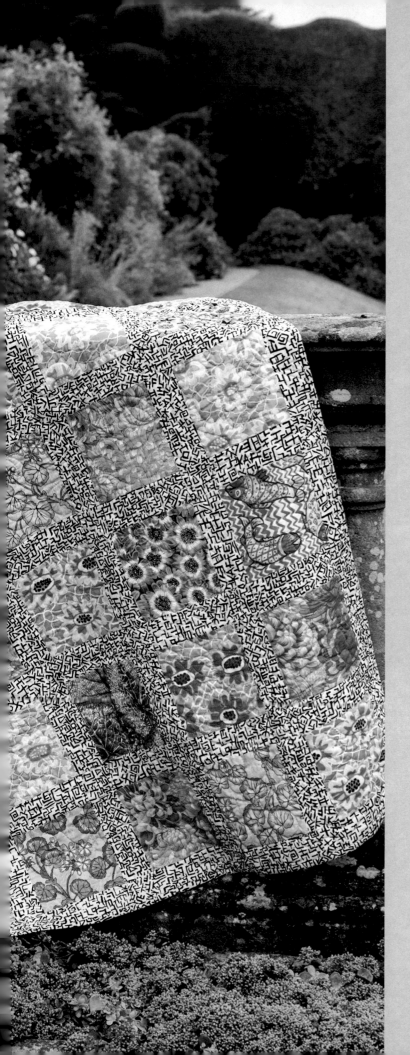

Contents

introduction

Powis Castle, high on a hill near Welshpool in mid-Wales, is a jewel box in a red sandstone casing. For a man who loves ornate overkill, this place was just the right setting for our newest collection of quilts. Coming up the drive to the castle, you are met by the pinkish-red stone walls and the huge silvered-oak door with dark metal studs over its entire surface.

Once through this door, you are struck first by the bold black-and-white tile floor and then by the large-scale murals on the walls, creating an opera-like sense of drama. As you progress through the rooms, you discover that every surface is decorated in the most elaborate fashion. There are carved ceilings above the upscale murals on the walls and boldly brocaded pieces of furniture – most of which are, in fact, either outstanding pieces of marquetry or ornately carved. In photographs, it can look vast and grand in scale, but in reality there is a very human, almost intimate, quality to the rooms.

Many of the ceilings are painted with life-sized characters in lush colours. And, something that always delights a textile maker like me, there are many detailed, powerful tapestries. I've also painted many murals in my time so I can imagine how much the Italian painters of the Powis murals must have loved working around the grand Baroque architectural shapes of the doorways and the massive staircase.

Our quilts found sympathetic homes among the various moods in this pattern-filled castle and its grounds. We spent three days climbing up and down the castle stairs, constantly surprised by some new embellishment as we entered each grand room.

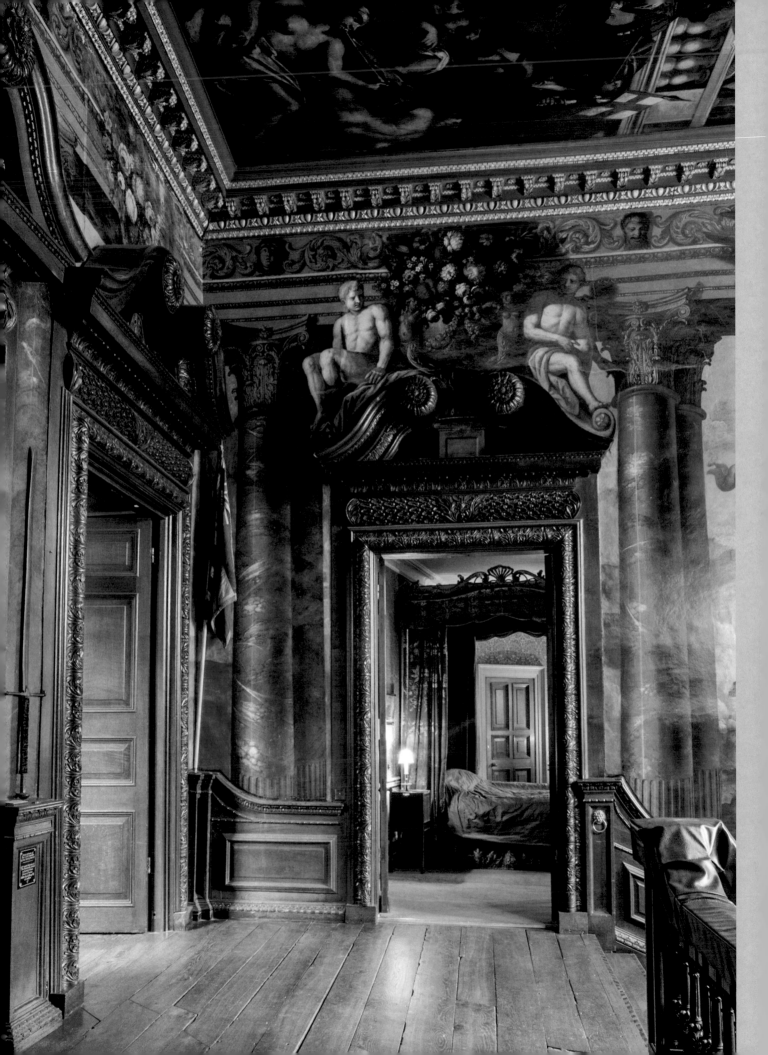

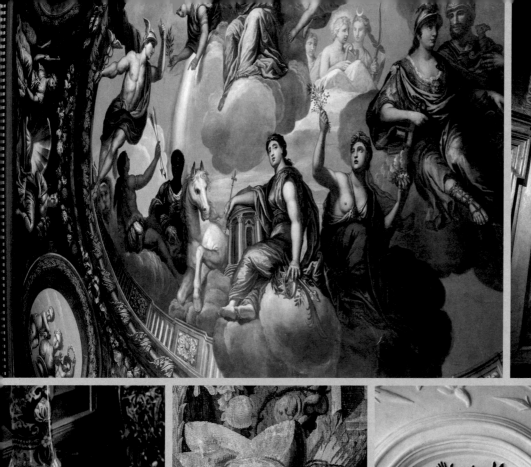
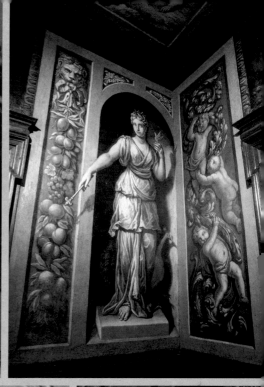

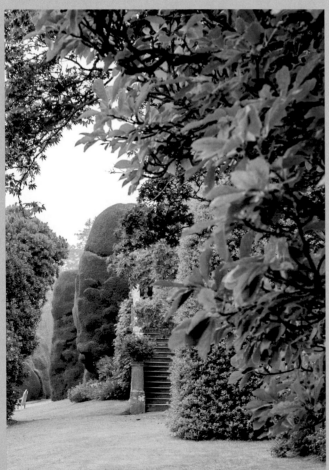

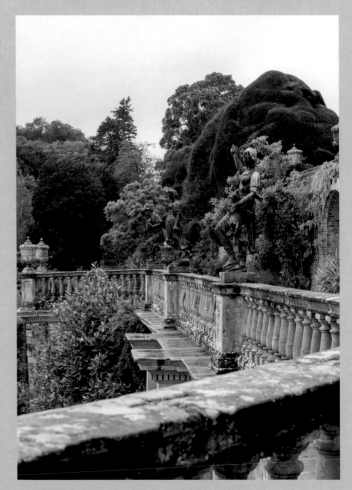

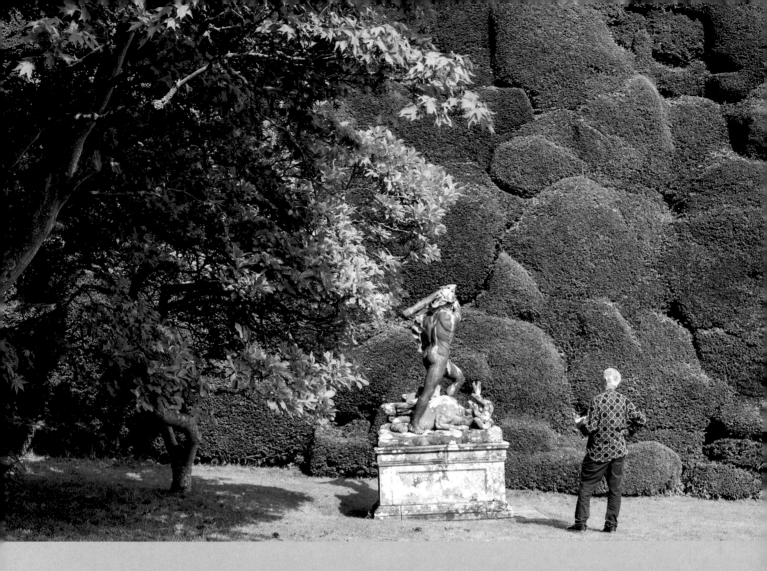

As much as I admired the theatrical boldness of the interior décor, my senses were really sent reeling by the lush layers of gardens down the slope from the castle. The Orangery and a columned sheltered space under the first terrace were charming spaces and the stairs leading down from them to the gardens were studded with lichen-covered stone balustrades with gorgeous old urns here and there. The lawns and topiary are kept immaculately and represent endless, meticulous effort.

Then we wandered farther into the unique gardens around the castle. The colour of flowers in the borders and cascading from the gorgeous urns placed on the stone walls gave us great settings for our brighter quilts. But the most unique thing about the gardens are the exquisitely sculpted yew hedges, which are on a scale that is off the charts! Great mountains of organic shapes tower over the visitors and created a rich dark background for our quilts that made them truly sing. There were also beautiful old apple trees and a grape arbour where, it being early autumn, the leaves were just on the turn.

One aspect of the place I appreciated were the quiet groups of people looking really happy to have found this gem in the Welsh countryside. We were also deeply grateful for the cheerful and constant support of the castle team, Alex and Sarah, who not only showed us around and instructed us on what we could and couldn't include in our photographs, but often helped by holding up the support frames for the quilts, particularly when we wanted to put them in high places or in the flowerbeds.

Editor's note: Powis Castle is owned by the National Trust. It is open to the public and information for visitors can be found on the website (www.nationaltrust.org.uk).
The location of the castle is shown on a map on page 144.

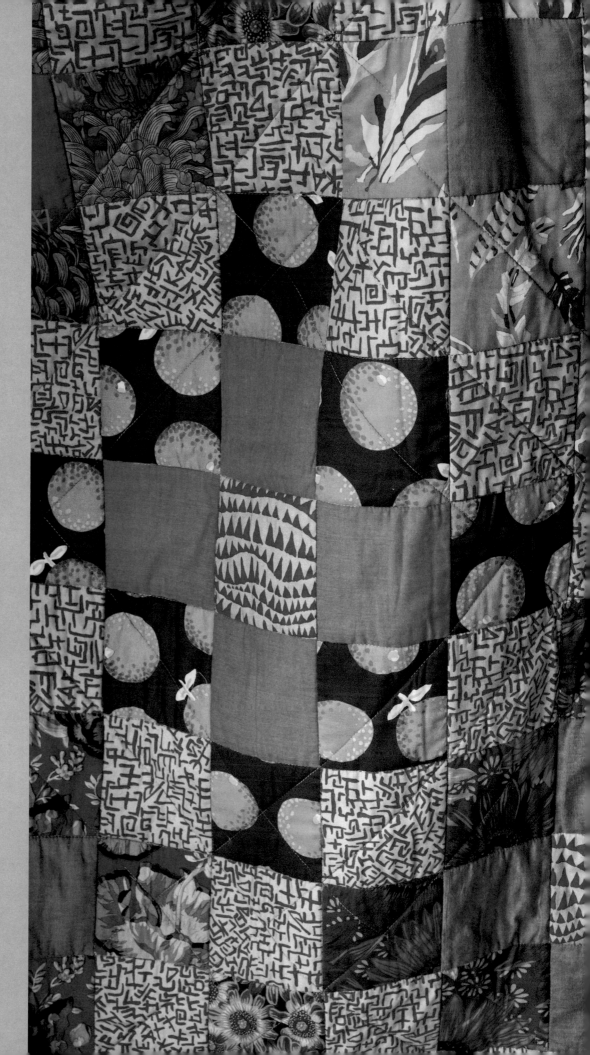

Toast and Marmalade
by Kaffe Fassett

I love quilts made of squares – one of the first things that captivated me about vintage quilts was how many inventive things those patchworkers made of the basic square. This design is based on an antique quilt that had caught my eye. Our new prints suited it perfectly and the colours of the old tapestries and paintings at Powis Castle inspired the warm palette.

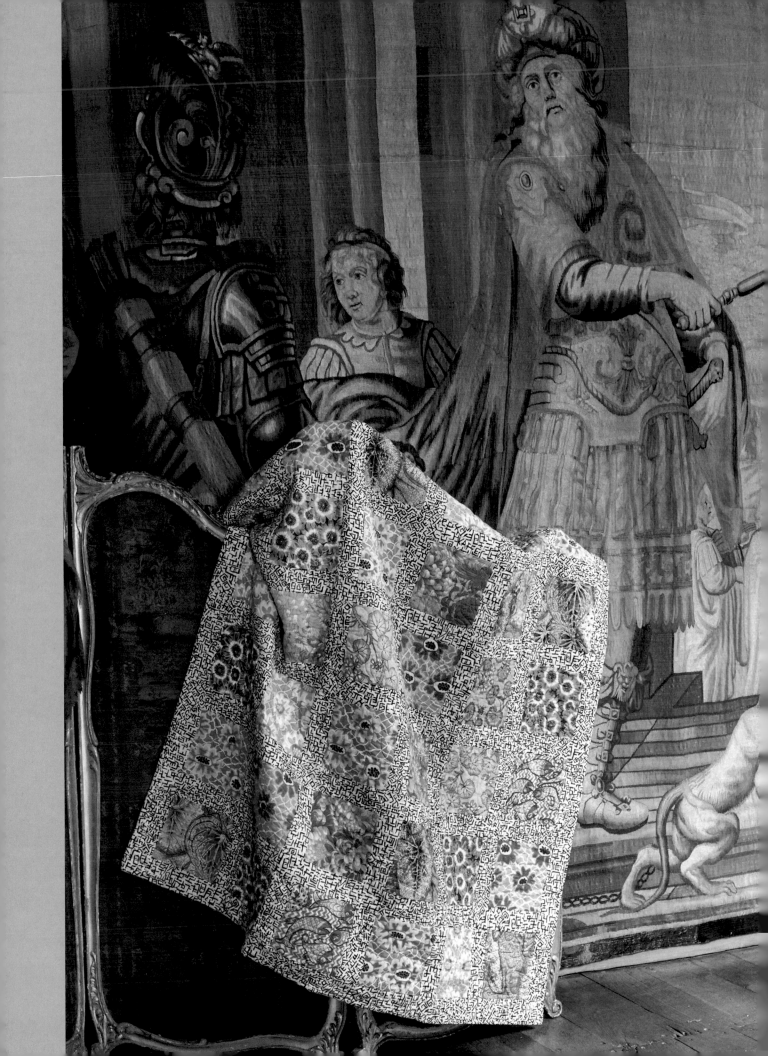

Cobweb
by Kaffe Fassett

This sort of camouflage effect is one I return to over and over, relishing the way prints almost merge but hold their own sufficiently to intrigue the viewer. There was a good selection of pastels in this season's prints to make a varied choice. I like the way the pastel Caladiums leaf print becomes quite ethereal against the textured background of the castle's tapestries and its ornate furniture.

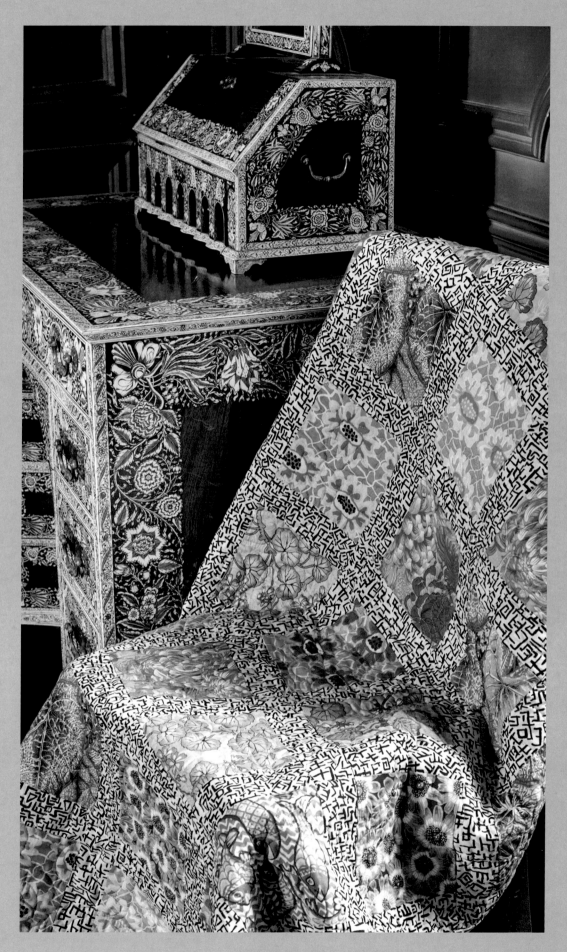

15

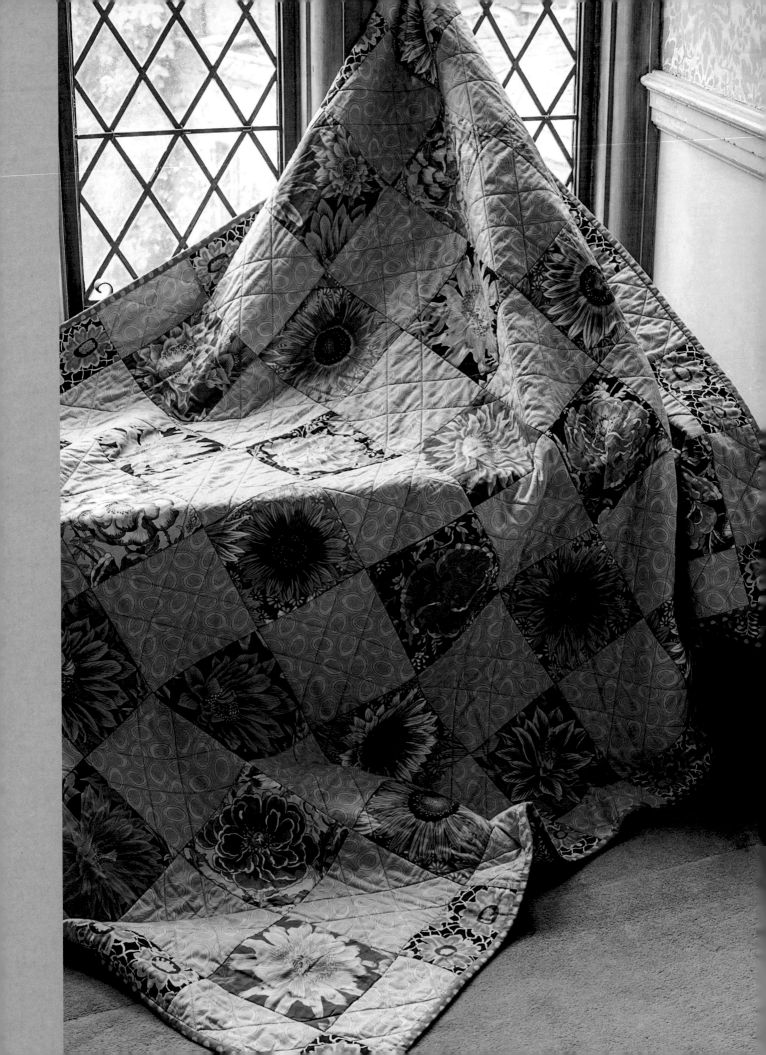

Blue Tiles
by Kaffe Fassett

Here again, I am struck by how much quilt designers can do with basic squares. In this quilt, I've checkerboarded my blue, green and lavender prints on a crisp blue background. The very simple layout allows the organic shapes in the fussy-cut flowers to do the work.

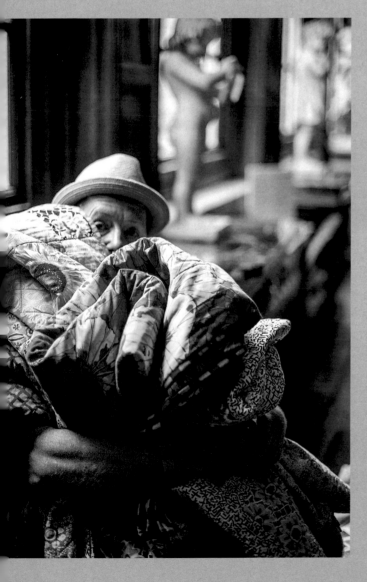

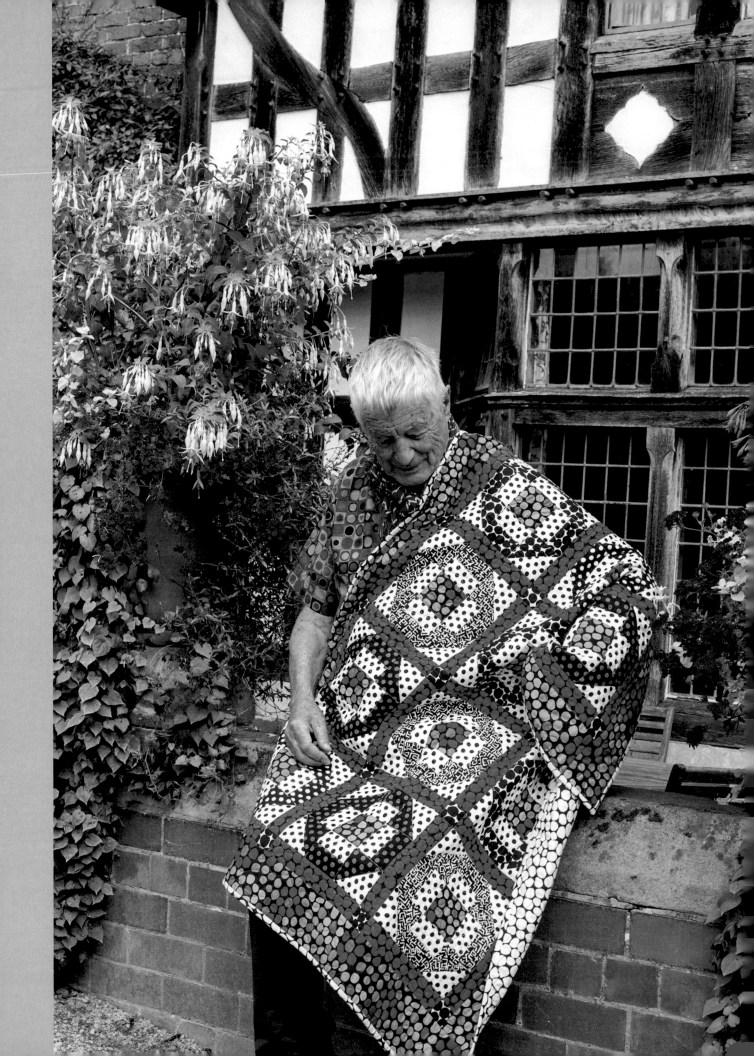

Sassy Baby
by Liza Prior Lucy

This black-and-white version of Liza's *Sweet Baby* quilt looks amazing in front of a half-timbered bothy in the castle grounds.

19

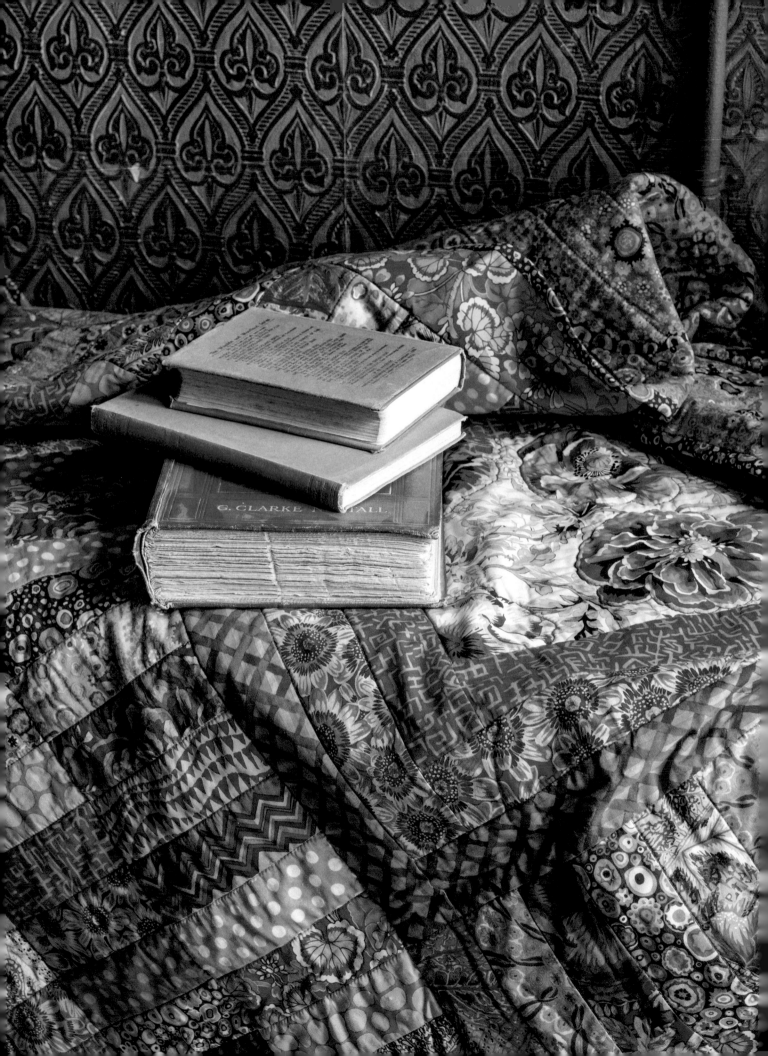

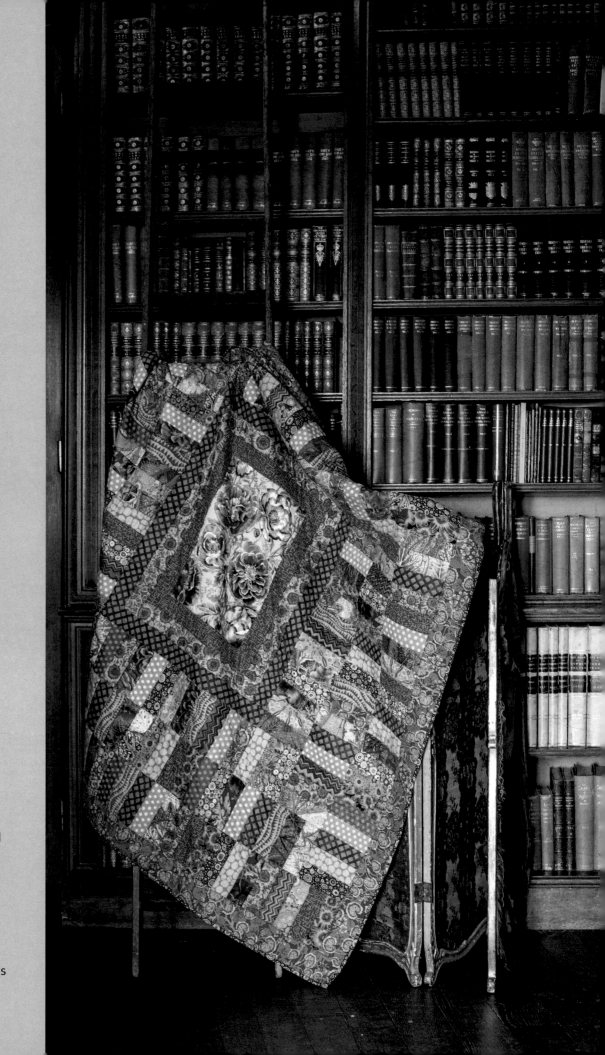

Vintage Library
by Kaffe Fassett

I was struck by the beautifully leather-bound book collections at aristocratic houses when I first came to England. This quilt echoes those autumnal shades that I recalled seeing on their bookshelves and that I found again in the castle's impressive library.

Saturated Red
by Kaffe Fassett

This bold use of our 'Van Gogh' sunflowers fabric really glows for me. I always do the red colourways on Philip Jacobs' and my prints before any of the other colours for the 'paint box' in each collection. They come into their own grouped together in this stunning setting.

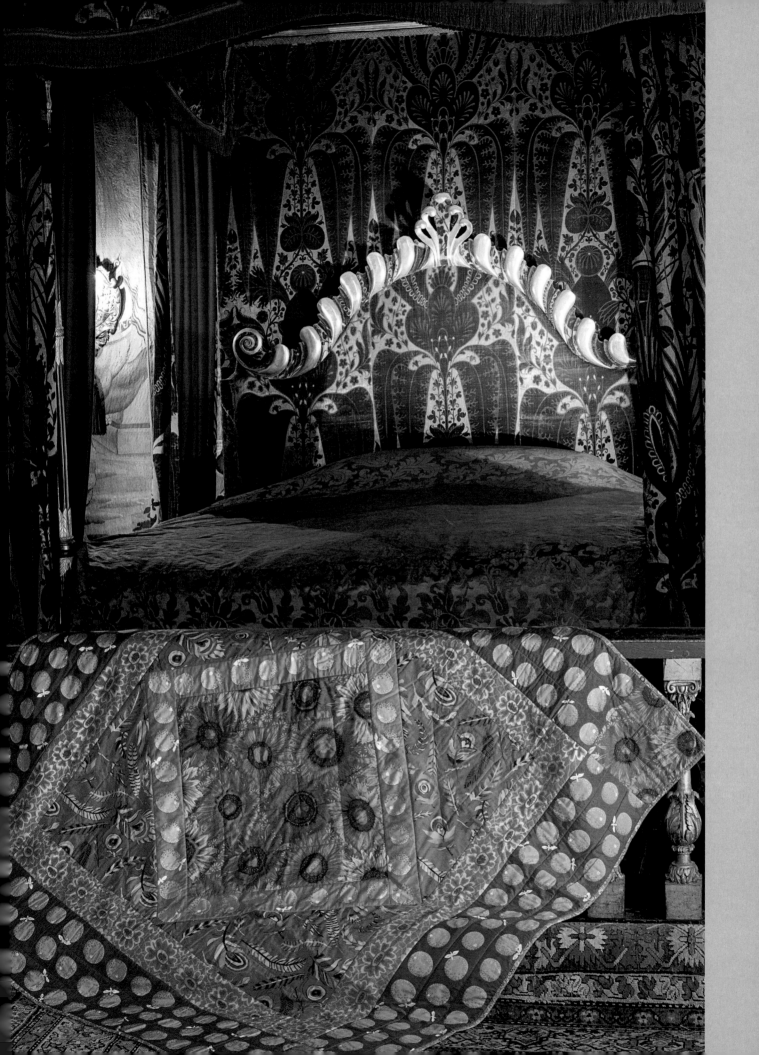

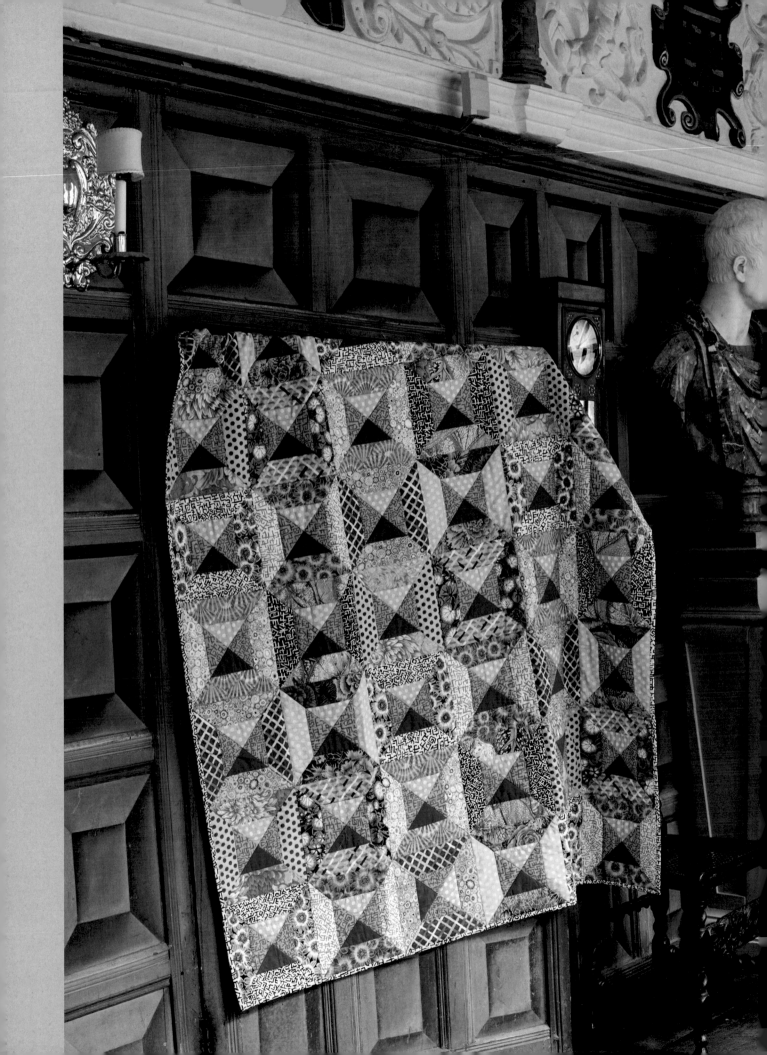

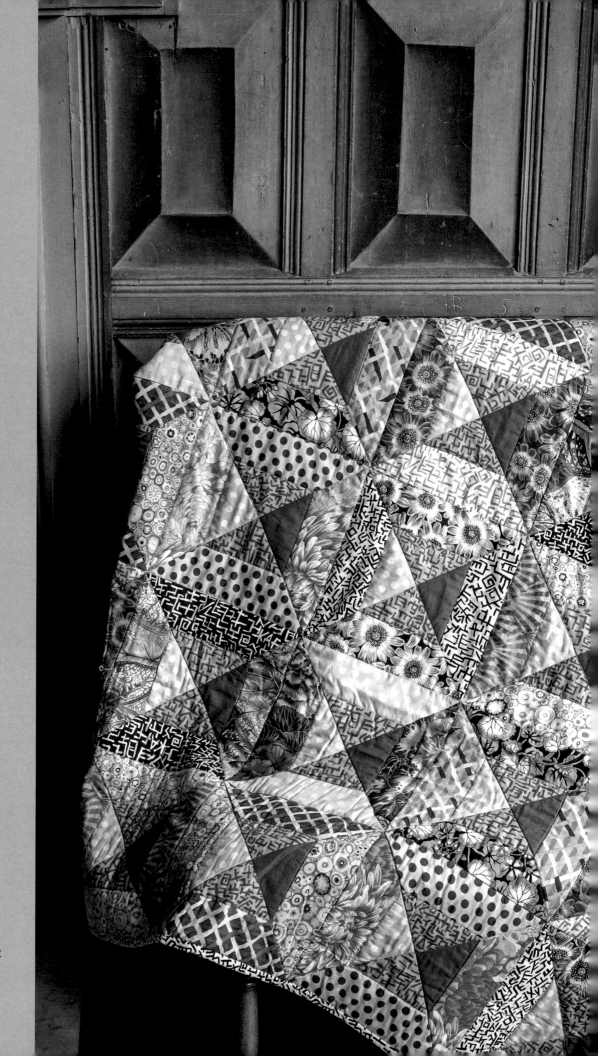

Marble Tiles
by Kaffe Fassett

I designed this specially
to go in the Long Gallery
at Powis Castle where the
painted panelling has the
same geometry. I like the
way the grey base of the
marble-like tiles in the quilt
is warmed up by pinks and
lavenders.

Golden Squares
by Kaffe Fassett

Figuring there would be autumn shades in the gardens when we shot this book, I created this high-contrast number. Of course, we found glorious high golden tones in the Powis borders to enhance our quilt.

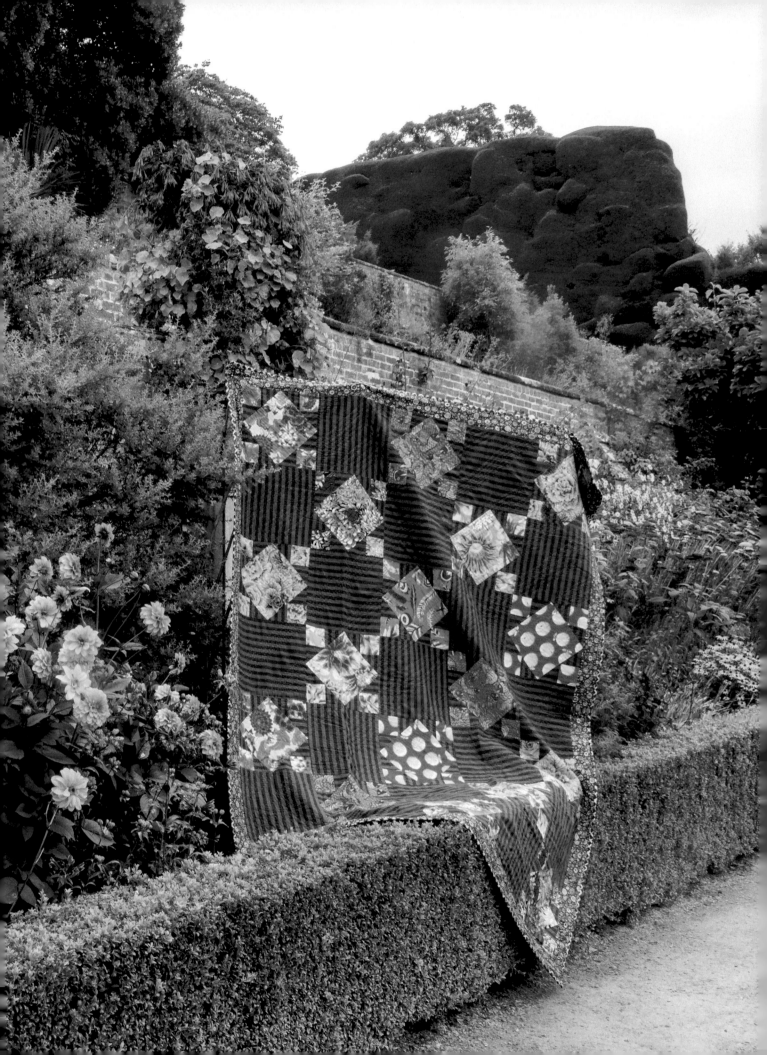

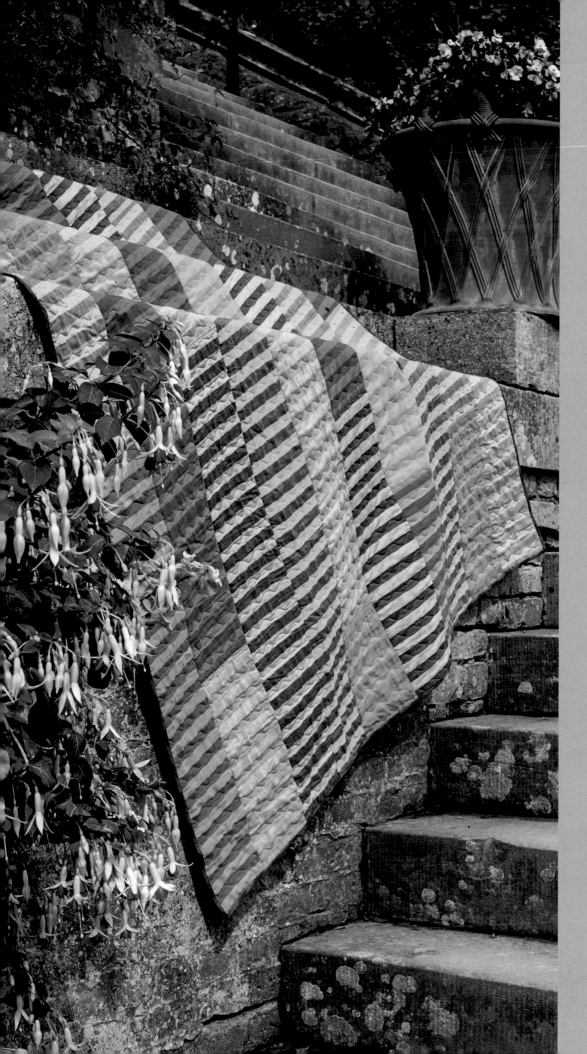

Stripy Strips
by Kaffe Fassett

This quilt was a joy to make. Just cutting the 6in (15cm) strips from my new Shot Cotton Stripes and sewing them at different lengths seems to bring their dusty colours to life, particularly so on the garden stairs at Powis.

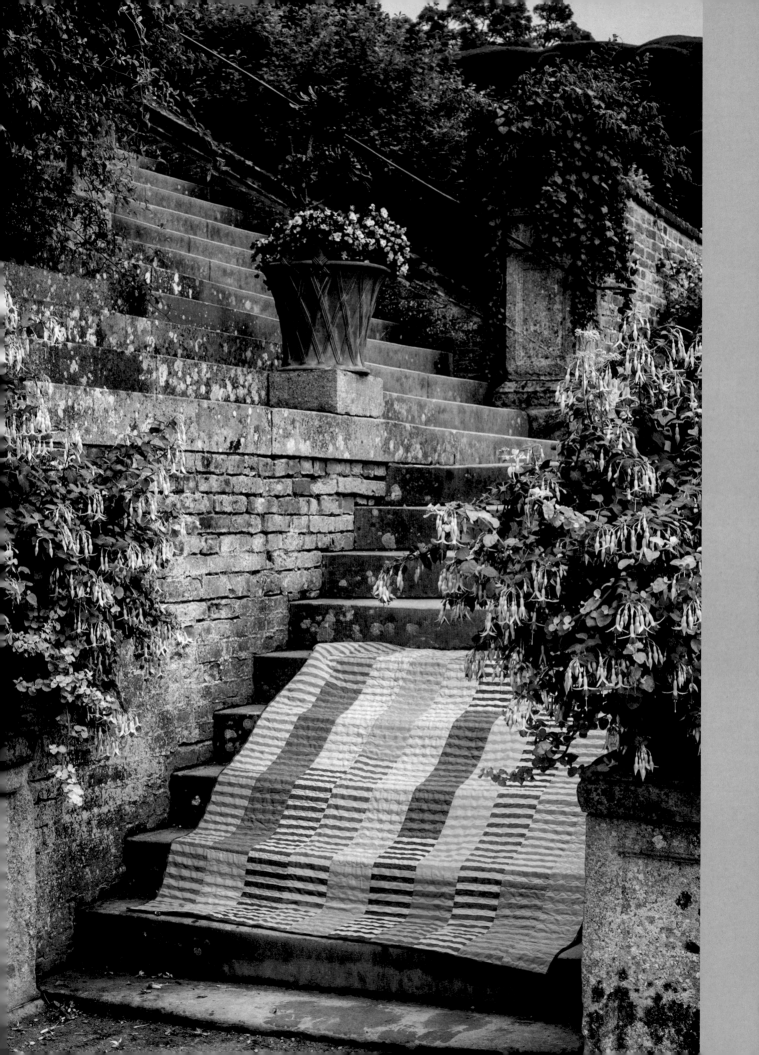

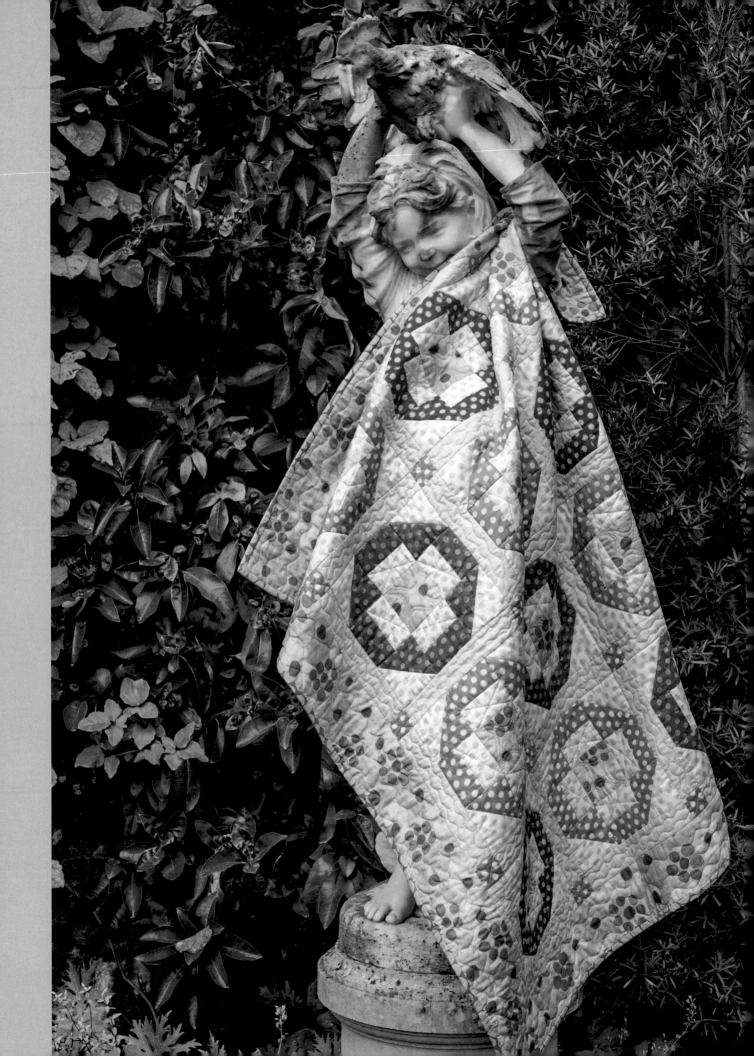

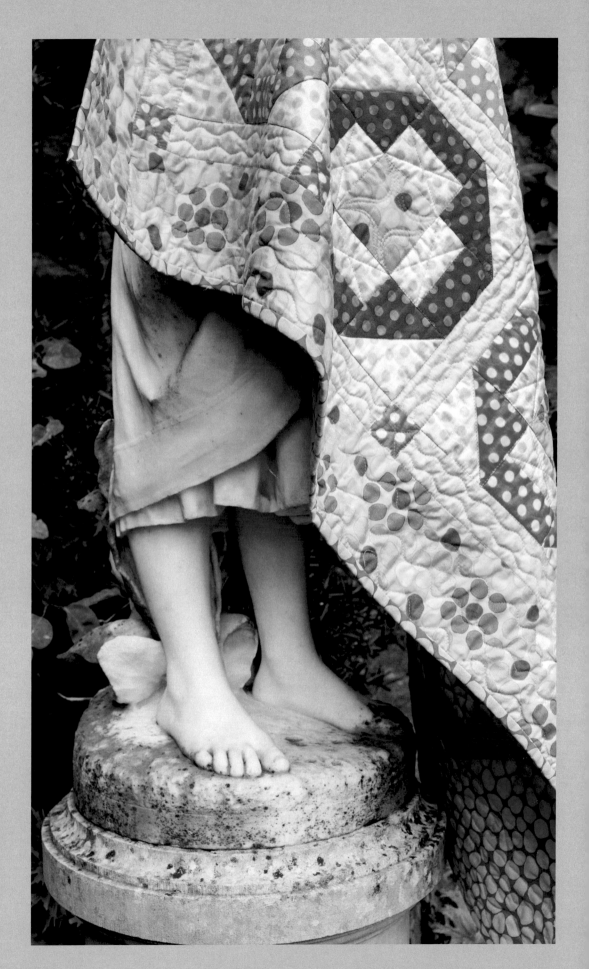

Sweet Baby
by Liza Prior Lucy

This quilt of Liza's has the same layout as *Sassy Baby*, but in a bright pastel palette, perfect for introducing a child to the world of colour. We found a lonely white marble statue on which to display it to great effect in the Powis gardens.

31

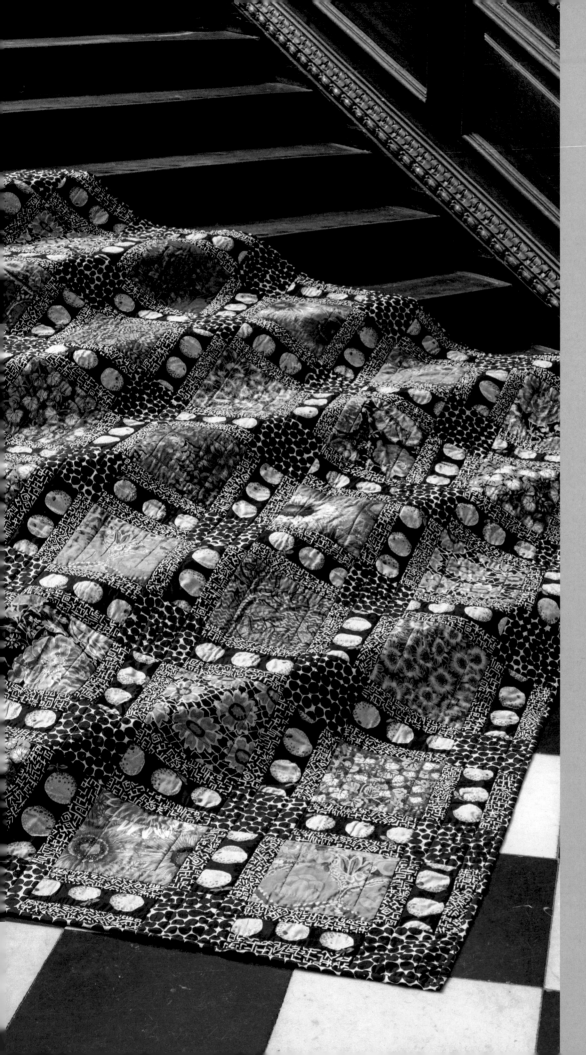

Cold Frames
by Kaffe Fassett

The classic black-and-white tiled floors in the entrance hall at Powis Castle inspired me to use my dramatic black and off-white Oranges print as a powerful sashing on this high-contrast quilt. I've done another version in hot reds but green would also have offered leafy excitement. Seeing *Cold Frames* on the weathered doors to the castle brings out the details in the quilt.

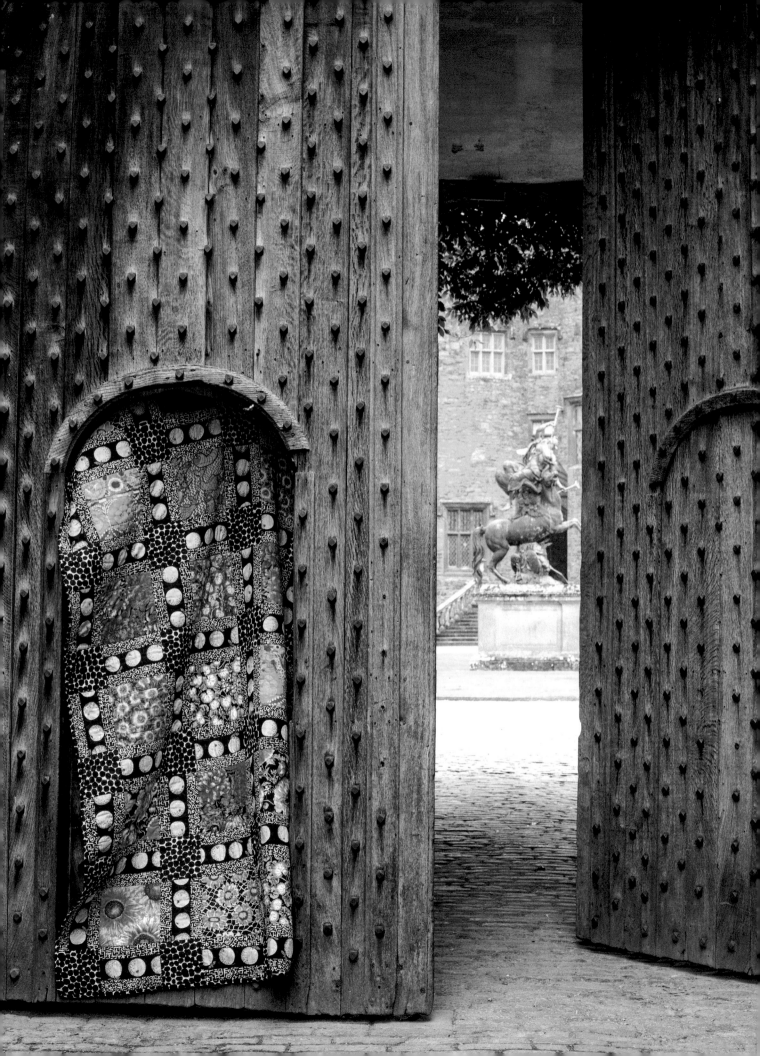

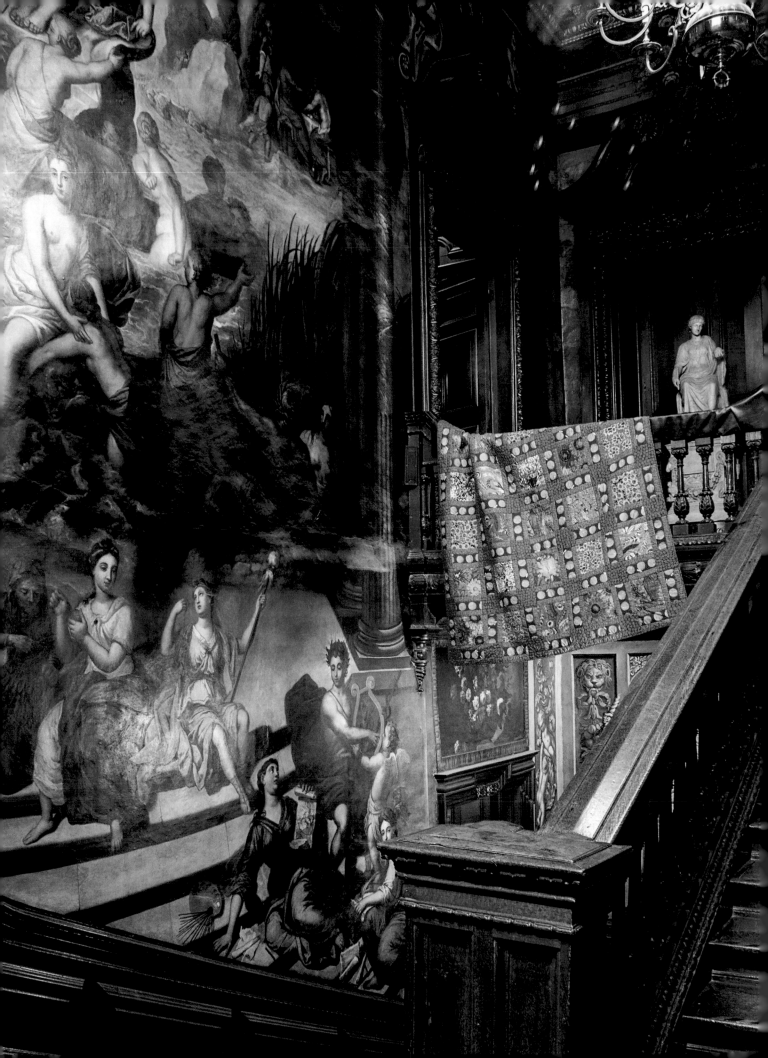

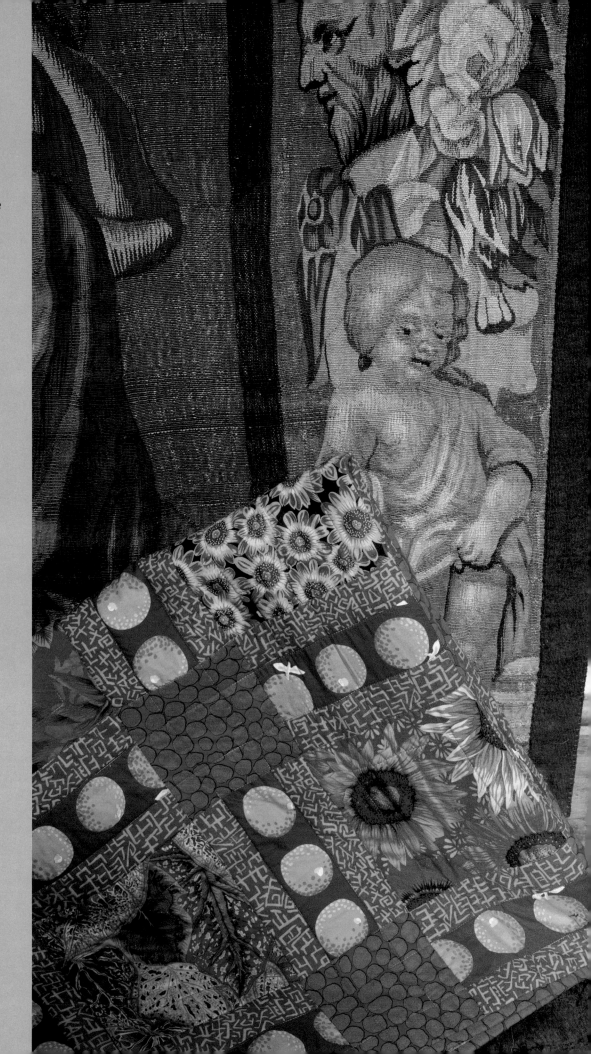

Hot Frames
by Kaffe Fassett

This quilt has the same layout as *Cold Frames* but uses all my bold red prints and the maroon-based Oranges print. I chose these glowing reds because of all the red details I had spotted in the murals and furnishings at the castle.

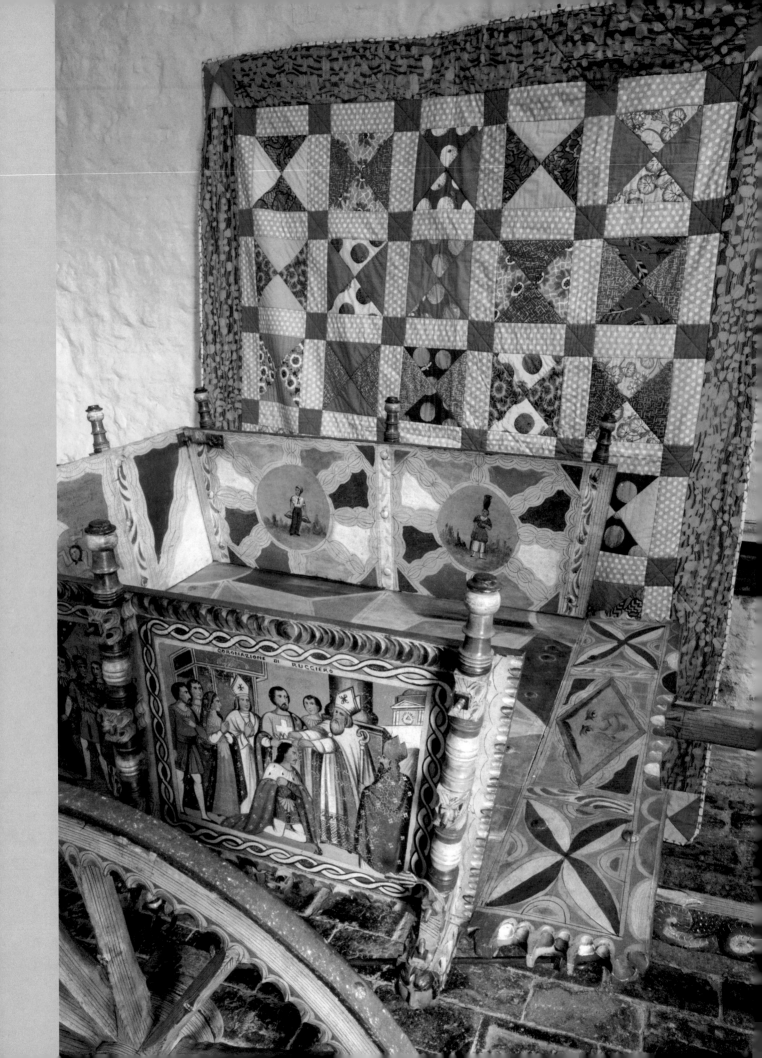

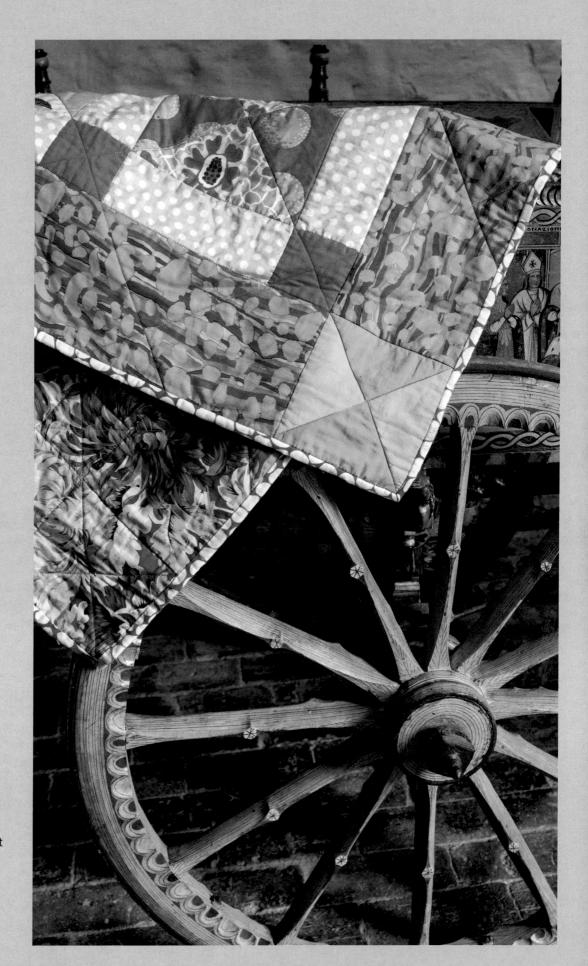

Jumping Jacks
by Kaffe Fassett

Most of my designs for quilts tend to be more tonal than high contrast. But I was struck by a vintage quilt that had child-like playfully dancing contrasts, so did my version of it here. How happy it looks alongside this Sicilian painted waggon.

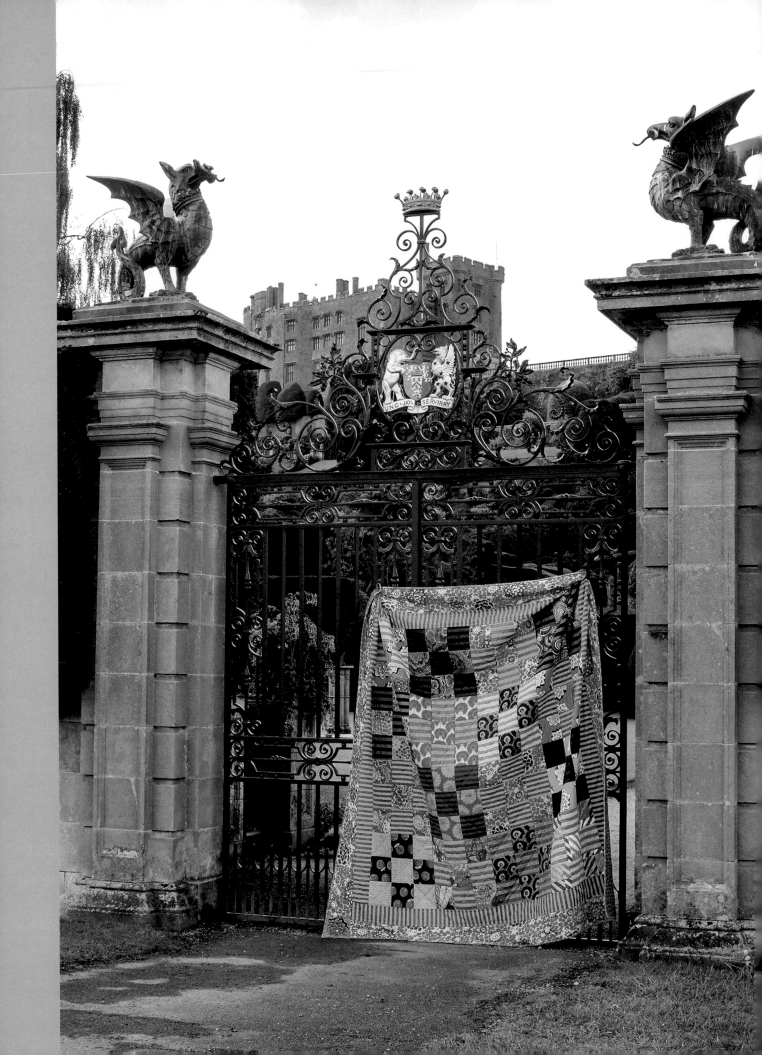

Checkerboard of Checkerboards
by Kaffe Fassett

I made this dark quilt with the wondrous Powis topiary in mind. Boy, did those deep blues also sing on the gates to the castle. The woven stripes in their bold two-tones work well as the consistent opposition to the prints. I'm often inspired by African Kente cloth that uses contrast stripes in this same checkerboard way.

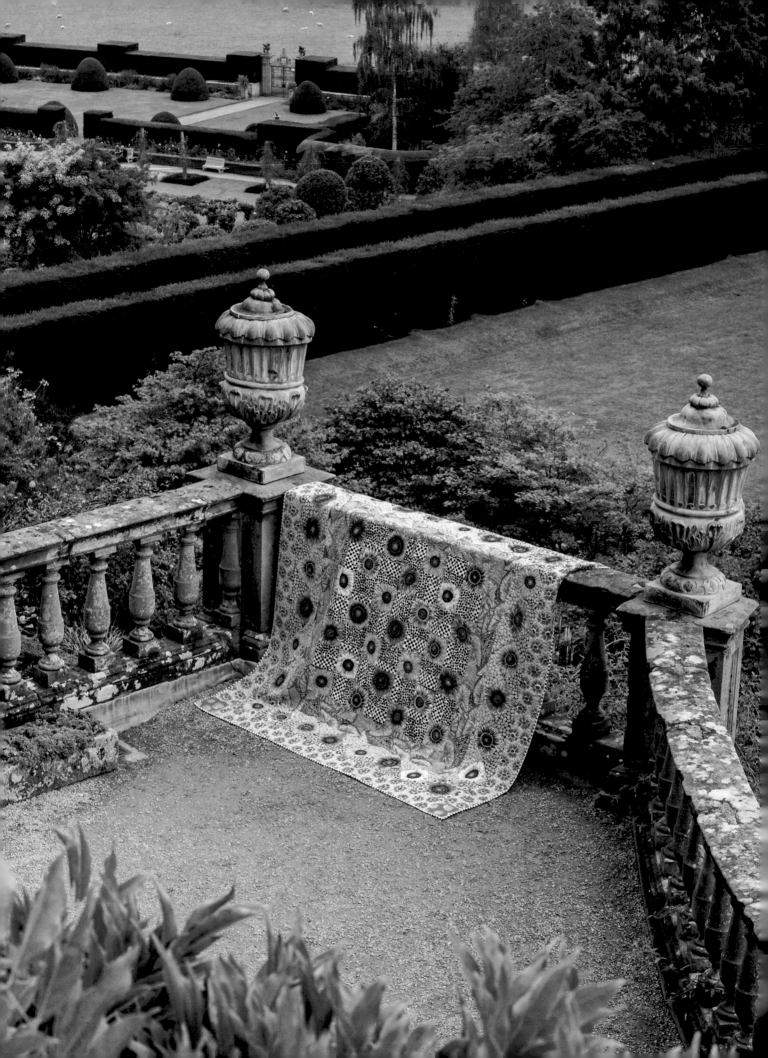

Sunflower Checkerboard
by Kaffe Fassett

Philip Jacobs designed these bold sunflowers for his other collection, Snow Leopard. I loved the way it cut up when I'd seen people using it in my workshops. Here, I've used the dark dramatic centres to echo Brandon's black-and-white Chips print. His Jumble fabric in the border has that strong black background and the Net Flowers design speaks to the soft pinks in this quilt. It holds its own in front of the beautiful garden terraces at the castle.

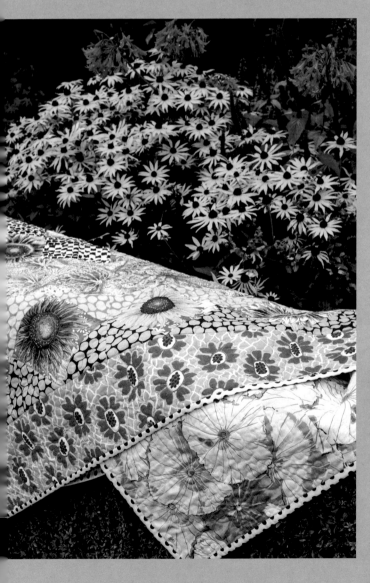

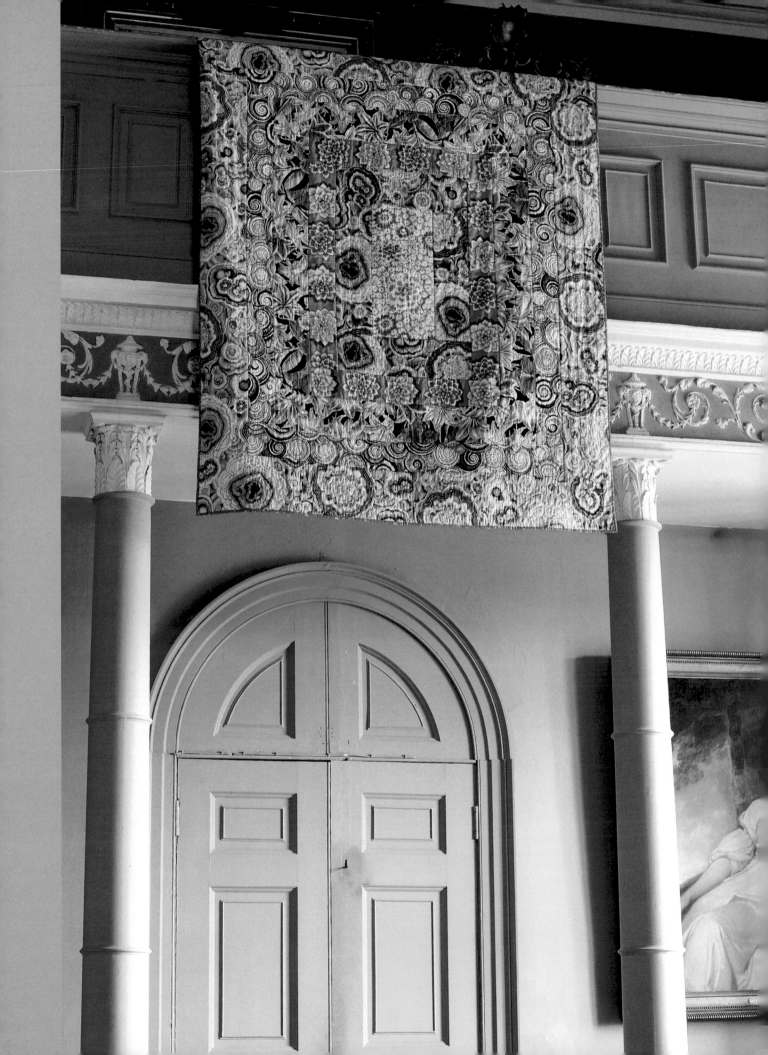

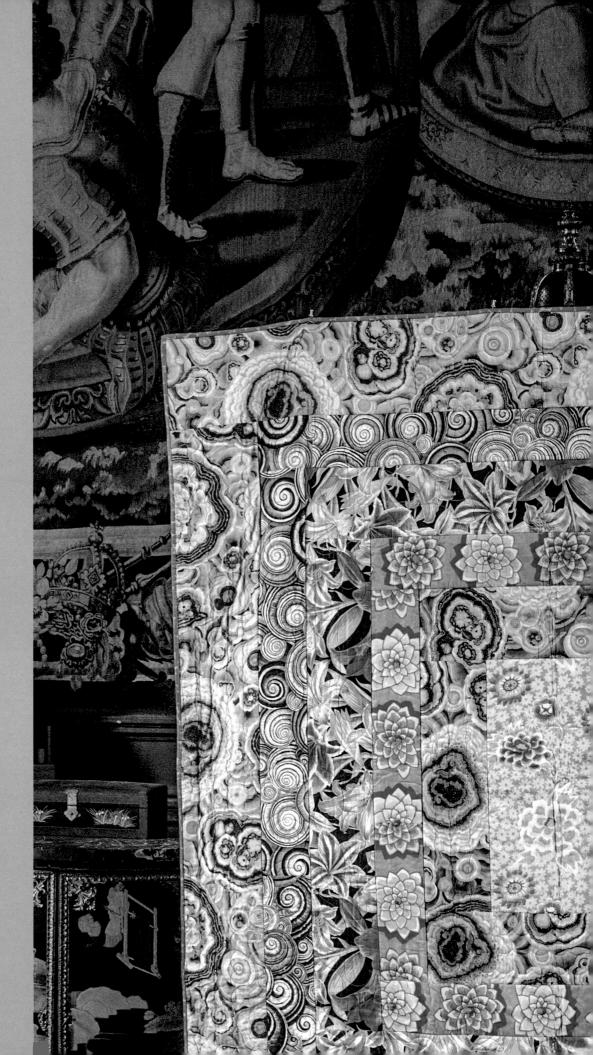

Turquoise Dream
by Kaffe Fassett

Because the prints in this quilt are so upscale and detailed, this very simple layout shows them to great advantage. Philip's Agate print particularly has great movement, just as in the details in the Powis tapestries.

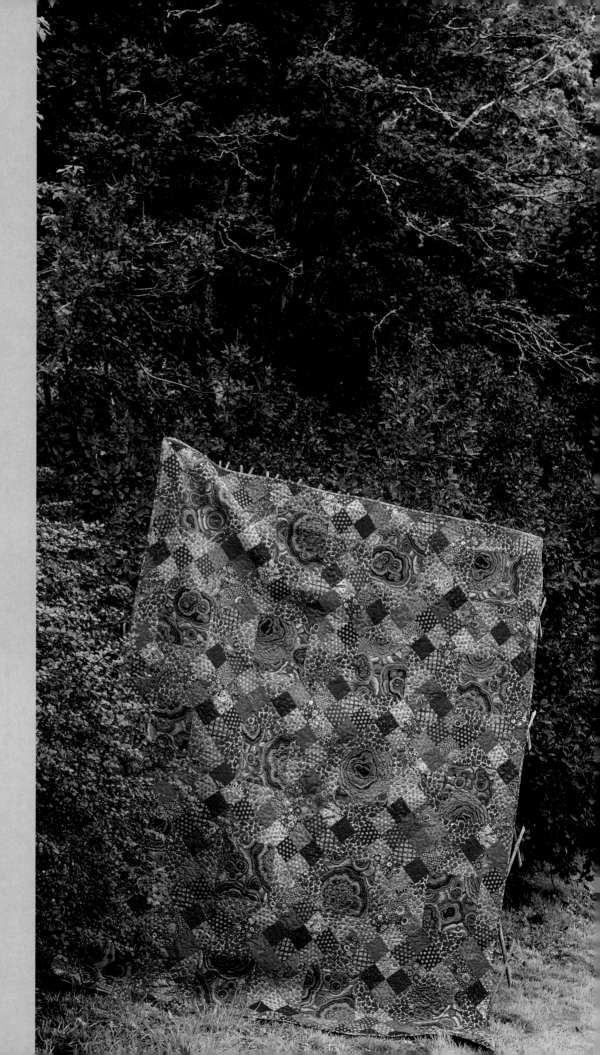

Plums and Ginger
by Liza Prior Lucy

The soft lavenders and
earthy browns in this quilt
by Liza echo the beautiful
bronzed grape vine and
the autumnal trees in the
castle grounds.

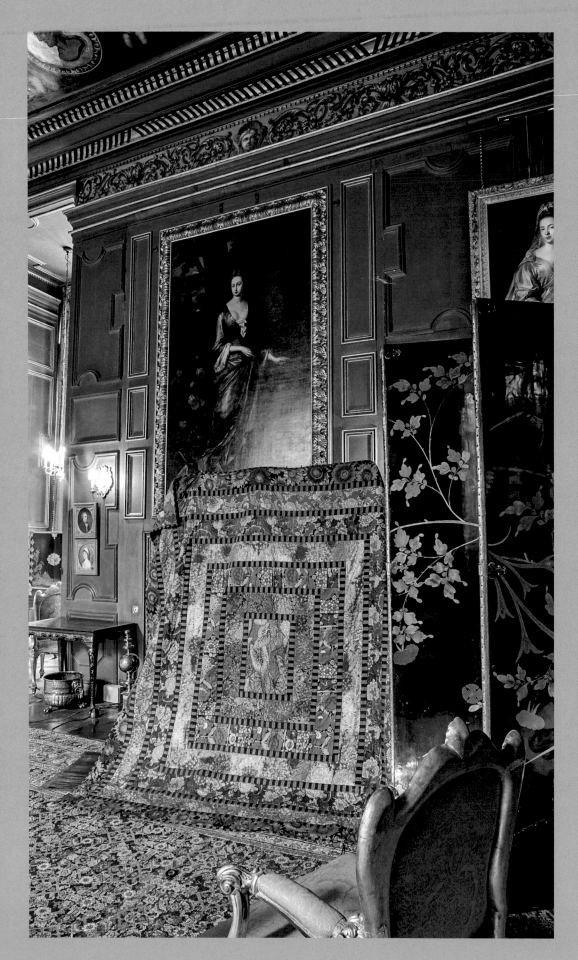

Topiary
by Kaffe Fassett

I love the way these dark prints are separated by sashing in my dark Fjord woven stripe. The dark palette of this elegant room and the Powis topiary both make this quilt's colours really glow.

46

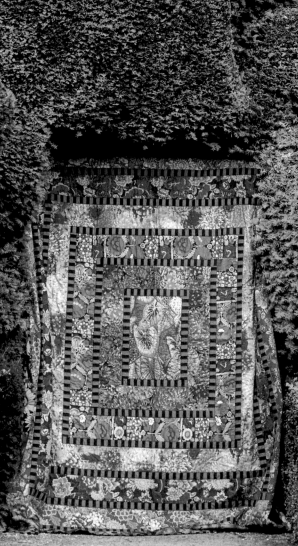

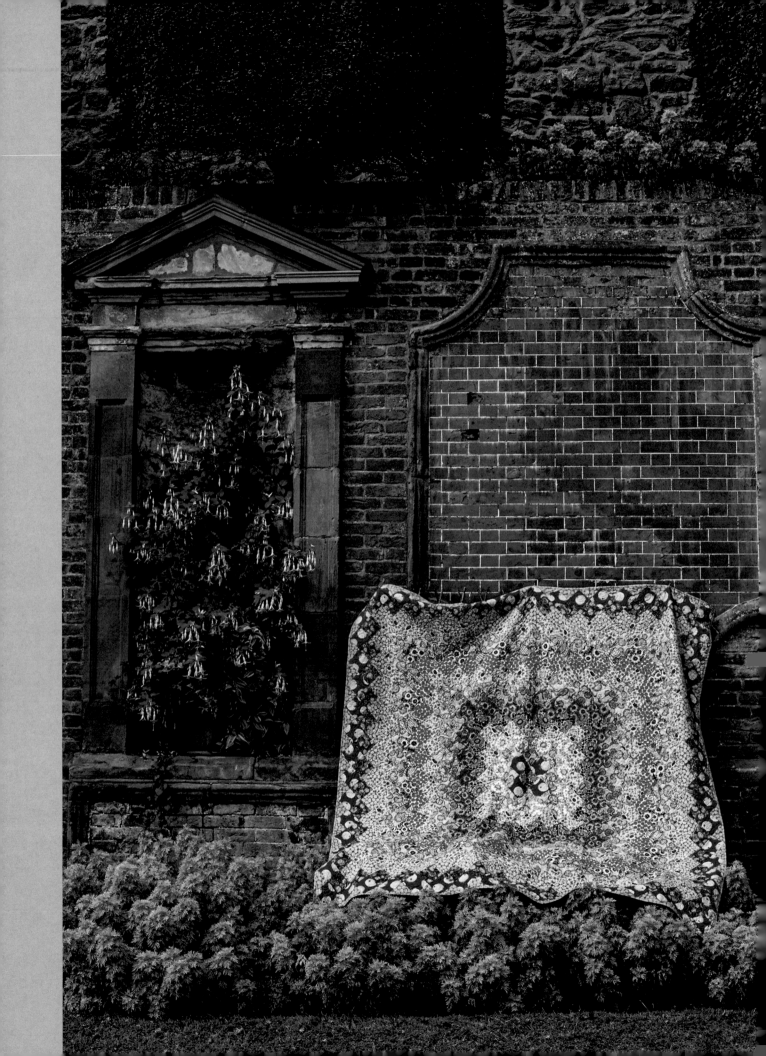

Lavender and Sage
by Kaffe Fassett

This Trip-Around-the-World in on-point squares is a form I've used in many different colour moods. These cool lavenders and blues work so well with the apple greens and pinks. I'm excited by the way prints slide into each other on the various layers of the quilt.

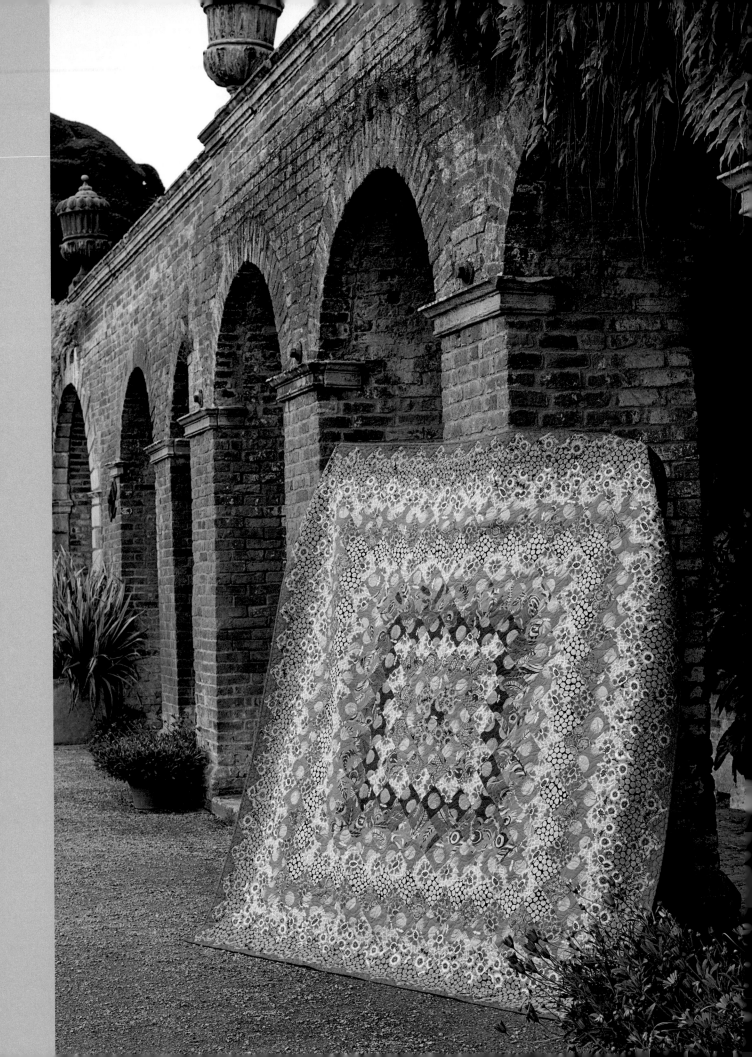

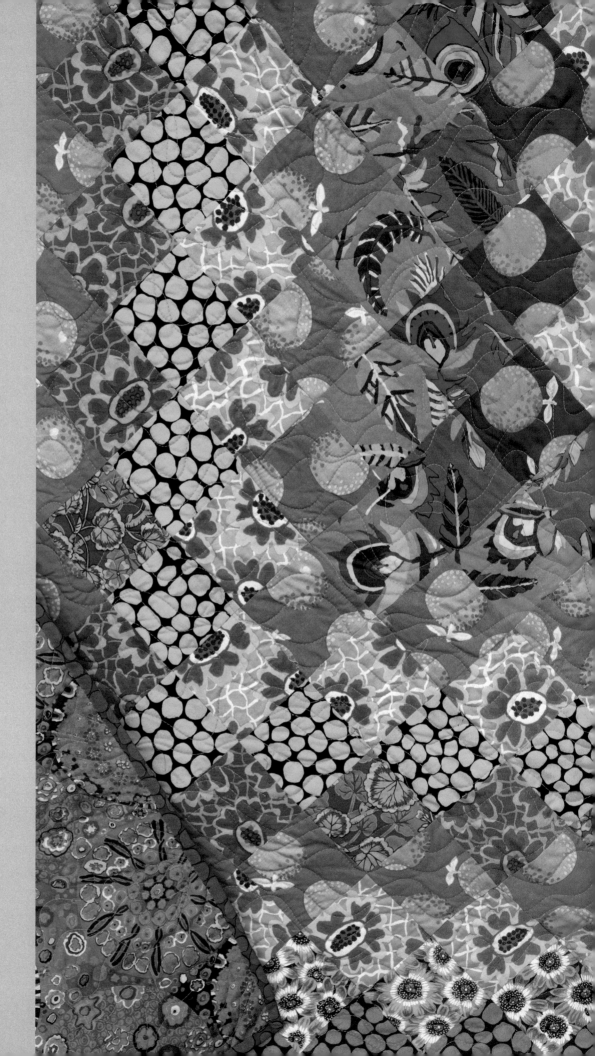

Bubbly
by Kaffe Fassett

This quilt has the same layout as *Lavender and Sage* but this time in a sizzling palette of reds and hot pink. The scale of my Oranges print is just right for these squares on point. Brandon's Jumble fabric and Philip's daisy print fabric, Lucy, work a treat. The old brick arches in the garden provide a sympathetic background.

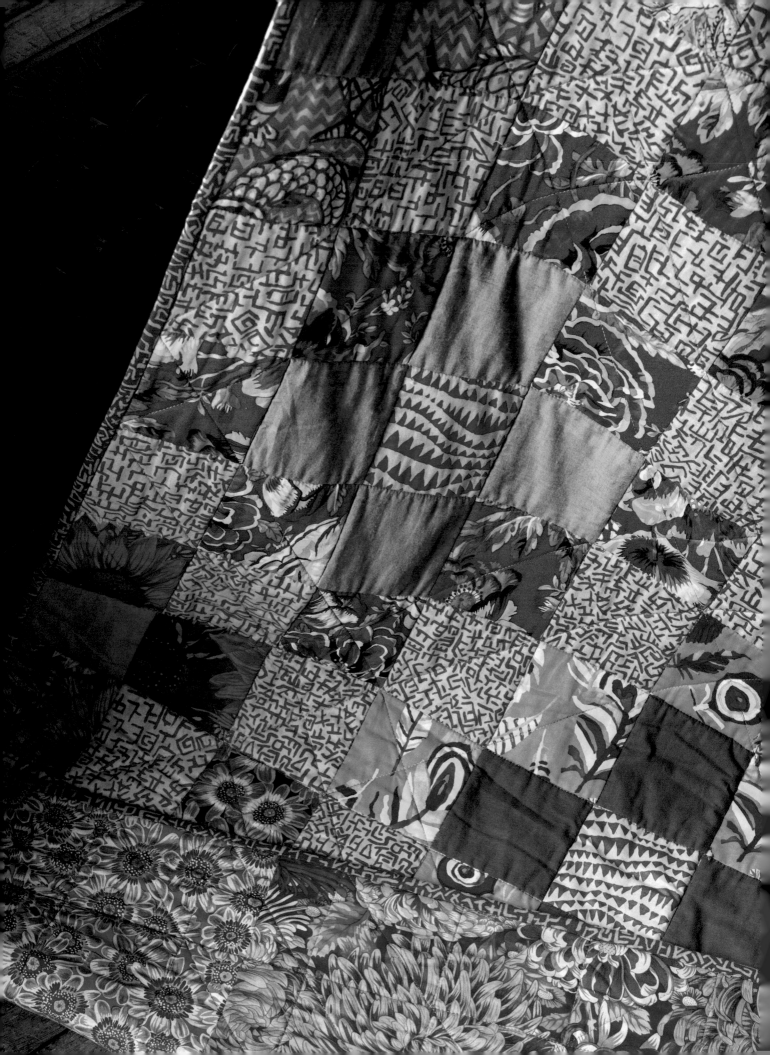

toast and marmalade *

Kaffe Fassett

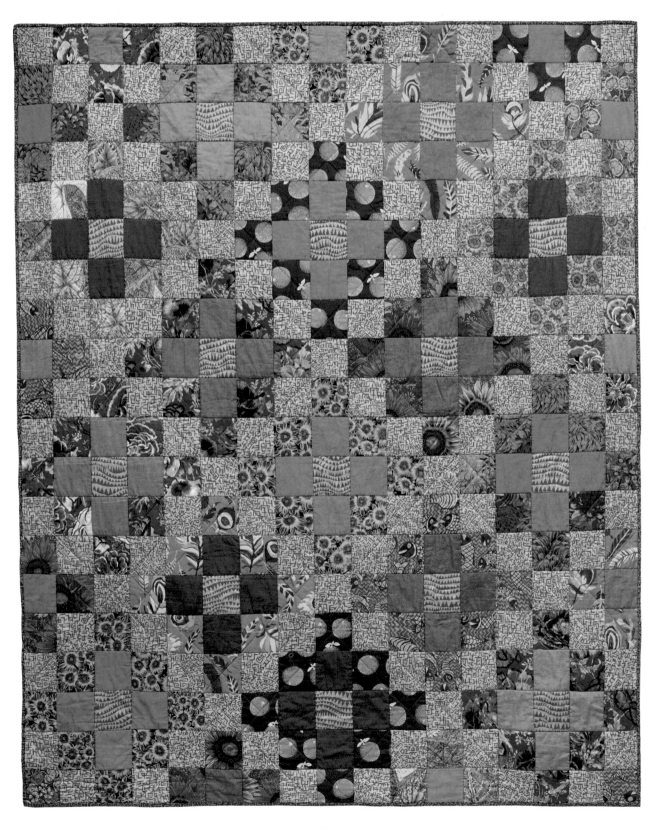

This quilt looks more complex than it is, laid out as 13-patch cross formations, each surrounded with background squares of grey Amaze fabric, but sewn together in rows.

SIZE OF FINISHED QUILT
80½in x 68½in (204cm x 174cm)

FABRICS
Fabrics have been calculated at a maximum width of 40in (102cm). Fabrics have been given a number – see Fabric Swatch Diagram for details.

Patchwork Fabrics
SHOT COTTON

Fabric 1	Khaki	⅜yd (40cm)
Fabric 2	Nutmeg	⅜yd (40cm)
Fabric 3	Paprika	¼yd (25cm)
Fabric 4	Camelia	½yd (50cm)
Fabric 5	Blood Orange	⅜yd (40cm)
Fabric 6	Lupin	⅜yd (40cm)

SHARKS TEETH

Fabric 7	Carnival	⅜yd (40cm)

KOI POLLOI

Fabric 8	Orange	⅜yd (40cm)

TICKLE MY FANCY

Fabric 9	Orange	½yd (50cm)

ORANGES

Fabric 10	Maroon	½yd (50cm)

HOKUSAI'S MUMS

Fabric 11	Hot	½yd (50cm)

* See also Backing Fabric

CALADIUMS

Fabric 12	Gold	⅜yd (40cm)

DOROTHY

Fabric 13	Brown	⅜yd (40cm)
Fabric 14	Red	⅜yd (40cm)

CLIMBING GERANIUMS

Fabric 15	Red	¼yd (25cm)

VAN GOGH

Fabric 16	Red	⅜yd (40cm)

LUCY

Fabric 17	Magenta	½yd (50cm)
Fabric 18	Orange	¼yd (25cm)

* See also Backing Fabric

AMAZE

Fabric 19	Grey	1¾yd (1.7m)

Backing and Binding Fabrics
HOKUSAI'S MUMS

Fabric 11	Hot	2½yd (2.3m)

* See also Patchwork Fabrics

LUCY

Fabric 18	Orange	2½yd (2.3m)

* See also Patchwork Fabrics

AMAZE

Fabric 20	Red	⅝yd (60cm)

Batting
89in x 77in (226cm x 196cm)

PATCHES
Patches are squares measuring 4in (10.2cm) finished, set in a cross formation and surrounded by diagonal rows of background squares in Amaze fabric.

CUTTING OUT
Fabric is cut across the width unless otherwise stated.

Squares
Cut strips 4½in (11.4cm) wide and cross-cut squares at 4½in (11.4cm). Each strip will yield 8 squares. Cut a total of 340 squares from fabrics as follows:
Fabric 1 (2 strips) 16 squares;
Fabric 2 (2 strips) 9 squares;
Fabric 3 (1 strip) 5 squares;
Fabric 4 (2 strips) 9 squares
Fabric 5 (2 strips) 16 squares;
Fabric 6 (2 strips) 16 squares;
Fabric 7 (2 strips) 15 squares;
Fabric 8 (2 strips) 12 squares;
Fabric 9 (3 strips) 19 squares;
Fabric 10 (3 strips) 19 squares;
Fabric 11 (3 strips) 19 squares;
Fabric 12 (2 strips) 11 squares;
Fabric 13 (2 strips) 16 squares;
Fabric 14 (2 strips) 14 squares;
Fabric 15 (1 strip) 4 squares;
Fabric 16 (2 strips) 14 squares;
Fabric 17 (3 strips) 19 squares;
Fabric 18 (1 strip) 8 squares;
Fabric 19 (13 strips) 99 squares.

Backing
From Fabric 11 cut a piece 39in x 89in (99cm x 226cm).
From Fabric 18 cut 2 pieces 20in x 89in (51cm x 226cm).

Binding
From Fabric 20 cut 8 strips 2½in (6.4 cm) wide. Remove selvedges and sew end to end with 45-degree seams (see page 141).

MAKING THE QUILT
Using a design wall will help to place patches in the required layout.
Use ¼in (6mm) seams throughout.

Lay out the squares referring to the Quilt Assembly Diagram and quilt photograph. Arrange the crosses as a 9-square block taking a centre Fabric 7 square, 4 shot cotton squares and 4 patterned squares, then add a further 4 patterned squares to create the cross motif. Add a line of Fabric 19 between each cross motif.
Stand back and check the layout is correct before sewing the squares together.

ASSEMBLING THE QUILT
Sew the squares together one row at a time, pressing seams in the opposite direction on alternate rows – odd rows to the left, even rows to the right – this will allow the finished seams to lie flat.
Pin, then sew the rows together, carefully matching the crossing seams.

FINISHING THE QUILT
Remove selvedges, and sew a Fabric 18 backing fabric piece to each side of the Fabric 11 backing piece and trim to form a backing 89in x 77in (226cm x 196cm).

Press the quilt top. Layer the quilt top, batting and backing, and baste together (see page 140).
Quilt as desired.
Trim the quilt edges and attach the binding (see page 141).

FABRIC SWATCH DIAGRAM

Patchwork Fabrics

Fabric 1
SHOT COTTON
Khaki
SC107KH

Fabric 2
SHOT COTTON
Nutmeg
SC102NM

Fabric 3
SHOT COTTON
Paprika
SC101PP

Fabric 4
SHOT COTTON
Camelia
SC109CX

Fabric 5
SHOT COTTON
Blood Orange
SC110BO

Fabric 6
SHOT COTTON
Lupin
SC113LU

Fabric 7
SHARKS TEETH
Carnival
BM060CV

Fabric 8
KOI POLLOI
Orange
BM079OR

Fabric 9
TICKLE MY FANCY
Orange
BM080OR

Fabric 10
ORANGES
Maroon
GP177MM

Fabric 11
HOKUSAI'S MUMS
Hot
PJ107HT

Fabric 12
CALADIUMS
Gold
PJ108BH

Fabric 13
DOROTHY
Brown
PJ109BR

Fabric 14
DOROTHY
Red
PJ108RD

Fabric 15
CLIMBING GERANIUMS
Red
PJ110RD

Fabric 16
VAN GOGH
Red
PJ111RD

Fabric 17
LUCY
Magenta
PJ112MG

Fabric 18
LUCY
Orange
PJ112OR

Fabric 19
AMAZE
Grey
BM078GY

Backing and Binding Fabrics

Fabric 11
HOKUSAI'S MUMS
Hot
PJ107HT

Fabric 18
LUCY
Orange
PJ112OR

Fabric 20
AMAZE
Red
BM078RD

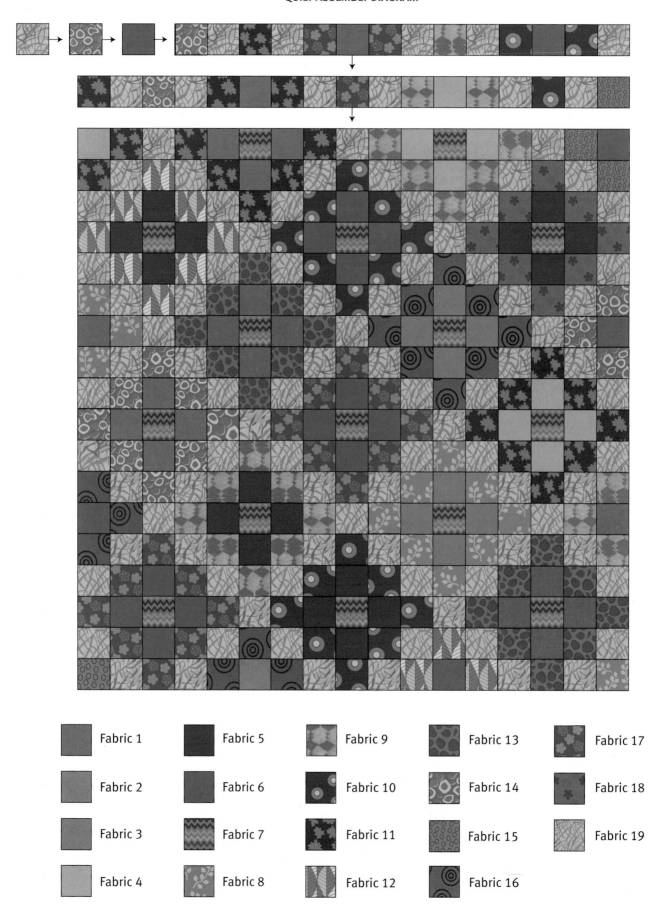

Fabric 1

Fabric 2

Fabric 3

Fabric 4

Fabric 5

Fabric 6

Fabric 7

Fabric 8

Fabric 9

Fabric 10

Fabric 11

Fabric 12

Fabric 13

Fabric 14

Fabric 15

Fabric 16

Fabric 17

Fabric 18

Fabric 19

vintage library **

Kaffe Fassett

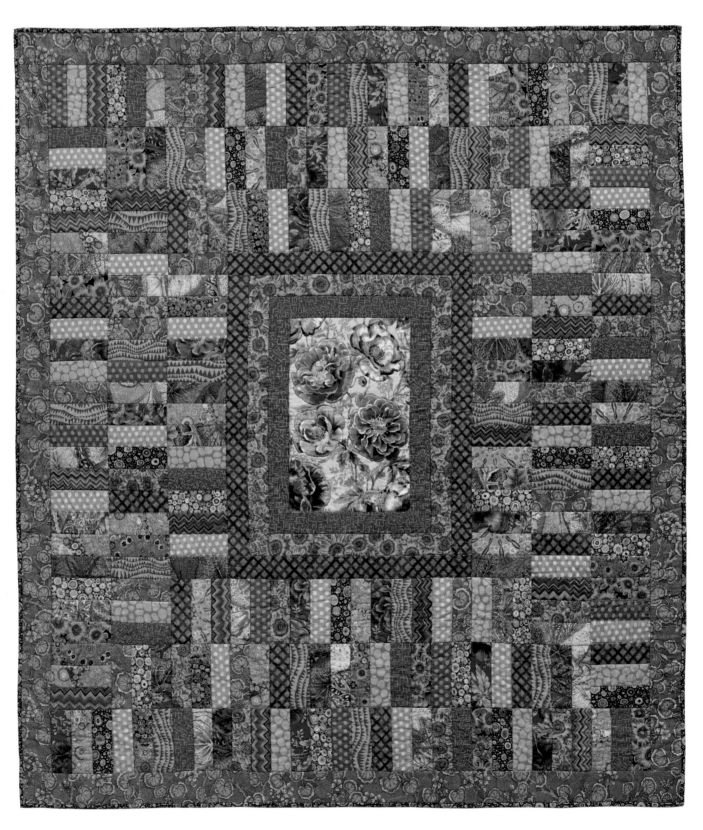

The centre medallion is framed by three narrow borders, then surrounded by three rows of pieced borders made from rectangles in alternating dark and light toned fabrics (to resemble books) and finally with a wider outer border.

SIZE OF FINISHED QUILT
72½in x 66½in (184cm x 169cm)

FABRICS
Fabrics have been calculated at a maximum width of 40in (102cm). Fabrics have been given a number – see Fabric Swatch Diagram for details.

Patchwork Fabrics
DOROTHY
Fabric 1 Natural ¾yd (70cm)

DARK FABRICS:
AMAZE
Fabric 2 Red ½yd (50cm)
MAD PLAID
Fabric 3 Rust ½yd (50cm)
DOROTHY
Fabric 4 Brown ¼yd (25cm)
CLIMBING GERANIUMS
Fabric 5 Red 1yd (95cm)
MILLEFIORE
Fabric 6 Antique ¼yd (25cm)
SPOT
Fabric 7 Cinnamon ¼yd (25cm)
ROMAN GLASS
Fabric 8 Byzantine ¼yd (25cm)
* See also Binding Fabric
CALADIUMS
Fabric 9 Gold ¼yd (25cm)
Fabric 10 Red ¼yd (25cm)
ZIG ZAG
Fabric 11 Rare ¼yd (25cm)

LIGHT FABRICS:
LUCY
Fabric 12 Orange ½yd (50cm)
Fabric 13 Magenta ¼yd (25cm)
MILLEFIORE
Fabric 14 Orange ⅜yd (40cm)
SPOT
Fabric 15 Ochre ⅜yd (40cm)
CALADIUMS
Fabric 16 Pastel ¼yd (25cm)
SHARKS TEETH
Fabric 17 Carnival ¼yd (25cm)
PAPERWEIGHT
Fabric 18 Pumpkin ¼yd (25cm)
JUMBLE
Fabric 19 Saffron ¼yd (25cm)

Backing and Binding Fabrics
MILLEFIORE
Fabric 20 Brown 4½yd (4.2m)
ROMAN GLASS
Fabric 8 Byzantine ⅝yd (60cm)
* See also Patchwork Fabrics

Batting
81in x 75in (206cm x 191cm)

PATCHES
All patches are cut from strips.
The centre medallion is surrounded by 3 borders 2in (5.1cm) wide finished. Then 3 further pieced borders are each made from 6in x 2in (15.2cm x 5.1cm) finished rectangles. The outer border is 3½in (8.9cm) wide finished.

CUTTING OUT
Fabric is cut across the width unless otherwise stated. When required strips are longer than 40in (102cm) – the usable width of the fabric – join strips end to end to obtain the required length, use ¼in (6mm) seams and press seams open.

Centre Medallion
From Fabric 1 cut a rectangle 18½in x 12½in (47cm x 31.8cm). Enough fabric has been allowed to cut a piece this size to best effect.

Border 1
From Fabric 2 cut 2 strips 2½in (6.4cm) wide and cut border pieces as follows:
2 pieces 18½in (47cm) long for the sides;
2 pieces 16½in (41.9cm) long for the top and bottom.

Border 2
From Fabric 12 cut 3 strips 2½in (6.4cm) wide, sew strips end to end and cut border pieces as follows:
2 pieces 22½in (57.2cm) long for the sides;
2 borders 20½in (52.1cm) long for the top and bottom.

Border 3
From Fabric 3 cut 3 strips 2½in (6.4cm) wide, sew strips end to end and cut border pieces as follows:
2 pieces 26½in (67.3cm) for the sides;
2 pieces 24½in (62.2cm) for the top and bottom.

Pieced Borders 4, 5 and 6
These borders are made using rectangles in which dark and light fabrics alternate. Cut strips 2½in (6.4cm) wide across the width of the fabric and cross-cut rectangles 2½in x 6½in (6.4cm x 16.5cm). Each strip will yield 6 rectangles. Cut strips for 138 dark fabric and 132 light fabric rectangles as follows:

DARK FABRICS:
Fabric 2 (3 strips) 13 rectangles;
Fabric 3 (3 strips) 15 rectangles;
Fabric 4 (3 strips) 17 rectangles;
Fabric 5 (2 strips) 12 rectangles;
Fabric 6 (2 strips) 10 rectangles;
Fabric 7 (2 strips) 12 rectangles;
Fabric 8 (2 strips) 10 rectangles;
Fabric 9 (3 strips) 15 rectangles;
Fabric 10 (3 strips) 17 rectangles;
Fabric 11 (3 strips) 17 rectangles.

LIGHT FABRICS:
Fabric 12 (3 strips) 15 rectangles;
Fabric 13 (2 strips) 11 rectangles;
Fabric 14 (4 strips) 19 rectangles;
Fabric 15 (4 strips) 24 rectangles;
Fabric 16 (3 strips) 13 rectangles;
Fabric 17 (3 strips) 18 rectangles;
Fabric 18 (3 strips) 14 rectangles;
Fabric 19 (3 strips) 18 rectangles.

Outer Border
From Fabric 5 cut 7 strips 3½in (8.9cm) wide. Join strips end to end using ¼in (6mm) seams and press seams open. From the length cut 4 pieces 66½in x 3½in (168.9cm x 8.9cm).

Backing
From Fabric 20 cut 1 piece 40in x 81in (102cm x 206cm) and 1 piece 35½in x 81in (90cm x 206cm).

Binding
From Fabric 8 cut 8 strips 2½in (6.4cm) wide. Remove selvedges and sew end to end with 45-degree seams (see page 141).

FABRIC SWATCH DIAGRAM

Patchwork Fabrics

Fabric 1
DOROTHY
Natural
PJ109NL

DARK FABRICS

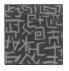
Fabric 2
AMAZE
Red
BM078RD

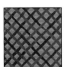
Fabric 3
MAD PLAID
Rust
BM037RU

Fabric 4
DOROTHY
Brown
PJ109BR

Fabric 5
CLIMBING GERANIUMS
Red
PJ110RD

Fabric 6
MILLEFIORE
Antique
GP092AN

Fabric 7
SPOT
Cinnamon
GP070CW

Fabric 8
ROMAN GLASS
Byzantine
GP001BY

Fabric 9
CALADIUMS
Gold
PJ108GD

Fabric 10
CALADIUMS
Red
PJ108RD

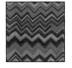
Fabric 11
ZIG ZAG
Rare
BM043RR

LIGHT FABRICS

Fabric 12
LUCY
Orange
PJ112OR

Fabric 13
LUCY
Magenta
PJ112MG

Fabric 14
MILLEFIORE
Orange
GP092OR

Fabric 15
SPOT
Ochre
GP070OC

Fabric 16
CALADIUMS
Pastel
PJ108PT

Fabric 17
SHARKS TEETH
Carnival
BM060CV

Fabric 18
PAPERWEIGHT
Pumpkin
GP020PN

Fabric 19
JUMBLE
Saffron
BM053SX

Backing and Binding Fabrics

Fabric 20
MILLEFIORE
Brown
GP092BR

Fabric 8
ROMAN GLASS
Byzantine
GP001BY

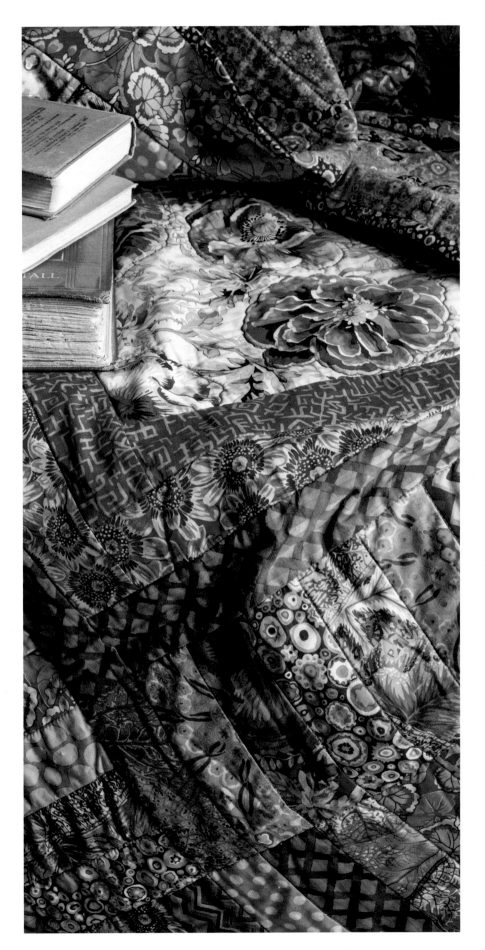

MAKING THE QUILT

Using a design wall will help to place patches in the required layout. Use ¼in (6mm) seams throughout.

Centre Medallion and Borders 1, 2 and 3

Referring to the Quilt Assembly Diagram and quilt photograph, sew the Border 1 sides to the centre medallion, press seams towards the border, then add Border 1 top and bottom strips.

Repeat the process for Borders 2 and 3, pinning and sewing the sides first, then the top and bottom. Press all seams towards the outer border as you go.

Pieced Borders 4, 5 and 6

Referring to the Quilt Assembly Diagram and quilt photograph for fabric placement, lay out the rectangles (alternating light and dark fabrics) to create each border. It is not necessary to copy the layout exactly, but make sure the fabrics contrast well and are spaced around the quilt.

Sew each set of border pieces together, pressing the seams in the opposite direction on alternate rows – odd rows to the left, even rows to the right – to allow finished seams to lie flat.

Carefully pin and sew each pieced length of Border 4, sides first, then the top and bottom, aligning crossing seams as you sew. Repeat for Borders 5 and 6.

Outer Border

Pin and sew Fabric 5 side borders, then top and bottom borders, to complete the Quilt Top.

FINISHING THE QUILT

Remove selvedges, and sew the Fabric 20 backing pieces together and trim to form a piece 81in x 75in (206cm x 191cm).

Press the quilt top. Layer the quilt top, batting and backing, and baste together (see page 140).
Quilt as desired.
Trim the quilt edges and attach the binding (see page 141).

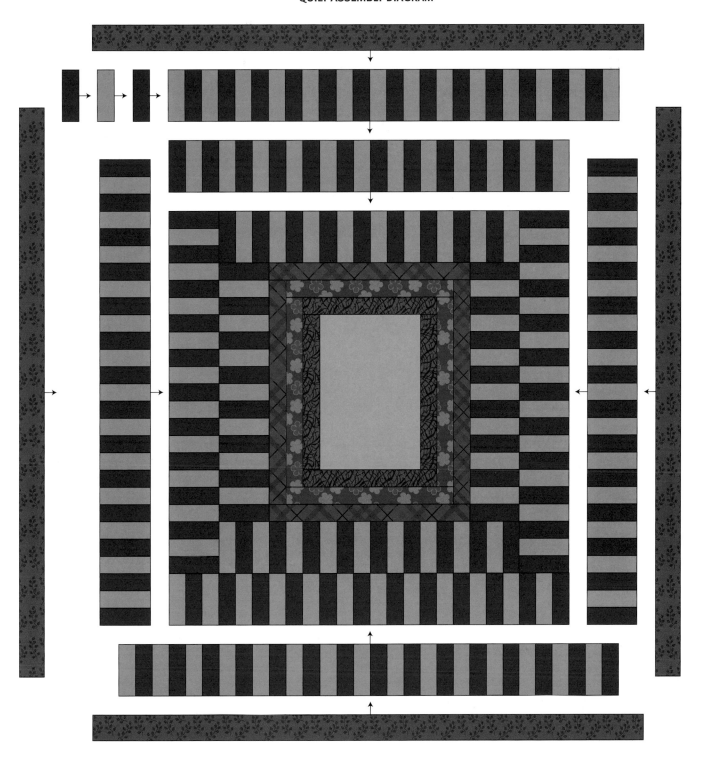

Note: The key for this quilt shows the fabrics in the order of construction.

Fabric 1

Fabric 12

Dark Fabrics (2–11)

Fabric 5

Fabric 2

Fabric 3

Light Fabrics (12–19)

cold frames **

Kaffe Fassett

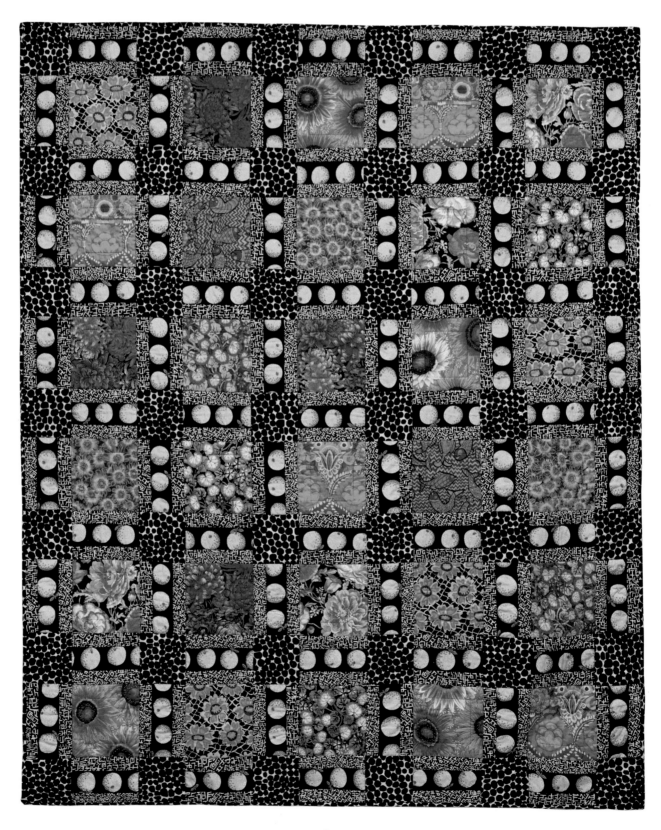

This striking quilt is composed of large-scale flower print squares at 8in (20.3cm) surrounded by pieced black-and-white sashing made from fussy-cut Oranges and Amaze fabrics, with sashing squares in Jumble.

SIZE OF FINISHED QUILT
87in x 73½in (221cm x 187cm)

FABRICS
Fabrics have been calculated at a maximum width of 40in (102cm). Fabrics have been given a number – see Fabric Swatch Diagram for details.

Patchwork Fabrics
ORANGES		
Fabric 1	Contrast	1¾yd (1.7m)
AMAZE		
Fabric 2	Black	2¼yd (2.1m)
JUMBLE		
Fabric 3	Black	1¼yd (1.2m)
* See also Binding Fabric		
HOKUSAI'S MUMS		
Fabric 4	Cool	¼yd (25cm)
VAN GOGH		
Fabric 5	Blue	¼yd (25cm)
EMBROIDERED FLOWER		
Fabric 6	Green	¼yd (25cm)
DOROTHY		
Fabric 7	Contrast	¼yd (25cm)
KOI POLLOI		
Fabric 8	Blue	¼yd (25cm)
LUCY		
Fabric 9	Lavender	¼yd (25cm)
FLOWER NET		
Fabric 10	Black	¼yd (25cm)
CLIMBING GERANIUMS		
Fabric 11	Black	¼yd (25cm)
Fabric 12	Purple	¼yd (25cm)

Backing and Binding Fabrics
MILLEFIORE		
Fabric 13	Blue	5½yd (5.1m)
JUMBLE		
Fabric 3	Black	¾yd (70cm)
* See also Patchwork Fabrics		

Batting
95in x 82in (241cm x 208cm)

FABRIC SWATCH DIAGRAM

Patchwork Fabrics

Fabric 1
ORANGES
Contrast
GP177CN

Fabric 2
AMAZE
Black
BM078BK

Fabric 3
JUMBLE
Black
BM053BK

Fabric 4
HOKUSAI'S MUMS
Cool
PJ107CL

Fabric 5
VAN GOGH
Blue
PJ111BL

Fabric 6
EMBROIDERED FLOWER
Green
GP185GN

Fabric 7
DOROTHY
Contrast
PJ109CN

Fabric 8
KOI POLLOI
Blue
BM079BL

Fabric 9
LUCY
Lavender
PJ112LV

Fabric 10
FLOWER NET
Black
BM081BK

Fabric 11
CLIMBING GERANIUMS
Black
PJ110BK

Fabric 12
CLIMBING GERANIUMS
Purple
PJ110PU

Backing and Binding Fabrics

Fabric 13
MILLEFIORE
Blue
GP092BL

Fabric 3
JUMBLE
Black
BM053BK

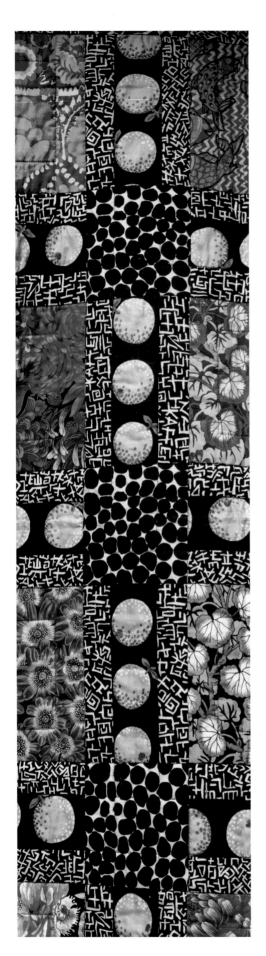

PATCHES

Feature squares are 8in (20.3cm) finished. They are separated by pieced sashing made from a strip of Fabric 1, fussy cut to centre the orange motifs, with a strip of Fabric 2 stitched to each side. Sashing sections are separated by squares in Fabric 3. The 30 sashed feature squares are set in 6 rows of 5 blocks.

CUTTING OUT

Fabric is cut across the width unless otherwise stated.

Feature Squares

Cut strips 8½in (21.6cm) wide and cross cut squares at 8½in (21.6cm). Each strip will yield 4 squares. Cut a total of 30 squares from fabrics as follows:
Fabric 4 (1 strip) 4 squares;
Fabric 5 (1 strip) 4 squares;
Fabric 6 (1 strip) 4 squares;
Fabric 7 (1 strip) 4 squares;
Fabric 8 (1 strip) 2 squares;
Fabric 9 (1 strip) 3 squares;
Fabric 10 (1 strip) 4 squares;
Fabric 11 (1 strip) 3 squares;
Fabric 12 (1 strip) 2 squares.

Pieced Sashing Sections

From Fabric 1 fussy cut 18 strips 3in (7.6cm) wide, centering a row of orange motifs along each strip. (Extra fabric has been allowed for this.) Cross cut 4 rectangles 3in x 8½in (7.6cm x 21.6cm) from each strip to make a total of 72. You will need 71 sashing sections.
From Fabric 2 cut 36 strips 2in (5.1cm) wide. Cross cut 4 rectangles 2in x 8½in (5.1cm x 21.6cm) from each strip. You will need 142 rectangles, 2 for each sashing section.

Sashing Squares

From Fabric 3 cut 7 strips 6in (15.2cm) wide and cross cut squares at 6in (15.2cm). Each strip will yield 6 squares. Cut a total of 42 squares.

Backing

Cut Fabric 13 into 2 pieces 95in x 40in (241cm x 102cm).

Binding

From Fabric 3 cut 9 strips 2½in (6.4cm) wide. Remove selvedges and sew end to end with 45-degree seams (see page 141).

PIECED SASHING ASSEMBLY DIAGRAM

MAKING THE QUILT

Using a design wall will help to place patches in the required layout.
Use ¼in (6mm) seams throughout.

Making the Pieced Sashing Sections

Sew a Fabric 2 sashing piece 2in x 8½in (5.1cm x 21.6cm) to each side of a Fabric 1 sashing piece 3in x 8½in (7.6cm x 21.6cm) to make each pieced sashing section. You will need to make 71 sections. After piecing, the sections will measure 6in x 8½in (15.2cm x 21.6cm).

Assembling the Quilt

Lay out the blocks, sashing sections and sashing squares, referring to the Quilt Assembly Diagram and quilt photograph for placement.
Sew together each sashing row and each block row, taking care to align crossing seams, and pressing all seams towards the sashing strips. This will allow the finished seams to lie flat.

FINISHING THE QUILT

Sew the 2 Fabric 13 backing pieces together.
Note: If you are intending to machine quilt, sew a 4in x 95in (10.2cm x 241cm) strip of a scrap fabric to one side of the backing piece, to widen the quilting allowance.

Press the quilt top. Layer the quilt top, batting and backing, and baste together (see page 140).
Quilt as desired.
Trim the quilt edges and attach the binding (see page 141).

 Fabric 1 Fabric 4 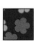 Fabric 7 Fabric 10

 Fabric 2 Fabric 5 Fabric 8 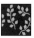 Fabric 11

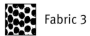 Fabric 3 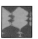 Fabric 6 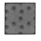 Fabric 9 Fabric 12

hot frames **

Kaffe Fassett

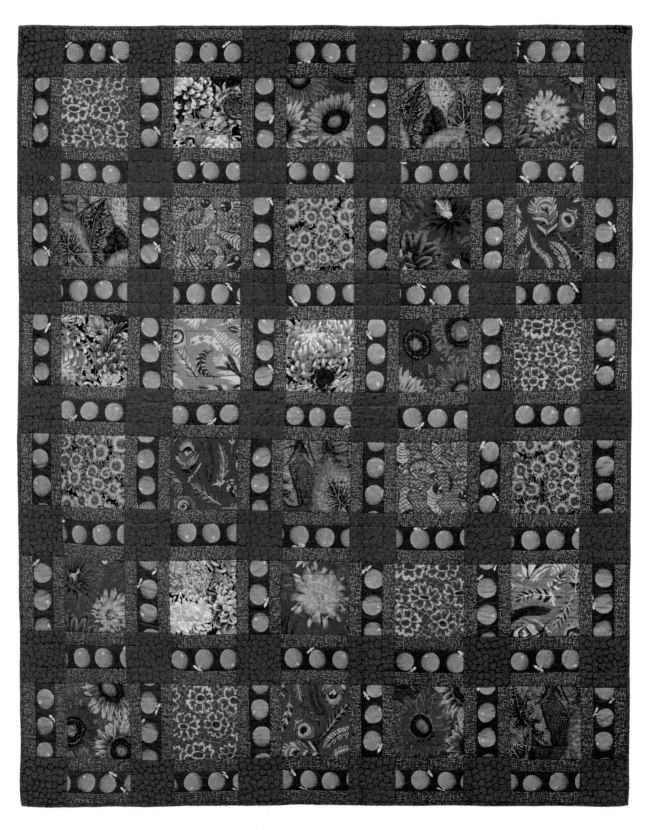

This alternative colourway to Cold Frames uses the warmer reds and oranges in the current collection. To make, use the Cold Frames instructions and layout on pages 62–65, but replace fabrics with those listed below, using the Quilt Assembly Diagram overleaf.

SIZE OF FINISHED QUILT
87in x 73½in (221cm x 187cm)

FABRICS
Fabrics have been calculated at a maximum width of 40in (102cm). Fabrics have been given a number – see Fabric Swatch Diagram for details.

Patchwork Fabrics

ORANGES			
Fabric 1	Maroon	1¾yd (1.7m)	
AMAZE			
Fabric 2	Red	2¼yd (2.1m)	
JUMBLE			
Fabric 3	Rust	1¼yd (1.2m)	

* See also Binding Fabric

HOKUSAI'S MUMS			
Fabric 4	Natural	¼yd (25cm)	
VAN GOGH			
Fabric 5	Red	¼yd (25cm)	
CALADIUMS			
Fabric 6	Red	¼yd (25cm)	
CACTUS FLOWER			
Fabric 7	Red	¼yd (25cm)	
KOI POLLOI			
Fabric 8	Orange	¼yd (25cm)	
LUCY			
Fabric 9	Magenta	¼yd (25cm)	
FLOWER NET			
Fabric 10	Red	¼yd (25cm)	
TICKLE MY FANCY			
Fabric 11	Red	¼yd (25cm)	
Fabric 12	Orange	¼yd (25cm)	

Backing and Binding Fabrics

MILLEFIORE			
Fabric 13	Tomato	5½yd (5.1m)	
JUMBLE			
Fabric 3	Rust	¾yd (70cm)	

* See also Patchwork Fabrics

Batting
95in x 82in (241cm x 208cm)

FABRIC SWATCH DIAGRAM

Patchwork Fabrics

Fabric 1
ORANGES
Maroon
GP177MM

Fabric 2
AMAZE
Red
BM078RD

Fabric 3
JUMBLE
Rust
BM053RU

Fabric 4
HOKUSAI'S MUMS
Natural
PJ107NL

Fabric 5
VAN GOGH
Red
PJ111RD

Fabric 6
CALADIUMS
Red
PJ108RD

Fabric 7
CACTUS FLOWER
Red
PJ096RD

Fabric 8
KOI POLLOI
Orange
PJ079OR

Fabric 9
LUCY
Magenta
PJ112MG

Fabric 10
FLOWER NET
Red
BM081RD

Fabric 11
TICKLE MY FANCY
Red
BM080RD

Fabric 12
TICKLE MY FANCY
Orange
BM080OR

Backing and Binding Fabrics

Fabric 13
MILLEFIORE
Tomato
GP092TM

Fabric 3
JUMBLE
Rust
BM053RU

QUILT ASSEMBLY DIAGRAM

Fabric 1	Fabric 4	Fabric 7	Fabric 10
Fabric 2	Fabric 5	Fabric 8	Fabric 11
Fabric 3	Fabric 6	Fabric 9	Fabric 12

marble tiles **

Kaffe Fassett

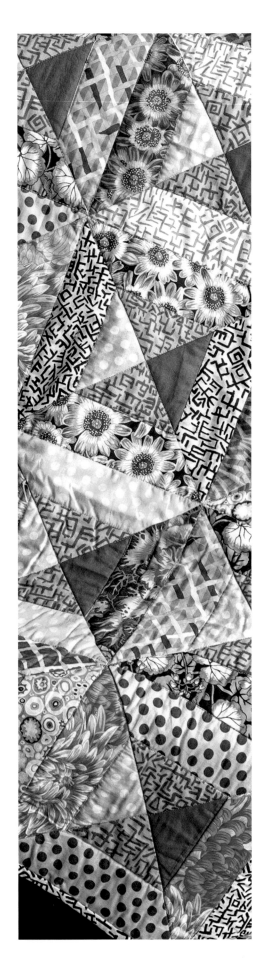

A new take on an early quilt in our 1990's *Glorious Patchwork*, this version uses many of the current neutral tones and soft colours to create a cool version of a marble tiled floor.

SIZE OF FINISHED QUILT
72½in x 54½in (184cm x 138cm)

FABRICS
Fabrics have been calculated at a maximum width of 40in (102cm) and have been given a number – see Fabric Swatch Diagram for details.

Patchwork Fabrics
SPOT
| Fabric 1 | Silver | ⅜ yd (40cm) |
AMAZE
| Fabric 2 | Grey | ¾ yd (70cm) |
SHOT COTTON
| Fabric 3 | Shadow | ⅜ yd (40cm) |
LUCY
| Fabric 4 | Lavender | ¼ yd (25cm) |
AMAZE
| Fabric 5 | Delft | ¼ yd (25cm) |
LUCY
| Fabric 6 | Grey | ¼ yd (25cm) |
AMAZE
| Fabric 7 | White | ¼ yd (25cm) |
* See also Binding Fabric
BRASSICA
| Fabric 8 | Dark | ¼ yd (25cm) |
SPOT
| Fabric 9 | Duck Egg | ¼ yd (25cm) |
PAPERWEIGHT
| Fabric 10 | Sludge | ¼ yd (25cm) |
MAD PLAID
| Fabric 11 | Contrast | ¼ yd (25cm) |
CLIMBING GERANIUMS
| Fabric 12 | Black | ¼ yd (25cm) |
MAD PLAID
| Fabric 13 | Stone | ¼ yd (25cm) |
HOKUSAI'S MUMS
| Fabric 14 | Grey | ¼ yd (25cm) |
SPOT
| Fabric 15 | Mauve | ¼ yd (25cm) |
AMAZE
| Fabric 16 | Black | ¼ yd (25cm) |
CALADIUMS
| Fabric 17 | Pastel | ¼ yd (25cm) |
PAPER FANS
| Fabric 18 | Cool | ¼ yd (25cm) |
PAPERWEIGHT
| Fabric 19 | Pastel | ¼ yd (25cm) |

Backing and Binding Fabrics
MILLEFIORE extra wide backing
| Fabric 20 | Pastel | 1¾ yd (1.7m) |
AMAZE
| Fabric 7 | White | ⅝ yd (60cm) |
* See also Patchwork Fabrics

Batting
81in x 63in (206cm x 160cm)

TEMPLATE

PATCHES
There are two different patch shapes to cut: trapezoids that are cut from strips using Template A (see page 137), and triangles that are cut from squares. Triangles are sewn to trapezoids to form large triangles, in turn sewn together to form square blocks that resemble framed hourglass blocks. Blocks are laid out in 8 rows of 6 with all but a few of the hourglass centres identical, with dark triangles at the top and pale ones at the bottom of each square.

CUTTING OUT
Fabric is cut across the width unless otherwise stated.

Centre Triangles
From Fabrics 1, 2 and 3 cut strips 5¾in (14.6cm) wide and cross cut squares at 5¾in (14.6cm). Each strip will yield 6 squares. Cut strips and squares as follows:

Fabric 1 (2 strips) 12 squares – 48 triangles;
Fabric 2 (4 strips) 24 squares – 96 triangles;
Fabric 3 (2 strips) 12 squares – 48 triangles.

Trapezoids
Cut 3 strips 2¾in (7cm) wide from each of Fabrics 4, 5, 6, 7, 8, 9, 10, 11, 12, 13, 14, 15, 16, 17, 18 and 19 and use Template A positioned along each strip to cut trapezoids. Rotating the template 180° after each cut will allow you to cut 4 from each strip. You will need 12 trapezoids from each fabric.

FABRIC SWATCH DIAGRAM

Patchwork Fabrics

Fabric 1
SPOT
Silver
PG070SV

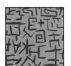
Fabric 2
AMAZE
Grey
BM078GY

Fabric 3
SHOT COTTON
Shadow
SC108SD

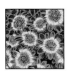
Fabric 4
LUCY
Lavender
PJ112LV

Fabric 5
AMAZE
Delft
BM078DF

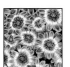
Fabric 6
LUCY
Grey
PJ112GY

Fabric 7
AMAZE
White
BM078WH

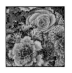
Fabric 8
BRASSICA
Dark
PJ051BR

Fabric 9
SPOT
Duck Egg
PG070DE

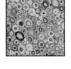
Fabric 10
PAPERWEIGHT
Sludge
GP020SL

Fabric 11
MAD PLAID
Contrast
BM037CN

Fabric 12
CLIMBING GERANIUMS
Black
PJ110BK

Fabric 13
MAD PLAID
Stone
BM037SN

Fabric 14
HOKUSAI'S MUMS
Grey
PJ107GY

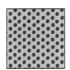
Fabric 15
SPOT
Mauve
PG070MV

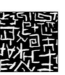
Fabric 16
AMAZE
Black
BM078BK

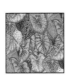
Fabric 17
CALADIUMS
Pastel
PJ108PT

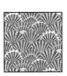
Fabric 18
PAPER FANS
Cool
GP143CL

Fabric 19
PAPERWEIGHT
Pastel
GP020PT

Backing and Binding Fabrics

Fabric 20
MILLEFIORE
Pastel
QB006PT

Fabric 7
AMAZE
White
BM078WH

BLOCK ASSEMBLY DIAGRAM

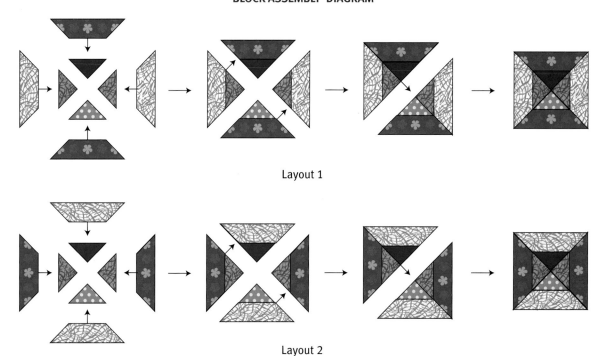

Layout 1

Layout 2

Backing
Trim Fabric 20 to 81in x 63in (206cm x 160cm).

Binding
From Fabric 7 cut 7 strips 2½in (6.4cm) wide. Remove selvedges and sew end to end with 45-degree seams (see page 141).

MAKING THE QUILT
Using a design wall will help to place patches in the required layout.
Use ¼in (6mm) seams throughout.

Kaffe's Note
You may spot that there is a patch misplacement in Row 1, block 4 (sideways) and again in Row 2 (upside down). These occasional quirks are a feature of my designs. Correct them if you want perfect symmetry.

Making the Blocks
Each block consists of 4 triangles and 4 trapezoids. Triangles and trapezoids are sewn together to form large triangles with patches carefully positioned so they form identical hourglass centres with pairs of trapezoids sitting opposite each other: one pair at the top and bottom of the block and another pair on each side to create the finished 9in (22.9cm) block.
Note: The trapezoids alternate between darker trapezoids on the top and bottom (see Block Assembly Diagram Layout 1) and darker trapezoids on the sides (see Block Assembly Diagram Layout 2).

The trapezoids are grouped in pairs of 2 fabrics. There are 8 pairs of fabrics as follows:
Fabrics 4 and 5; Fabrics 6 and 7; Fabrics 8 and 9; Fabrics 10 and 11; Fabrics 12 and 13; Fabrics 14 and 15; Fabrics 16 and 17; and Fabrics 18 and 19. Make 6 blocks using each of the pairs.

Referring to the Block Assembly Diagram, sew a Fabric 1 triangle to the top trapezoid, a Fabric 3 triangle to the bottom trapezoid, and sew Fabric 2 triangles to the side trapezoids. Press

seams lightly towards the trapezoids, then sew the large triangles together in pairs, press seams towards the darker trapezoids, then sew both halves of the block together.

ASSEMBLING THE QUILT
Lay out the blocks in 8 rows of 6 blocks, referring to the Quilt Assembly Diagram and quilt photograph and paying attention to alternating the block layouts between Layout 1 and Layout 2, as shown. The centre triangles always have the dark triangle at the top, the light at the bottom and the medium on each side.

Sew the blocks together one row at a time, pressing seams in the opposite direction on alternate rows – odd rows to the left, even rows to the right – as this will allow the finished seams to lie flat.

FINISHING THE QUILT
Press the quilt top. Layer the quilt top, batting and backing, and baste together (see page 140).
Quilt as desired.
Trim the quilt edges and attach the binding (see page 141).

QUILT ASSEMBLY DIAGRAM

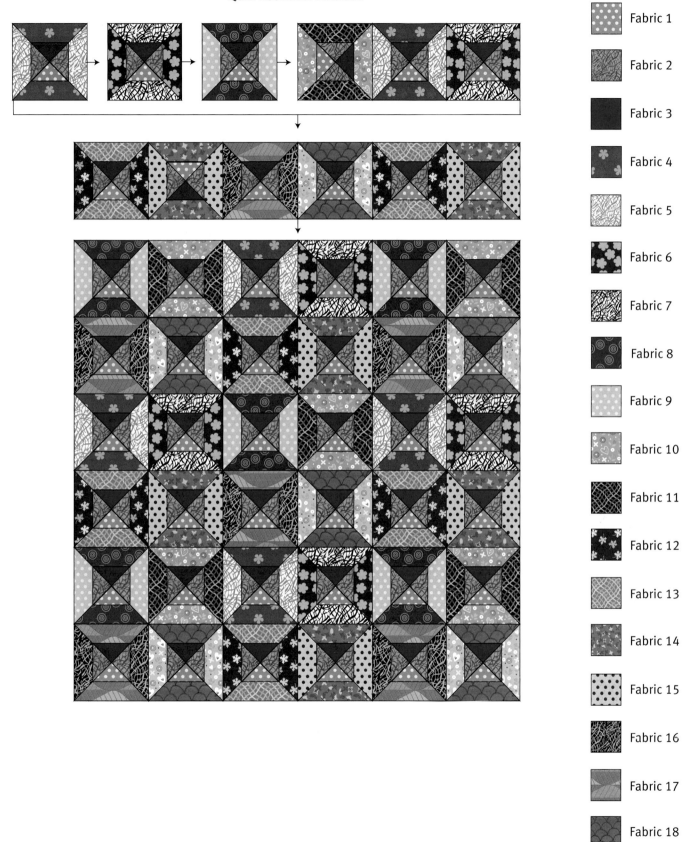

Fabric 1

Fabric 2

Fabric 3

Fabric 4

Fabric 5

Fabric 6

Fabric 7

Fabric 8

Fabric 9

Fabric 10

Fabric 11

Fabric 12

Fabric 13

Fabric 14

Fabric 15

Fabric 16

Fabric 17

Fabric 18

Fabric 19

topiary *

Kaffe Fassett

Made in a single log cabin format, this quilt is pieced around a rectangular panel in Philip Jacobs' Caladiums fabric. The finished 1½in (3.8cm) striped fabric borders alternate with wider 5in (12.7cm) borders in large-flowered fabrics, all in deep, rich colourways.

SIZE OF FINISHED QUILT
96½in x 90½in (245cm x 230cm)

FABRICS
Fabrics have been calculated at a maximum width of 40in (102cm). Fabrics have been given a number – see Fabric Swatch Diagram for details.

Patchwork Fabrics
CALADIUMS
Fabric 1 Red ⅝yd (60cm)
HOKUSAI'S MUMS
Fabric 2 Dark ½yd (50cm)
EMBROIDERED FLOWER
Fabric 3 Purple 1⅛yd (1.1m)
HOKUSAI'S MUMS
Fabric 4 Green 1yd (95cm)
CLOISONNE
Fabric 5 Purple 1⅛yd (1.1m)
Fabric 6 Blue 1⅜yd (1.3m)
VAN GOGH
Fabric 7 Dark 1½yd (1.4m)
WIDE STRIPE
Fabric 8 Fjord 2yd (1.9m)
* See also Binding Fabric

Backing and Binding Fabrics
LOTUS LEAF extra wide backing
Fabric 9 Purple 3yd (2.8m)
WIDE STRIPE
Fabric 8 Fjord ⅞yd (85cm)
* See also Patchwork Fabrics

Batting
105in x 99in (267cm x 251cm)

PATCHES
A large central feature rectangle surrounded by six wide floral borders, each separated by a narrow, striped border.

CUTTING OUT
Fabric is cut across the width unless otherwise stated. When required strips are longer than 40in (102cm) – the usable width of the fabric – join strips end to end to obtain the required length, use ¼in (6mm) seams and press seams open. If you wish to pattern match joining seams, you will need to allow extra fabric.

Centre Rectangle
From Fabric 1 cut a rectangle 18½in x 12½in (47cm x 31.8cm). Extra fabric has been allowed to cut this to best effect.

Wide Border 1
From Fabric 2 cut 3 strips 5½in (14cm) wide and cut borders as follows:
2 borders 21½in (54.6cm) for the sides;
2 borders 25½in (64.8cm) for the top and bottom.

Wide Border 2
Cutting strips down the length of the fabric (to use the cross-section of the floral stripes) from Fabric 3 cut 4 strips 5½in (14cm) wide and cut borders as follows:
2 borders 34½in (87.6cm) for the sides;
2 borders 38½in (97.8cm) for the top and bottom.

Wide Border 3
From Fabric 4 cut 6 strips 5½in (14cm) wide, sew end to end and cut borders as follows:
2 borders 47½in (120.7cm) for the sides;
2 borders 51½in (130.8cm) for the top and bottom.

Wide Border 4
From Fabric 5 cut 7 strips 5½in (14cm) wide and cut borders as follows:
2 borders 60½in (153.7cm) for the sides;
2 borders 64½in (163.8cm) for the top and bottom.

Wide Border 5
From Fabric 6 cut 8 strips 5½in (14cm) wide and cut borders as follows:
2 borders 73½in (186.7cm) for the sides;
2 borders 77½in (196.9cm) for the top and bottom.

Wide Border 6
From Fabric 7 cut 9 strips 5½in (14cm) wide and cut borders as follows:
2 borders 86½in (219.7cm) for the sides;
2 borders 90½in (229.9cm) for the top and bottom.

FABRIC SWATCH DIAGRAM

Patchwork Fabrics

Fabric 1
CALADIUMS
Red
PJ108RD

Fabric 2
HOKUSAI'S MUMS
Dark
PJ107DK

Fabric 3
EMBROIDERED FLOWER
Purple
GP185PU

Fabric 4
HOKUSAI'S MUMS
Green
PJ107GN

Fabric 5
CLOISONNE
Purple
GP046PU

Fabric 6
CLOISONNE
Blue
GP046BL

Fabric 7
VAN GOGH
Dark
PJ111DK

Fabric 8
WIDE STRIPE
Fjord
SS01FJ

Backing and Binding Fabrics

Fabric 9
LOTUS LEAF
Purple
QB007.PU

Fabric 8
WIDE STRIPE
Fjord
SS01FJ

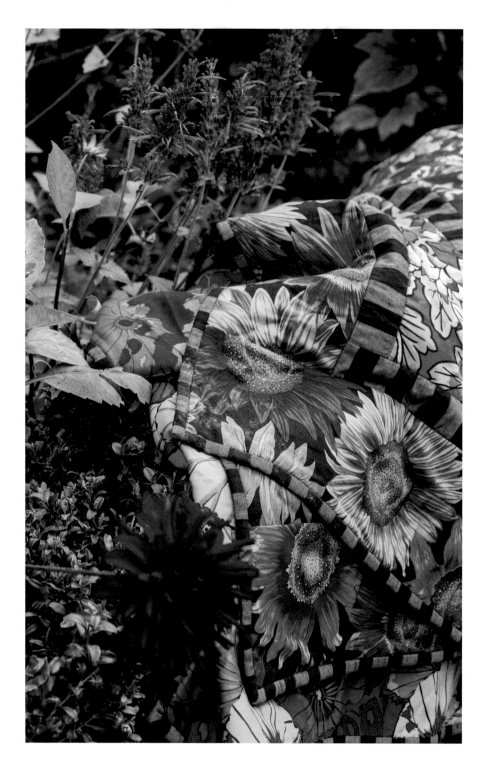

Narrow Border 4: 2 pieces 57½in (146.1cm) for the sides;
2 pieces 54½in (138.4cm) for the top and bottom.

Narrow Border 5: 2 pieces 70½in (179.1cm) for the sides;
2 pieces 67½in (171.5cm) for the top and bottom.

Narrow Border 6: 2 pieces 83½in (212.1cm) for the sides;
2 pieces 80½in (204.5cm) for the top and bottom.

Backing
Trim Fabric 9 to 105in x 99in (267cm x 251cm).

Binding
From Fabric 8 cut 11 strips 2½in (6.4cm) wide. Remove selvedges and sew end to end with 45-degree seams (see page 141).

MAKING THE QUILT
Using a design wall will help to place patches in the required layout.
Use ¼in (6mm) seams throughout.

Referring to the Quilt Assembly Diagram and quilt photograph, lay out the centre panel and surrounding borders.

To prevent the long borders from stretching, pin the border pieces to the centre at each end and regularly along the length before stitching. Press each seam very lightly after stitching (without pushing the iron), to avoid any stretching.

Starting with Narrow Border 1, sew the side borders to the centre panel, then add the top and bottom borders. Continue adding first the longer side borders, then the shorter top and bottom ones in the following sequence: Wide Border 1, followed by Narrow Border 2. followed by Wide Border 2, and so on.

FINISHING THE QUILT
Press the quilt top. Layer the quilt top, batting and backing, and baste together (see page 140).
Quilt as desired.
Trim the quilt edges and attach the binding (see page 141).

Narrow Striped Borders
From Fabric 8 cut 31 strips 2in (5.1cm) wide and where necessary, sew strips together, matching the stripes so they look continuous. Cut border pieces as follows:

Narrow Border 1: 2 pieces 18½in (47cm) for the sides;
2 pieces 15½in (39.4cm) for the top and bottom.

Narrow Border 2: 2 pieces 31½in (80cm) for the sides;
2 pieces 28½in (72.4cm) for the top and bottom.

Narrow Border 3: 2 pieces 44½in (113cm) for the sides;
2 pieces 41½in (105.4cm) for the top and bottom.

QUILT ASSEMBLY DIAGRAM

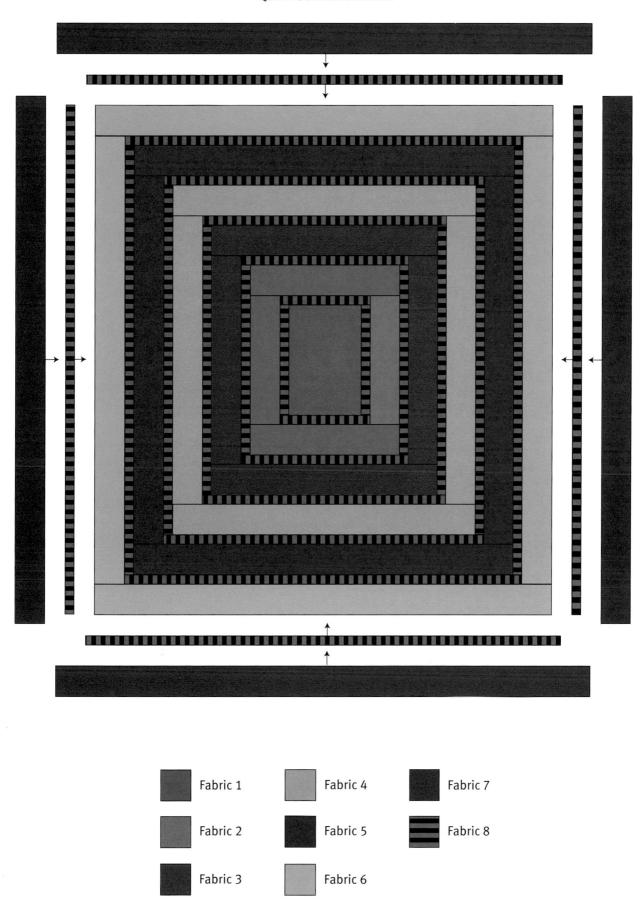

Fabric 1	Fabric 4	Fabric 7
Fabric 2	Fabric 5	Fabric 8
Fabric 3	Fabric 6	

golden squares **

Kaffe Fassett

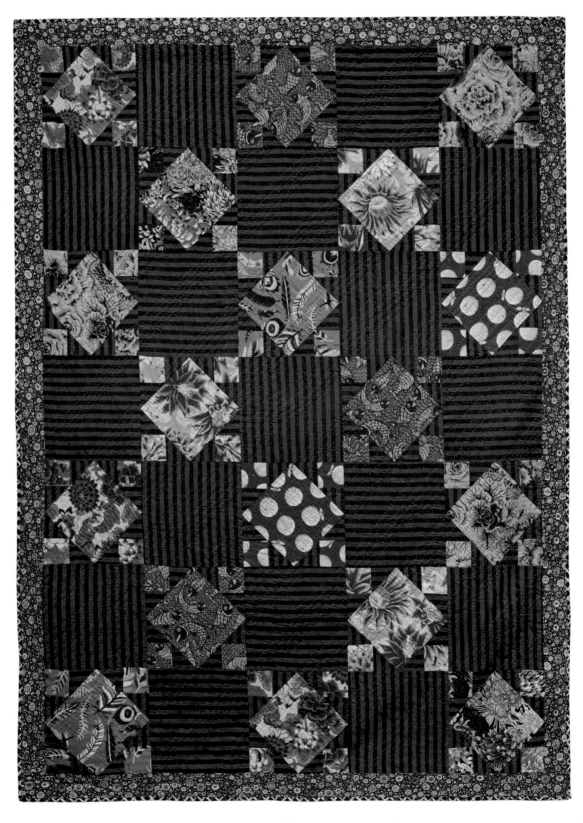

The feature fabric blocks, in a role reversal, take on the role of background fabric, allowing the stripy fabric used for the triangles in these blocks to become the points of the larger stripy stars.

SIZE OF FINISHED QUILT
90½in x 66½in (230cm x 169cm)

FABRICS
Fabrics have been calculated at a maximum width of 40in (102cm) and have been given a number – see Fabric Swatch Diagram for details.

Patchwork Fabrics
NARROW STRIPE
| Fabric 1 | Cocoa | 3yd (2.8m) |
CLOISONNE
| Fabric 2 | Orange | ⅜yd (40cm) |
KOI POLLOI
| Fabric 3 | Orange | ⅜yd (40cm) |
BRASSICA
| Fabric 4 | Orange | ⅜yd (40cm) |
HOKUSAI'S MUMS
| Fabric 5 | Natural | ⅜yd (40cm) |
CACTUS FLOWER
| Fabric 6 | Yellow | ⅜yd (40cm) |
TICKLE MY FANCY
| Fabric 7 | Orange | ⅜yd (40cm) |
ORANGES
| Fabric 8 | Yellow | ⅜yd (40cm) |
ROMAN GLASS
| Fabric 9 | Byzantine | ⅞yd (85cm) |

Backing and Binding Fabrics
MAD PLAID
| Fabric 10 | Rust | 5½yd (5.1m) |
MAD PLAID
| Fabric 11 | Maroon | ¾yd (70cm) |

Batting
99 in x 75in (251cm x 191cm)

Special Quilting Thread
Aurifil Mako'ne 12/2, shade 2145 1FD.

PATCHES
Square blocks, at 12in (30.5cm) finished, alternate between striped squares and feature Ohio Star blocks. Patches are set in 7 rows of 5.

CUTTING OUT
Fabric is cut across the width unless otherwise stated. When cutting different

FABRIC SWATCH DIAGRAM

Patchwork Fabrics

Fabric 1
NARROW STRIPE
Cocoa
SS002CO

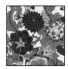
Fabric 2
CLOISONNE
Orange
GP046OR

Fabric 3
KOI POLLOI
Orange
BM079OR

Fabric 4
BRASSICA
Orange
PJ051OR

Fabric 5
HOKUSAI'S MUMS
Natural
PJ107NL

Fabric 6
CACTUS FLOWER
Yellow
PJ096YE

Fabric 7
TICKLE MY FANCY
Orange
BM080OR

Fabric 8
ORANGES
Yellow
GP177YE

Fabric 9
ROMAN GLASS
Byzantine
GP001BY

Backing and Binding Fabrics

Fabric 10
MAD PLAID
RUST
BM037RU

Fabric 11
MAD PLAID
Maroon
BM037MM

pieces from the same fabric, always cut the larger pieces first.

When required strips are longer than 40in (102cm) – the usable width of the fabric – join strips end to end to obtain the required length, use ¼in (6mm) seams and press seams open.

Striped Stars
From Fabric 1 cut 6 strips 12½in (31.8cm) wide and cross cut 17 squares at 12½in (31.8cm). Each strip will yield 3 squares.

From the remaining Fabric 1 cut 8 strips 3⅞in (9.8cm) wide and cross cut 72 squares at 3⅞in (9.8cm). Each strip will yield 10 squares. Cut each square in half diagonally to make 144 half square triangles.

Feature Blocks
Cut a strip 9in (22.9cm) wide and cross cut large squares at 9in (22.9cm). From the remaining fabric cut strips 3½in (8.9cm) wide and cross cut small squares at 3½in (8.9cm):
Fabric 2 3 large squares,12 small squares;
Fabric 3 3 large squares,12 small squares;
Fabric 4 3 large squares,12 small squares;
Fabric 5 2 large squares, 8 small squares;
Fabric 6 3 large squares,12 small squares;
Fabric 7 2 large squares, 8 small squares;
Fabric 8 2 large squares, 8 small squares;

Border
From Fabric 9 cut 8 strips 3½in (8.9cm) wide and sew end to end. From the length cut 2 pieces 84½in (215.6cm) long for the side borders; 2 pieces 66½in (168.9cm) long for the top and bottom borders.

79

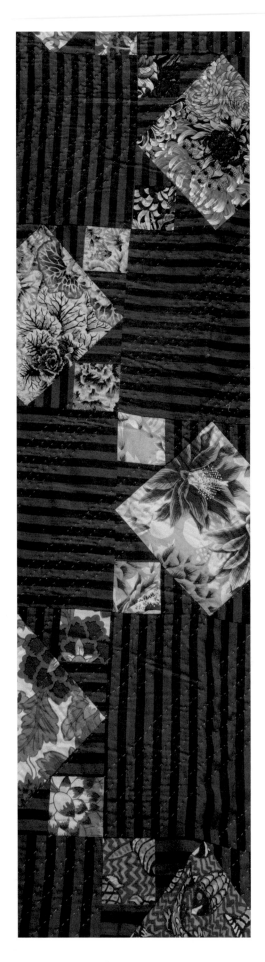

Backing
From Fabric 10 cut 2 pieces 99in x 40in (251cm x 102cm), remove selvedges and sew together down the long edge.

Binding
From Fabric 11 cut 9 strips 2½in (6.4cm) wide. Remove selvedges and sew end to end with 45-degree seams (see page 141).

MAKING THE QUILT
Using a design wall will help to place patches in the required layout.
Use ¼in (6mm) seams throughout.

Making the Feature Blocks
Referring to the Block Assembly Diagram, take a large square and 4 small squares in Fabric 2 and 8 triangles in Fabric 1. Be sure to place the striped triangles randomly. (The striped triangles can be placed without paying too much attention to the direction of the stripes.)
Sew 2 triangles to each of the small squares to form 4 corner sections and press seams towards the triangles. Sew the 4 corner sections to the large square and press seams towards the triangles. Repeat for all 18 feature blocks.

ASSEMBLING THE QUILT
Lay out the blocks alternating feature blocks and striped squares in 7 rows of 5 blocks, referring to the Quilt Assembly Diagram and quilt photograph. Sew together one row at a time, pressing seams towards the striped squares to allow the finished seams to lie flat.

Pin and sew on the side borders and press, then pin and sew on the top and bottom borders to complete the quilt top.

FINISHING THE QUILT
Press the quilt top. Layer the quilt top, batting and backing, and baste together (see page 140).
Quilt as desired. The original was quilted by Kaffe using Aurifil Mako'ne 12/2 in shade 2145 1FD using Kantha-style stitches in loose diagonal lines.
Trim the quilt edges and attach the binding (see page 141).

BLOCK ASSEMBLY DIAGRAM

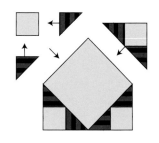

Fabric 1

Fabric 2

Fabric 3

Fabric 4

Fabric 5

Fabric 6

Fabric 7

Fabric 8

Fabric 9

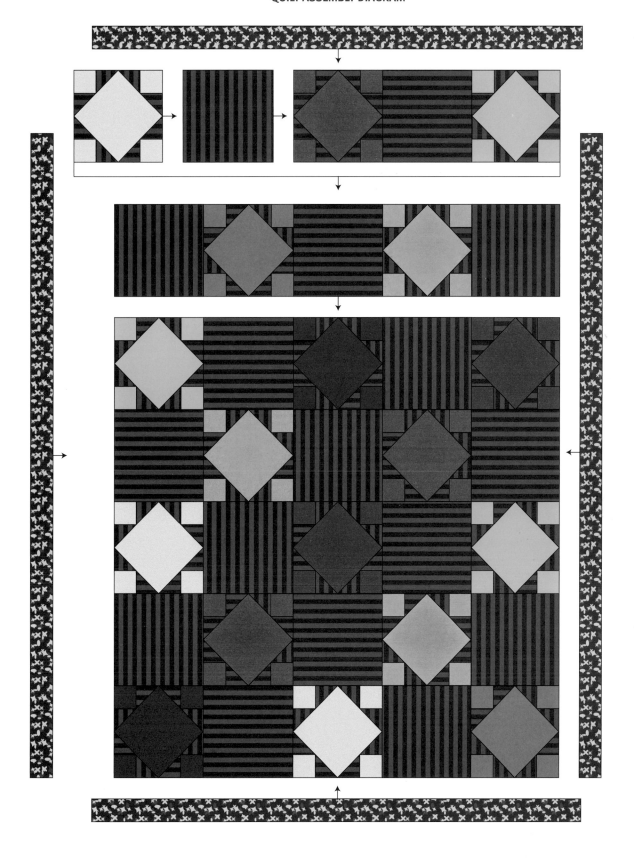

sassy baby **

Liza Prior Lucy

This interesting variation on a 9-square block is known as a Grecian Square. It is set with narrow 1½in (3.8cm) sashing strips and squares, finished with a 4in (10.2cm) border.

SIZE OF FINISHED QUILT
52in x 41½in (132cm x 105cm)

FABRICS
Fabrics have been calculated at a maximum width of 40in (102cm) and have been given a number – see Fabric Swatch Diagram for details.

Patchwork Fabrics
SPOT
Fabric 1 White ⅝yd (60cm)
FLOWER DOT
Fabric 2 Black 1⅜yd (1.3m)
JUMBLE
Fabric 3 Blue ½yd (50cm)
Fabric 4 Black ⅜yd (40cm)
SPOT
Fabric 5 Black ¼yd (25cm)
Fabric 6 Noir ¼yd (25cm)
AMAZE
Fabric 7 Black ¼yd (25cm)

Backing and Binding Fabric
JUMBLE
Fabric 8 White 2⅞yd (2.7m)

Batting
60in x 50in (152cm x 127cm)

PATCHES
Patches are 3in (7.6cm) squares formed of half-square triangles and rectangles with a central square, assembled into 9-patch blocks. There are 4 rows of 3 blocks that are connected by 1½in (3.8cm) sashing strips with sashing squares.

CUTTING OUT
Fabric is cut across the width unless otherwise stated. When required strips are longer than 40in (102cm) – the usable width of the fabric – join strips end to end to obtain the required length, use ¼in (6mm) seams and press seams open. When cutting different pieces from the same fabric, always cut the larger pieces first.

Background
From Fabric 1 cut 3 strips 3⅞in (9.8cm) wide and cross cut 24 squares 3⅞in (9.8cm), 10 each from 2 strips and 4 from the third strip. Cut each square in half diagonally to yield 48 half-square triangles for the block corners.
Trim the remainder of the third strip to 3½in (8.9cm) wide and cross cut 8 rectangles 3½in x 2in (8.9cm x 5.1cm). Cut an additional 2 strips 3½in (8.9cm) wide and cross cut 40 rectangles 3½in x 2in (8.9cm x 5.1cm), 20 from each strip, to yield a total of 48 rectangles.

Border and Centre Squares
From Fabric 2, cutting down the length of the fabric, cut 4 strips 4½in (11.4cm) wide. Trim to the following lengths:
2 lengths at 44in (111.8cm) for the side borders;
2 lengths at 41½in (105.4cm) for the top and bottom borders.
Also from Fabric 2, cutting down the length of the fabric, cut 1 strip 3½in (8.9cm) wide and cross cut 12 squares at 3½in (8.9cm) for the block centre squares.

Blocks
From Fabrics 4, 5, 6 and 7 cut the following to make 3 blocks from each fabric:
Cut 1 strip 3⅞in (9.8cm) wide and cross cut 6 squares at 3⅞in (9.8cm). Cut each square diagonally to yield 12 half-square triangles.
Cut 1 strip 3½in (8.9cm) wide and cross cut 12 rectangles 3½in x 2in (8.9cm x 5.1cm)

Sashing Strips and Squares
From Fabric 2 cut 8 strips 2in (5.1cm) wide and cross cut 4 rectangles 2in x 9½in (5.1cm x 24.1cm) from each strip. Cut a total of 31 sashing rectangles. From the remaining Fabric 4 cut 1 strip 2in (5.1cm) wide and cross cut 20 squares at 2in (5.1cm) for the sashing squares.

Backing
From Fabric 8 remove selvedges and cut 2 pieces 50in x 31in (127cm x 78.7cm). Sew edge to edge to make a backing piece 60in x 50in (152cm x 127cm).

Binding
From the remaining Fabric 8 cut 4 strips 2½in (6.4cm) wide down the 50in (127cm) length and sew end to end with 45-degree seams (see page 141).

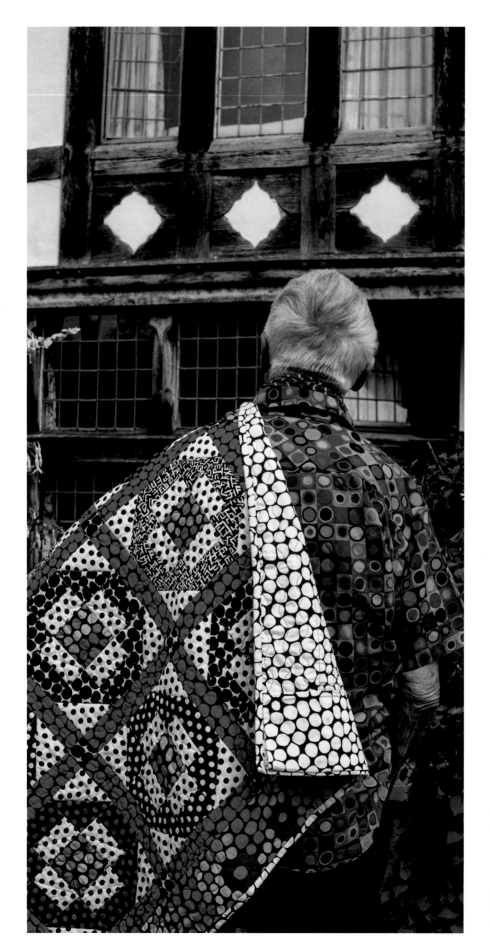

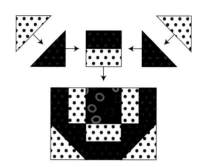

MAKING THE QUILT

Using a design wall will help to place patches in the required layout.
Use ¼ in (6mm) seams throughout.

Making the Blocks

Each block has 4 background triangles, 4 background rectangles, 4 colour triangles, 4 colour rectangles and 1 centre square. Lay out the 12 blocks referring to the Block Assembly Diagram and the quilt photograph.

Sew 4 pairs of half-square triangles together and press seams toward the darker triangles. Sew 4 pairs of rectangles together and press seams towards the darker rectangles.

Check the 9 squares are correctly laid out, then sew each row of 3 squares together, lightly press, and then sew the 3 rows together. Sew all 12 blocks and return them to the layout.

Centre

Add the sashing strips and sashing squares to the layout, referring to the Quilt Assembly Diagram and quilt photograph.

Sew the horizontal sashing strips and sashing squares together, then sew the blocks and vertical sashing strips together. Press all seams towards the sashing strips. This will help the finished seams to lie flat. Sew the rows of horizontal sashing and the rows of blocks together, again pressing seams towards the sashing strips.

Borders

Pin and sew the longer side borders to the centre, press. Then pin and sew the top and borders to the centre to complete the quilt top.

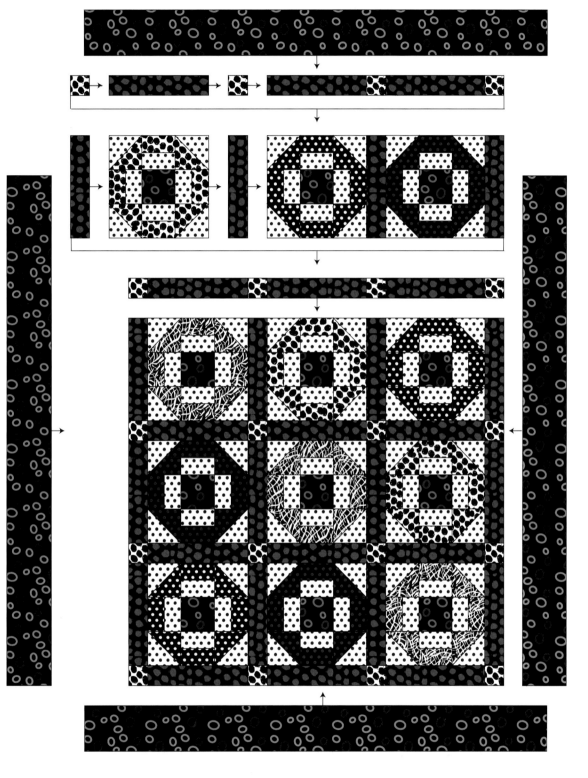

Fabric 1

Fabric 2

Fabric 3

Fabric 4

Fabric 5

Fabric 6

Fabric 7

FINISHING THE QUILT
Press the quilt top. Layer the quilt top, batting and backing, and baste together (see page 140).

Quilt as desired.
Trim the quilt edges and attach the binding (see page 141).

sweet baby **

Liza Prior Lucy

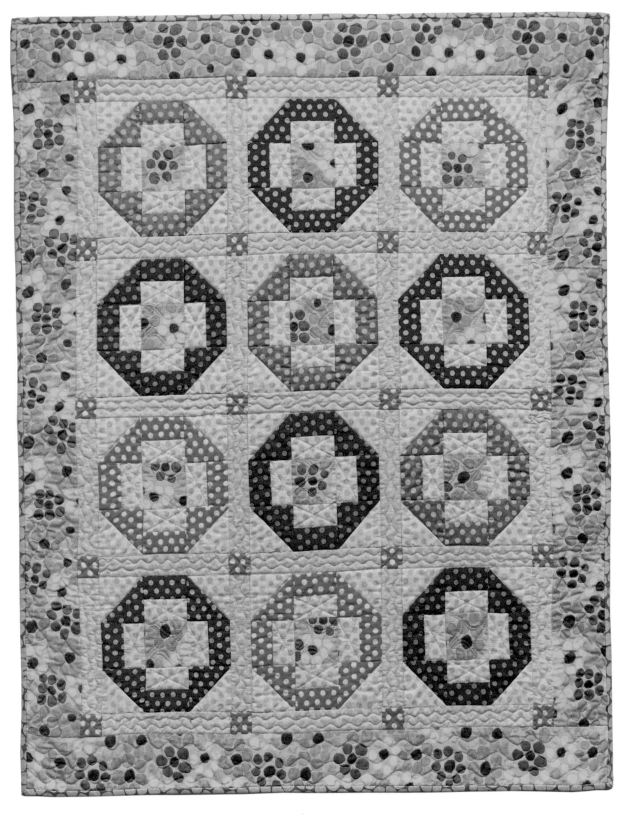

This softer version of *Sassy Baby* shows off the Grecian Square blocks in pretty pastel colours. Use the *Sassy Baby* instructions and layout on pages 82–85, and replace fabrics with those listed below, using the Quilt Assembly Diagram overleaf.

SIZE OF FINISHED QUILT
52in x 41½in (132cm x 105cm)

FABRICS
Fabrics have been calculated at a maximum width of 40in (102 cm) and have been given a number – see Fabric Swatch Diagram for details.

Patchwork Fabrics
SPOT			
Fabric 1	Soft blue	⅝yd (60cm)	
FLOWER DOT			
Fabric 2	Aqua	1⅜yd (1.3m)	
SPOT			
Fabric 3	Apple	½yd (50cm)	
Fabric 4	Spring	⅜yd (40cm)	
Fabric 5	Melon	¼yd (25cm)	
Fabric 6	Ochre	¼yd (25cm)	
Fabric 7	Shocking	¼yd (25cm)	

Backing and Binding Fabric
JUMBLE			
Fabric 8	Turquoise	2⅞yd (2.7m)	

Batting
60in x 50in (152cm x 127cm)

Patchwork Fabrics

Fabric 1
SPOT
Soft blue
GP070SF

Fabric 2
FLOWER DOT
Aqua
BM077AQ

Fabric 3
SPOT
Apple
GP070AL

Fabric 4
SPOT
Spring
GP070SP

Fabric 5
SPOT
Melon
GP070ME

Fabric 6
SPOT
Ochre
GP070OC

Fabric 7
SPOT
Shocking
GP070SG

Backing and Binding Fabric

Fabric 8
JUMBLE
Turquoise
BM05TQ

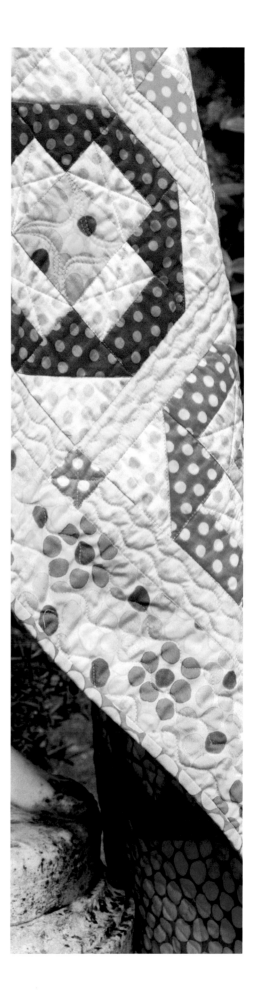

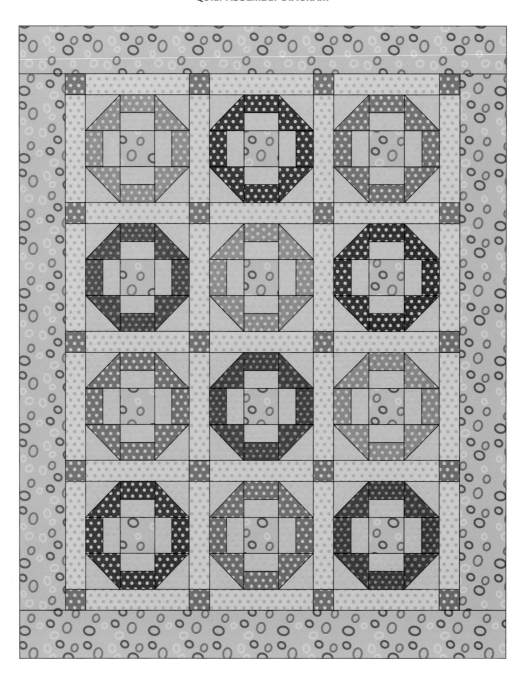

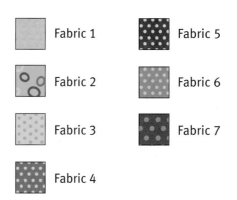

Fabric 1 Fabric 5

Fabric 2 Fabric 6

Fabric 3 Fabric 7

Fabric 4

plums and ginger **

Liza Prior Lucy

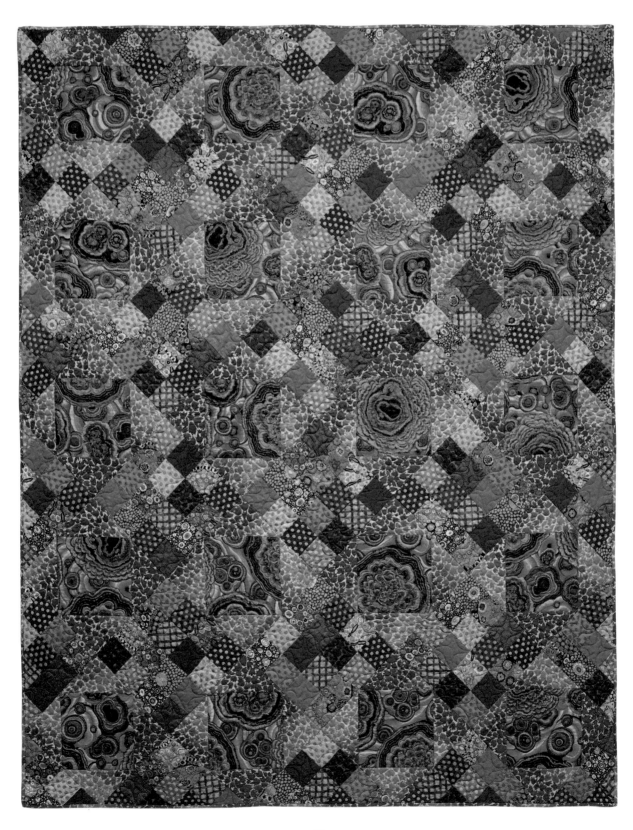

The layout of this quilt is primarily composed of two different pieced blocks: a square-in-square block, placed on point, and a 16-square checkerboard block.

SIZE OF FINISHED QUILT
85½in x 68½in (217cm x 174cm)

FABRICS
Fabrics have been calculated at a maximum width of 40in (102 cm) and have been given a number – see Fabric Swatch Diagram for details.

PATCHWORK FABRICS
AGATE
Fabric 1 Ochre 1⅜ yd (1.3m)
OMBRE LEAVES
Fabric 2 Purple 1⅝ yd (1.5m)
* see also Backing and Binding Fabrics

DARK FABRICS:
SPOT
Fabric 3 Royal ½ yd (50cm)
Fabric 4 Indigo ½ yd (50cm)
JUMBLE
Fabric 5 Prune ½ yd (50cm)
MILLEFIORE
Fabric 6 Blue ½ yd (50cm)
ROMAN GLASS
Fabric 7 Byzantine ½ yd (50cm)
ABORIGINAL DOT
Fabric 8 Plum ½ yd (50cm)
Fabric 9 Periwinkle ½ yd (50cm)
PAPERWEIGHT
Fabric 10 Purple ½ yd (50cm)

LIGHT FABRICS:
SPOT
Fabric 11 Tobacco ½ yd (50cm)
Fabric 12 Autumn ½ yd (50cm)
Fabric 13 Cinnamon ½ yd (50cm)
MAD PLAID
Fabric 14 Rust ½ yd (50cm)
MILLEFIORE
Fabric 15 Dusty ½ yd (50cm)
Fabric 16 Brown ½ yd (50cm)
GUINEA FLOWER
Fabric 17 Brown ½ yd (50cm)
ABORIGINAL DOT
Fabric 18 Pumpkin ½ yd (50cm)

FABRIC SWATCH DIAGRAM

Patchwork Fabrics

Fabric 1
AGATE
Ochre
PJ106OC

Fabric 2
OMBRE LEAVES
Purple
GP174PU

DARK FABRICS

Fabric 3
SPOT
Royal
GP070RY

Fabric 4
SPOT
Indigo
GP070IN

Fabric 5
JUMBLE
Prune
BM053PV

Fabric 6
MILLEFIORE
Blue
GP092BL

Fabric 7
ROMAN GLASS
Byzantine
GP001BY

Fabric 8
ABORIGINAL DOT
Plum
GP071PL

Fabric 9
ABORIGINAL DOT
Periwinkle
GP071PE

Fabric 10
PAPERWEIGHT
Purple
GP020PU

LIGHT FABRICS

Fabric 11
SPOT
Tobacco
GP070TO

Fabric 12
SPOT
Autumn
GP070AU

Fabric 13
SPOT
Cinnamon
GP070CW

Fabric 14
MAD PLAID
Rust
BM037RU

Fabric 15
MILLEFIORE
Dusty
GP092DY

Fabric 16
MILLEFIORE
Brown
GP092BR

Fabric 17
GUINEA FLOWER
Brown
GP059BR

Fabric 18
ABORIGINAL DOT
Pumpkin
GP071PN

Backing and Binding Fabrics

Fabric 19
LOTUS LEAF
Purple
QB007PU

Fabric 2
OMBRE LEAVES
Purple
GP174PU

Backing and Binding Fabrics
LOTUS LEAF wide backing
Fabric 19 Purple 2¼ yd (2.1m)
OMBRE LEAVES
Fabric 2 Purple ¾ yd (70cm)
* see also Patchwork Fabrics

Batting
94in x 77in (239cm x 196cm)

PATCHES
Patches are squares and half-square triangles cut from strips. There are two different pieced blocks: a square-in-square block made of large squares and half-square triangles (HSTs); and a 16-square checkerboard block made of 3in (7.6cm) finished squares. Blocks are set in alternating diagonal rows and set with an edge of quarter-square triangles (QSTs).

CUTTING OUT
Fabric is cut across the width unless otherwise stated.
When cutting different pieces from the same fabric, always cut the larger pieces first.

Square-in-square Blocks
From Fabric 1 cut 5 strips 9in (22.9cm) wide and cross cut 20 squares at 9in (22.9cm).
From Fabric 2 cut 8 strips 6⅞in (17.5cm) wide and cross cut 40 squares at 6⅞in (17.5cm). Cut each square diagonally once to make 80 HSTs.

Checkerboard Blocks
From each of the Dark Fabrics (3, 4, 5, 6, 7, 8, 9 and 10) cut 1 square at 5½in (14cm) and cross cut each square

diagonally twice to yield 4 QSTs from each, making 32 Dark QSTs in total.
From the remainder of each of the Dark Fabrics (3, 4, 5, 6, 7, 8, 9 and 10) cut 2 strips 3½in (8.9cm) wide and cross cut 17 squares at 3½in (8.9cm) from each fabric. Each full strip will yield 11 squares.

From each of the Light Fabrics (11, 12, 13, 14, 15, 16, 17 and 18) cut 1 or 2 squares at 5½in (14cm) and cross cut each square diagonally twice to yield 4 QSTs from each. You will need 40 Light QSTs in total.
From the remainder of each of the Light Fabrics (11, 12, 13, 14, 15, 16, 17 and 18) cut 2 strips 3½in (8.9cm) wide and cross cut 19 squares at 3½in (8.9cm) from each fabric. Each full strip will yield 11 squares.

Backing
Trim Fabric 19 to 94in x 77in (239cm x 196cm).

Binding
From Fabric 2 cut 9 strips 2½in (6.4cm) wide. Remove selvedges and sew end to end with 45-degree seams (see page 141).

MAKING THE QUILT
Using a design wall will help to place patches in the required layout.
Use ¼in (6mm) seams throughout.

Square-in-square Blocks
Referring to the Square-in-Square Block Diagram, make 20 square-in-square blocks. Sew a Fabric 2 triangle to each side of a Fabric 1 square, then sew a Fabric 2 triangle to the top and bottom of the square.

Checkerboard Blocks
These are scrappy blocks and there is no need to make them exactly as in the original. Referring to the Checkerboard Block Diagrams, make 12 checkerboard blocks alternating dark and light squares. Choose 8 different dark squares and 8 different light squares to make each Checkerboard block.

Setting Top and Bottom Triangles
Make 6 setting top and bottom triangles using 4 light squares, 2 dark squares and 4 dark QSTs.

Setting Side Triangles
Make 8 setting side triangles using 4 dark squares, 2 light squares and 4 light QSTs.

Setting Corner Triangles
Make 2 of each colour combination (a) and (b) of corner setting triangles, each using 1 light square, 1 dark square, 2 light QSTs and 2 dark QSTs.

SQUARE-IN-SQUARE BLOCK DIAGRAM

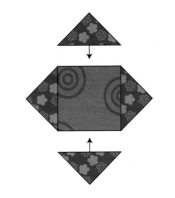

CHECKERBOARD BLOCK DIAGRAMS

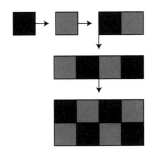

Checkerboard Blocks

Setting Top and Bottom Triangles

Setting Side Triangles

Setting Corner Triangles

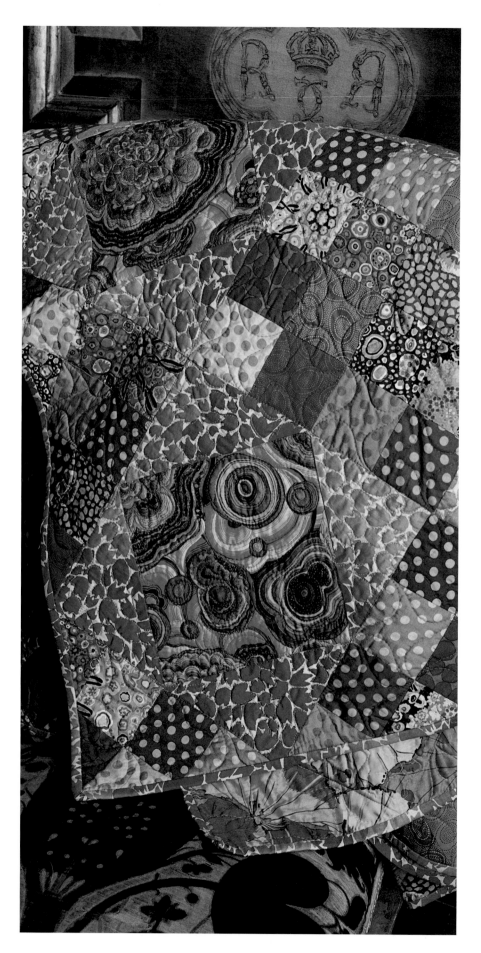

ASSEMBLING THE QUILT

Referring to the Quilt Assembly Diagram and the quilt photograph, arrange the completed blocks on point in diagonal rows, ensuring the checkerboard blocks and setting triangles are correctly positioned.

Sew the blocks together in diagonal rows, pressing seams towards the square-in-square blocks – this will allow the finished seams to lie flat.

Pin then sew the rows together to complete the quilt top, taking care to match crossing seams.

FINISHING THE QUILT

Press the quilt top. Layer the quilt top, batting and backing, and baste together (see page 140).

Quilt as desired.

Trim the quilt edges and attach the binding (see page 141).

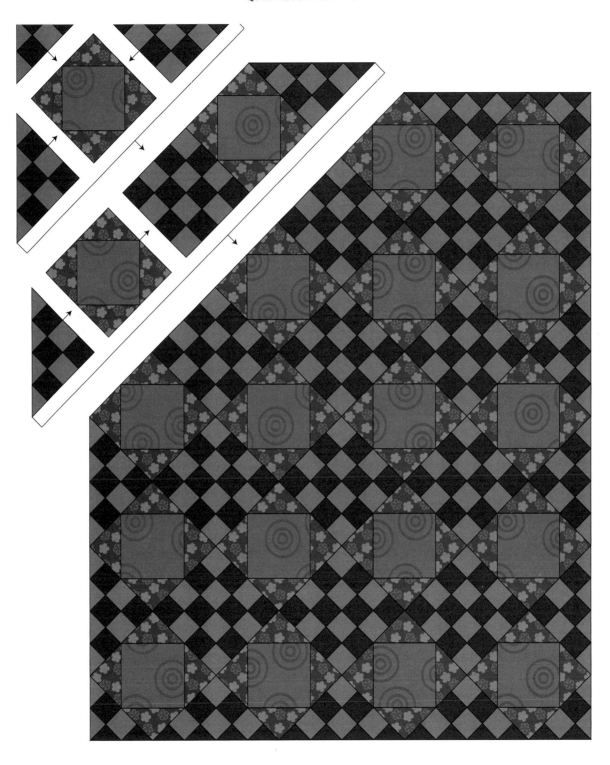

Fabric 1

Fabric 3–10

Fabric 2

Fabric 11–18

saturated red **

Kaffe Fassett

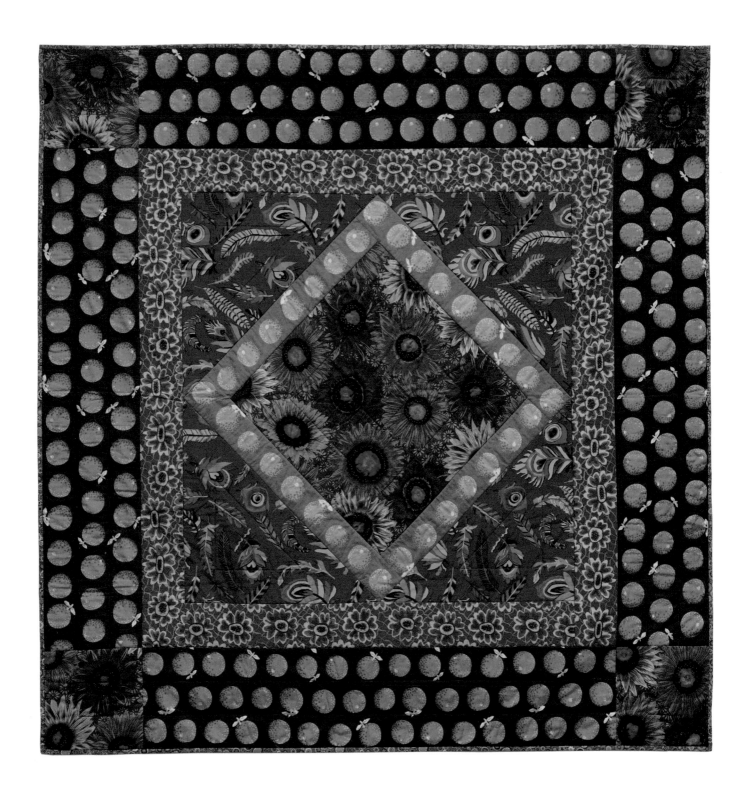

This medallion quilt is based around a square on point framed with a row of fussy-cut orange motifs, set into a square framed with a row of fussy-cut Flower Net fabric. A chunky outer border made up of three rows of orange motifs is finished off with flowery Van Gogh corner squares.

SIZE OF FINISHED QUILT
63in x 63in (160cm x 160cm)

FABRICS
Fabrics have been calculated at a maximum width of 40in (102cm) and cut across the width, unless otherwise stated. Fabrics have been given a number – see Fabric Swatch Diagram for details.

Patchwork Fabrics
VAN GOGH		
Fabric 1	Red	⅝yd (60cm)
ORANGES		
Fabric 2	Pink	½yd (50cm)
TICKLE MY FANCY		
Fabric 3	Red	⅝yd (60cm)
FLOWER NET		
Fabric 4	Red	⅞yd (85cm)
ORANGES		
Fabric 5	Maroon	1¾yd (1.7m)

Backing and Binding Fabrics
DOROTHY		
Fabric 6	Red	4yd (3.7m)
PAPERWEIGHT		
Fabric 7	Red	⅝yd (60cm)

Batting
72in x 72in (183cm x 183cm)

PATCHES
The framed 20in (50.8cm) centre square is set on point with half-square triangles to form the main medallion in its frame. The wide 9in (22.9cm) outer border of Fabric 5 is finished with corner squares echoing Fabric 1 centre.

CUTTING OUT
Fabric is cut across the width unless otherwise stated.
When required strips are longer than 40in (102cm) – the usable width of the fabric – join strips end to end to obtain the required length, use ¼in (6mm) seams and press seams open.

Centre and Corner Squares
From Fabric 1 cut 1 square 20½in x 20½in (52.1cm x 52.1cm) for the centre square. From the remaining Fabric 1 cut 2 strips 9½in (24.1cm) wide and cross cut 2 squares at 9½in (24.1cm) from each strip for the corner squares.

Border 1
From Fabric 2 fussy cut 4 strips 3½in (8.9cm) wide, centering a row of orange motifs along each strip. Trim 2 strips to 20½in (52.1cm) long and 2 strips to 26½in (67.3cm) long.

Half-square Setting Triangles
From Fabric 3 cut a strip 19½in (49.5cm) wide and cross cut 2 squares at 19½in (49.5cm). Cut each square in half diagonally once to yield 4 half-square triangles.

Border 2
From Fabric 4 fussy cut 5 strips 4½in (11.4cm) wide, centering a row of flowers along each strip. Remove selvedges and sew strips together end to end, between the flowers. From the length cut 2 strips 37¼in (94.6cm) long and 2 strips 45¼in (114.9cm) long.

Border 3
From Fabric 5 fussy cut 5 strips 9½in (24.1cm) wide across the width of the fabric, centering 3 rows of the orange motifs along each strip. Join the strips end to end, matching the rows of oranges. Then from the length cut 4 strips 45¼in (114.9cm) long.

Backing
From Fabric 6 cut 2 pieces 72in (183cm) long, remove selvedges and sew together down the long edge. Trim to make a piece 72in x 72in (183cm x 183cm).

Binding
From Fabric 7 cut 7 strips 2½in (6.4cm) wide. Remove selvedges and sew end to end with 45-degree seams (see page 141).

Patchwork Fabrics

Fabric 1
VAN GOGH
Red
PJ111RD

Fabric 2
ORANGES
Pink
GP177PK

Fabric 3
TICKLE MY FANCY
Red
BM080RD

Fabric 4
FLOWER NET
Red
BM081RD

Fabric 5
ORANGES
Maroon
GP177MM

Backing and Binding Fabrics

Fabric 6
DOROTHY
Red
PJ109RD

Fabric 7
PAPERWEIGHT
Red
GP020RD

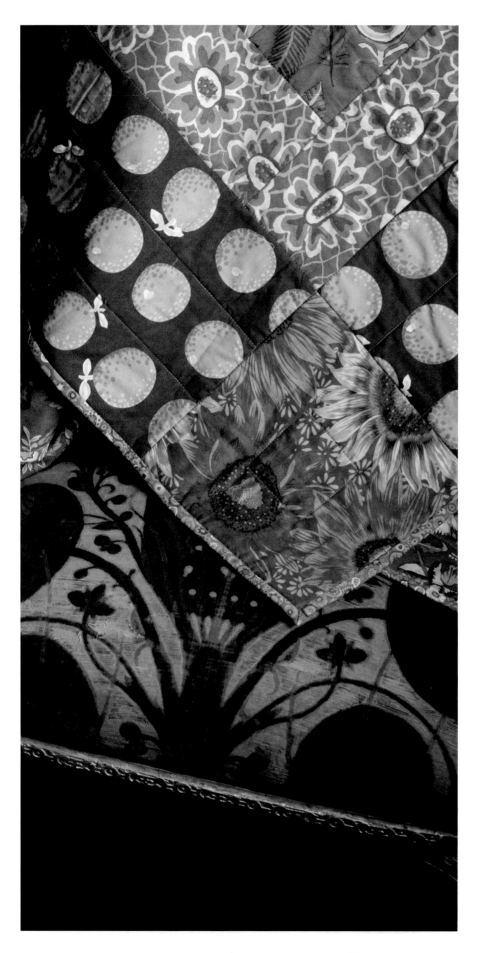

MAKING THE QUILT

Using a design wall will help to place patches in the required layout.
Use ¼in (6mm) seams throughout.

Assembling the Quilt

Lay out the pieces referring to the Quilt Assembly Diagram and quilt photograph. Lightly press all seams towards the outside of the quilt.
Sew the 2 shorter Border 1 pieces to opposite sides of the centre square, press, then sew the longer 2 pieces to the top and bottom. Sew a half-square triangle to opposite sides of Border 1, press, then sew the remaining 2 triangles to the remaining 2 sides.
Sew the 2 shorter Border 2 pieces to the top and bottom, press, then sew the 2 longer Border 2 pieces to the sides.
Pin then sew a Border 3 piece to each side of the quilt. Sew a corner square to each end of the remaining 2 Border 3 pieces and press. Sew the top and bottom completed border sections to the quilt.

FINISHING THE QUILT

Press the quilt top and backing. Layer the quilt top, batting and backing, and baste together (see page 140).
Quilt as desired.
Trim the quilt edges and attach the binding (see page 141).

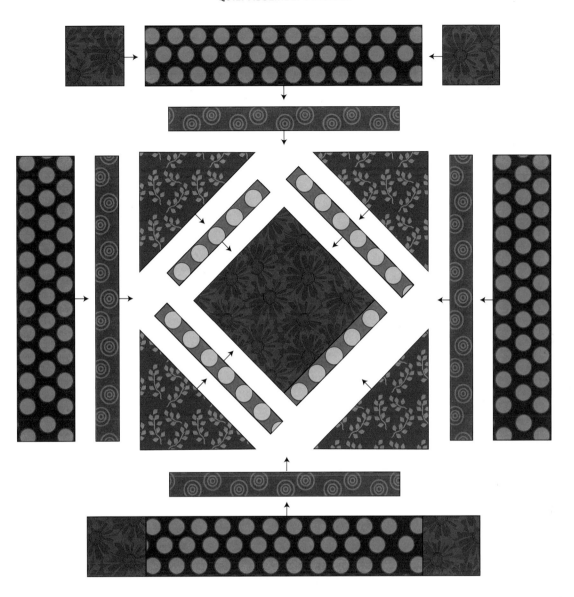

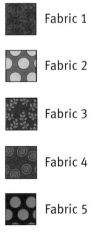

Fabric 1

Fabric 2

Fabric 3

Fabric 4

Fabric 5

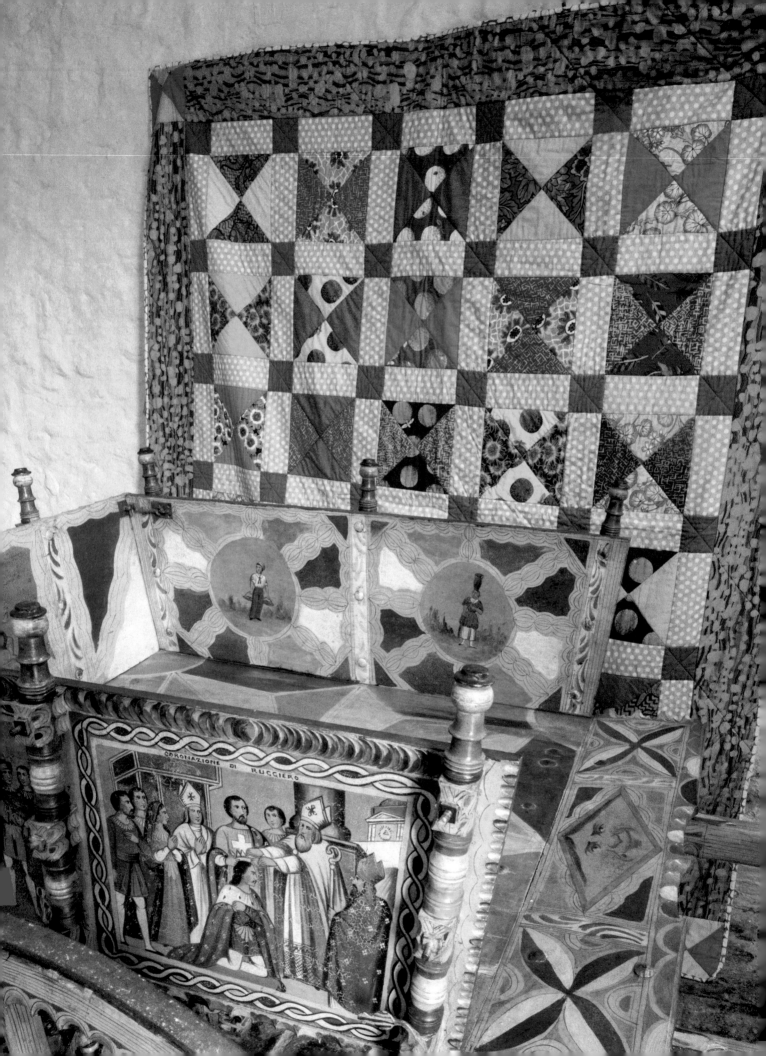

jumping jacks *

Kaffe Fassett

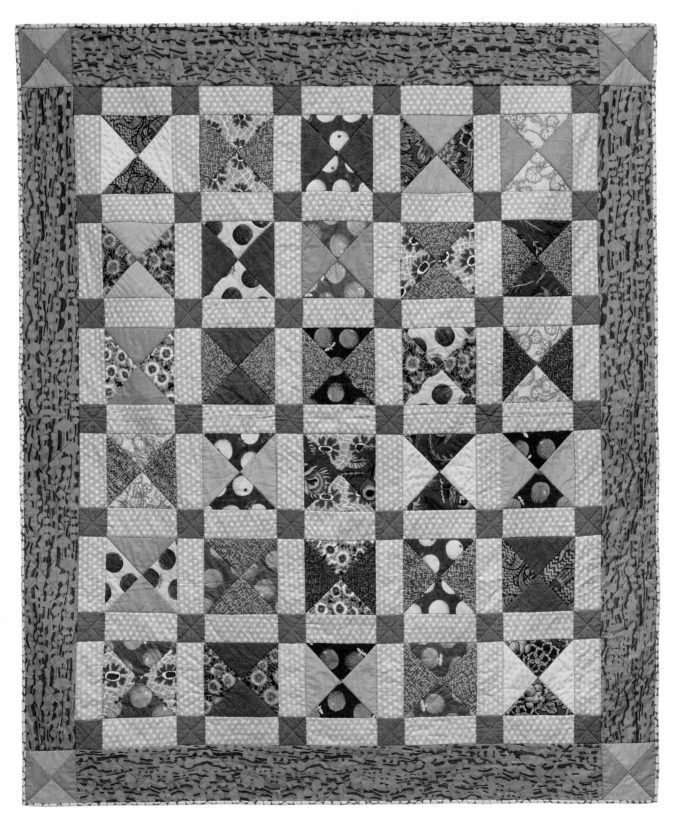

Large hourglass blocks, connected with wide sashing strips, are punctuated with contrasting sashing squares and framed with a wide border of Brandon's Stream fabric.

SIZE OF FINISHED QUILT
81in x 70in (206cm x 178cm)

FABRICS
Fabrics have been calculated at a maximum width of 40in (102cm). Fabrics have been given a number – see Fabric Swatch Diagram for details.

Patchwork Fabrics
AMAZE
Fabric 1	Blue	³⁄₈yd (40cm)
Fabric 2	Pink	³⁄₈yd (40cm)
Fabric 3	Red	¹⁄₄yd (25cm)

CLIMBING GERANIUMS
| Fabric 4 | Green | ¹⁄₄yd (25cm) |

CLOISONNE
| Fabric 5 | Blue | ¹⁄₄yd (25cm) |

TICKLE MY FANCY
| Fabric 6 | Red | ¹⁄₄yd (25cm) |

FLOWER NET
| Fabric 7 | Blue | ³⁄₈yd (40cm) |

KOI POLLOI
| Fabric 8 | Blue | ¹⁄₄yd (25cm) |

LUCY
| Fabric 9 | Pink | ¹⁄₄yd (25cm) |
| Fabric 10 | Lavender | ¹⁄₄yd (25cm) |

ORANGES
Fabric 11	Citrus	¹⁄₄yd (25cm)
Fabric 12	Lavender	¹⁄₄yd (25cm)
Fabric 13	Maroon	¹⁄₄yd (25cm)
Fabric 14	Pink	³⁄₈yd (40cm)

SPOT
| Fabric 15 | Apple | ¹⁄₄yd (25cm) |
| Fabric 16 | Silver | 1³⁄₄yd (1.7m) |

SHOT COTTON
Fabric 17	Camelia	³⁄₈yd (40cm)
Fabric 18	Sunflower	¹⁄₂yd (50cm)
Fabric 19	Pistachio	¹⁄₂yd (50cm)
Fabric 20	Lupin	¹⁄₂yd (50cm)

STREAM
| Fabric 21 | Orange | 1³⁄₈yd (1.3m) |

Backing and Binding Fabrics
SHAGGY
Fabric 22	Dark	5yd (4.65m)

JUMBLE
| Fabric 23 | Lemon | ⁵⁄₈yd (60cm) |

Batting
90in x 79in (229cm x 201cm)

PATCHES
Quarter-square triangles are set in hourglass blocks, finished at 8in (20.3cm).
Blocks are set with sashing and sashing squares in 6 rows of 5.

CUTTING OUT
Fabric is cut across the width unless otherwise stated. When required strips are longer than 40in (102cm) – the usable width of the fabric – join strips end to end to obtain the required length, use ¹⁄₄in (6mm) seams and press seams open.

Hourglass Blocks
Cut strips 4⁵⁄₈in (11.7cm) wide and cross cut 45° triangles, referring to the Patch Cutting Diagram. Line up the 45° ruler marking with the end of the strip (a) and cut across the strip at 45°. Next, line up the 45° ruler marking straight along the bottom of the strip with the right-hand side of the ruler aligned with the top point of the strip (b) and cut the other side of the triangle. To cut the second triangle, rotate the ruler and turn it over so the 45° line runs straight along the top of the strip, aligning the right-hand side of the ruler with the bottom point of the strip (c) and cut to create the triangle. Continue turning the ruler, aligning and

cutting triangles across the strip. Each strip will yield 7 triangles. Cut a total of 120 triangles from fabrics as follows:
Fabric 1 (2 strips) 10 triangles;
Fabric 2 (2 strips) 8 triangles;
Fabric 3 1 strip) 4 triangles;
Fabric 4 (1 strip) 6 triangles;
Fabric 5 (1 strip) 4 triangles;
Fabric 6 (1 strip) 6 triangles;
Fabric 7 (2 strips) 8 triangles;
Fabric 8 (1 strip) 4 triangles;
Fabric 9 (1 strip) 4 triangles;
Fabric 10 (1 strip) 6 triangles;
Fabric 11 (1 strip) 6 triangles;
Fabric 12 (1 strip) 6 triangles;
Fabric 13 (1 strip) 6 triangles;
Fabric 14 (2 strips) 8 triangles;
Fabric 15 (1 strip) 6 triangles;
Fabric 17 (2 strips) 10 triangles;
Fabric 18 (2 strips) 10 triangles;
Fabric 19 (2 strips) 8 triangles.

Sashing Strips and Squares
From Fabric 16 cut 7 strips 8¹⁄₂in (21.6cm) wide and cross cut a total of 71 rectangles 8¹⁄₂in x 3¹⁄₂in (21.6cm x 8.9cm). Each strip will yield 11 rectangles.
From Fabric 20 cut 4 strips 3¹⁄₂in (8.9cm) wide and cross cut a total of 41 squares at 3¹⁄₂in (8.9cm). Each strip will yield 11 squares.

Border
From Fabric 21 cut 7 strips 6¹⁄₂in (16.5cm) wide. Remove selvedges and sew end to end. Use ¹⁄₄in (6mm) seams and press seams open. From the length, cut border pieces as follows:
Cut 2 pieces 69¹⁄₂in (176.5cm) long for the side borders;
Cut 2 pieces 58¹⁄₂in (148.6cm) long for the top and bottom borders.

PATCH CUTTING DIAGRAM

a

b

c

FABRIC SWATCH DIAGRAM

Patchwork Fabrics

Fabric 1
AMAZE
Blue
BM078BL

Fabric 2
AMAZE
Pink
BM078PK

Fabric 3
AMAZE
Red
BM078RD

Fabric 4
CLIMBING GERANIUMS
Green
PJ110GN

Fabric 5
CLOISONNE
Blue
GP046BL

Fabric 6
TICKLE MY FANCY
Red
BM080RD

Fabric 7
FLOWER NET
Blue
BM081BL

Fabric 8
KOI POLLOI
Blue
BM079BL

Fabric 9
LUCY
Pink
PJ112PK

Fabric 10
LUCY
Lavender
PJ112LV

Fabric 11
ORANGES
Citrus
GP177CT

Fabric 12
ORANGES
Lavender
GP177LV

Fabric 13
ORANGES
Maroon
GP177MM

Fabric 14
ORANGES
Pink
GP177PK

Fabric 15
SPOT
Apple
GP070AL

Fabric 16
SPOT
Silver
GP070SV

Fabric 17
SHOT COTTON
Camelia
SC109CX

Fabric 18
SHOT COTTON
Sunflower
SC112SF

Fabric 19
SHOT COTTON
Pistachio
SC111PX

Fabric 20
SHOT COTTON
Lupin
SC113LU

Fabric 21
STREAM
Orange
BM075OR

Backing and Binding Fabrics

Fabric 22
SHAGGY
Dark
PJ072DK

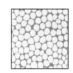
Fabric 23
JUMBLE
Lemon
BM053LE

Corner Squares

From the remaining Fabrics 18 and 19 cut 2 squares at 7¼in (18.4cm). Cut each square diagonally twice to make 4 quarter-square triangles – a total of 8 triangles from each fabric.

Backing

From Fabric 22 cut 2 pieces 40in x 90in (101.6cm x 229cm), remove selvedges and sew the 2 pieces together using a ¼in (6mm) seam allowance to form a piece 79in x 90in (201cm x 229cm).

Binding

From Fabric 23 cut 8 strips 2½in (6.4cm) wide. Remove selvedges and sew end to end with 45-degree seams (see page 141).

MAKING THE QUILT

Using a design wall will help to place patches in the required layout.
Use ¼in (6mm) seams throughout.

Making the Blocks

Referring to the Block Assembly Diagram and Quilt Assembly Diagram for fabric selections, select 2 pairs of triangles and sew 1 of each fabric together along a short edge, then sew the remaining 2 triangles together in the same way. Lightly press seams towards the darker fabric, avoiding stretching the bias edges, and sew the 2 halves of the block together. Make 30 blocks.

Centre

Referring to the Quilt Assembly Diagram and quilt photograph, lay out the hourglass blocks on the design wall and add the sashing strips and sashing squares. Check that the layout is correct and looks balanced.

Sew the sashing rectangles to the block sides to make 6 rows of 5 blocks. Press seams towards the sashing rectangles. Sew the remaining sashing rectangles and sashing squares together to form 7 sashing rows. Press seams towards the sashing rectangles.

Pin and sew the rows together following the Quilt Assembly Diagram, ensuring crossing seams align.

Border and Corner Squares

From the smaller Fabric 18 and 19 corner quarter-square-triangles make 4 corner squares, using the hourglass block method and referring to the Block Assembly Diagram.

Pin and sew the longer side borders to the quilt centre. Press seams towards the borders.

Sew the corner blocks to each end of the shorter top and bottom borders, ensuring the Fabric 19 triangles are on the sides of the squares. Press seams towards the borders.

Pin and sew the top and bottom borders to the quilt, ensuring crossing seams align.

FINISHING THE QUILT

Press the quilt top. Layer the quilt top, batting and backing, and baste together (see page 140).
Quilt as desired.
Trim the quilt edges and attach the binding (see page 141).

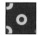 Fabric 1
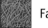 Fabric 12
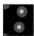 Fabric 2
 Fabric 13
 Fabric 3
 Fabric 14
 Fabric 4
 Fabric 15
 Fabric 5
 Fabric 16
 Fabric 6
 Fabric 17
 Fabric 7
 Fabric 18
 Fabric 8
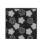 Fabric 19
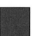 Fabric 9
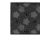 Fabric 20
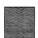 Fabric 10
 Fabric 21
Fabric 11

BLOCK ASSEMBLY DIAGRAM

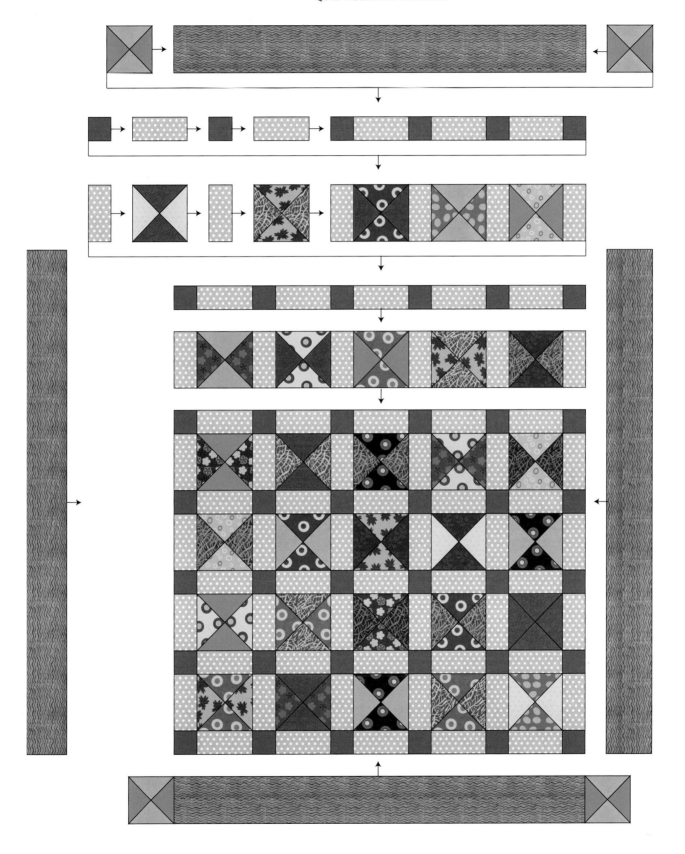

blue tiles *

Kaffe Fassett

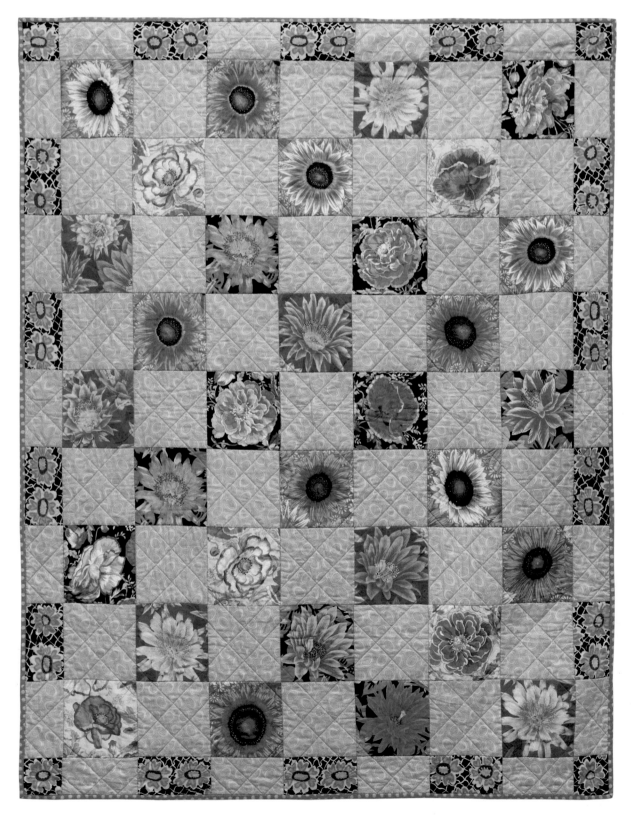

A simple layout, reminiscent of a Victorian fireplace surround, shows off Philip Jacobs' current selection of fabrics with their beautiful cool blooms.

SIZE OF FINISHED QUILT
70½in x 56½in (179cm x 144cm)

FABRICS
Fabrics have been calculated at a maximum width of 40in (102cm) and have been given a number – see Fabric Swatch Diagram for details.
Extra fabric has been included for fussy cutting the floral patches.

Patchwork Fabrics

CACTUS FLOWER		
Fabric 1	Blue	1yd (95cm)
Fabric 2	Cool	¾yd (70cm)
VAN GOGH		
Fabric 3	Blue	1yd (95cm)
DOROTHY		
Fabric 4	Blue	¾yd (70cm)
Fabric 5	Contrast	¾yd (70cm)
ABORIGINAL DOT		
Fabric 6	Turquoise	2yd (1.9m)
FLOWER NET		
Fabric 7	Black	¾yd (70cm)

Backing and Binding Fabrics

HOKUSAI'S MUMS		
Fabric 8	Grey	2¼yd (2.1m)
FERNS		
Fabric 9	Periwinkle	2¼yd (2.1m)
SPOT		
Fabric 10	Sapphire	⅝yd (60cm)

Batting
79in x 65in (201cm x 165cm)

PATCHES
The finished quilt is a checkerboard pattern of 7in (17.8cm) squares, alternating patches fussy cut from large-scale floral fabrics with patches cut from a smaller tone-on-tone print. The border is made of 7in x 3½in (17.8cm x 8.9cm) alternating rectangles with 3½in (8.9cm) corner squares.

FABRIC SWATCH DIAGRAM

Patchwork Fabrics

Fabric 1
CACTUS FLOWER
Blue
PJ096BL

Fabric 2
CACTUS FLOWER
Cool
PJ096CL

Fabric 3
VAN GOGH
Blue
PJ111BL

Fabric 4
DOROTHY
Blue
PJ109BL

Fabric 5
DOROTHY
Contrast
PJ109CN

Fabric 6
ABORIGINAL DOT
Turquoise
GP071TQ

Fabric 7
FLOWER NET
Black
BM081BK

Backing and Binding Fabrics

Fabric 8
HOKUSAI'S MUMS
Grey
PJ107GY

Fabric 9
FERNS
Periwinkle
GP147PE

Fabric 10
SPOT
Sapphire
GP070SP

CUTTING OUT
Fabric is cut across the width unless otherwise stated. When cutting different pieces from the same fabric, always cut the larger pieces first.

Centre
Centering a flower motif in each patch, fussy cut a total of 32 squares at 7½in (19.1cm) from fabrics as follows:
Fabric 1 7 squares;
Fabric 2 5 squares;
Fabric 3 10 squares;
Fabric 4 5 squares;
Fabric 5 5 squares.

From Fabric 6 cut 7 strips 7½in (19.1cm) wide and cross cut squares at 7½in (19.1cm). Each strip will yield 5 squares. Cut a total of 31 squares.

Border
From the remaining Fabric 6 cut 4 strips 4in (10.2cm) wide and cross cut rectangles 7½in x 4in (19.1cm x 10.2cm). Each strip will yield 5 rectangles. Cut a total of 18 rectangles.
From Fabric 7 fussy cut 4 strips 4in (10.2cm) wide, centering flower motifs along the strip, and cross cut rectangles 7½in x 4in (19.1cm x 10.2cm). Each strip will yield 5 rectangles. Cut a total of 14 rectangles. From the 4th strip cut 4 squares at 4in (19.1cm) for the corner squares, centering a flower in each square.

Backing
From Fabric 8 cut a piece 79in x 40in (201cm x 102cm).
From Fabric 9 cut 2 pieces 79in x 13in (201cm x 33cm).

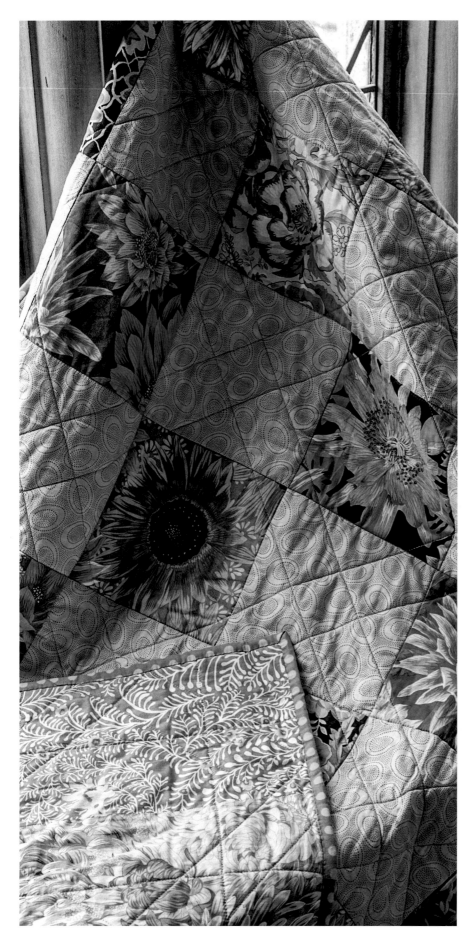

Binding

From Fabric 10 cut 7 strips 2½in (6.4cm) wide. Remove selvedges and sew end to end with 45-degree seams (see page 141).

MAKING THE QUILT

Using a design wall will help to place patches in the required layout.
Use ¼in (6mm) seams throughout.

Assembling the Quilt

Lay out the blocks referring to the Quilt Assembly Diagram and quilt photograph. Sew the patches together one row at a time, including the border pieces, pressing seams in opposite directions on alternate rows – odd rows to the left, even rows to the right – to allow the finished seams to lie flat.
Pin, then sew the rows together, taking care to match crossing seams.

FINISHING THE QUILT

Sew a piece of Fabric 9 backing fabric to each side of the Fabric 8 backing fabric to form a piece 79in x 65in (201cm x 165cm).

Press the quilt top. Layer the quilt top, batting and backing, and baste together (see page 140).
Quilt as desired.
Trim the quilt edges and attach the binding (see page 141).

QUILT ASSEMBLY DIAGRAM

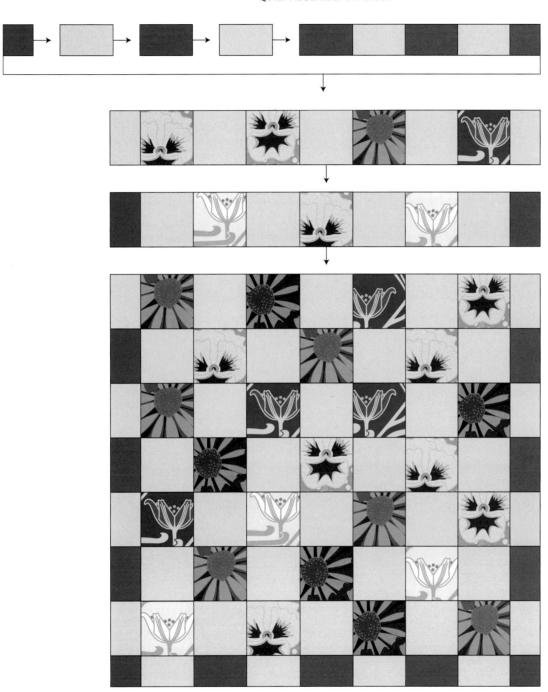

Fabric 1 Fabric 5

Fabric 2 Fabric 6

Fabric 3 Fabric 7

Fabric 4

turquoise dream *

Kaffe Fassett

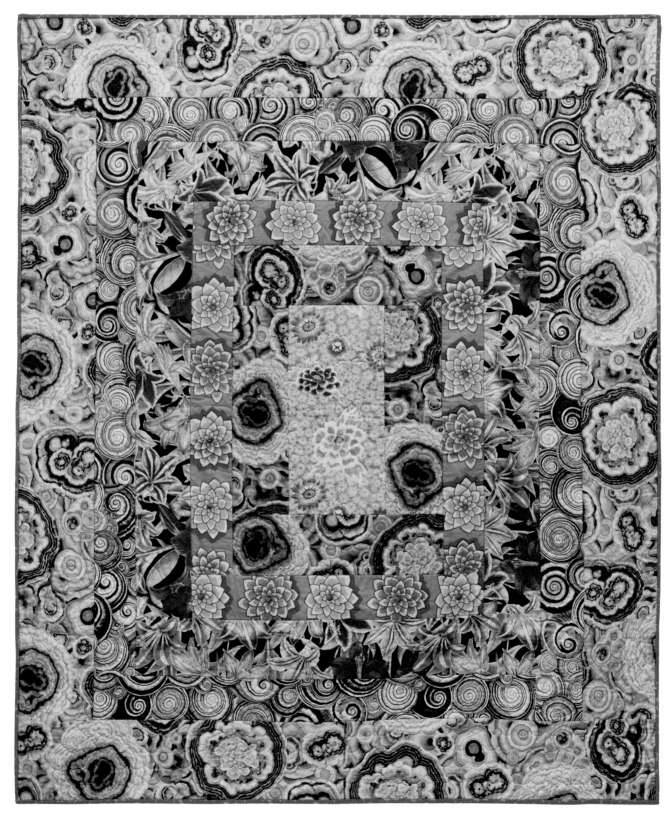

This cool blue quilt is made in a single log cabin format with five feature borders around a rectangular centre panel.

SIZE OF FINISHED QUILT
72in x 62in (183cm x 157cm)

FABRICS
Fabrics have been calculated at a maximum width of 40in (102cm). Fabrics have been given a number – see Fabric Swatch Diagram for details.

PATCHWORK FABRICS
CHARLOTTE
Fabric 1 Teal ⅝yd (60cm)
AGATE
Fabric 2 Sky ⅝yd (60cm)
Fabric 3 Turquoise 1⅝yd (1.5m)
SHADOW FLOWER
Fabric 4 Teal ½yd (50cm)
AMARYLLIS
Fabric 5 Lavender ¾yd (70cm)
SPIRAL SHELLS
Fabric 6 Contrast ¾yd (70cm)

Backing and Binding Fabrics
JAPANESE CHRYSANTHEMUM
Fabric 7 Magenta 4½yd (4.2m)
JUMBLE
Fabric 8 Aqua ⅝yd (60cm)

Batting
81in x 71in (206cm x 180cm)

CUTTING OUT
Fabric is cut across the width unless otherwise stated. When required strips are longer than 40in (102cm) – the usable width of the fabric – remove selvedges and join strips end to end to obtain the required length, use ¼in (6mm) seams and press seams open.

Centre Panel
From Fabric 1 cut a rectangle 10in x 20in (25.4cm x 50.8cm).
Note: Extra fabric has been allowed so the panel can be cut to best effect.

Border 1
From Fabric 2 cut 3 strips 6in (15.2cm) wide and cross cut borders as follows:
2 borders 6in x 20in (15.2cm x 50.8cm) for the sides; and 2 borders 6in x 21in (15.2cm x 53.3cm) for the top and bottom.

Border 2
From Fabric 4 fussy cut 3 strips 4½in (11.4cm) wide, centering a row of flowers along each strip, and join strips end to end. From the length, cut borders as follows:
2 borders 4½in x 31in (11.4cm x 78.7cm) wide for the sides; and 2 borders 4½in wide x 29in (11.4cm x 73.7cm) for the top and bottom.
Note: Extra fabric has been allowed to enable fussy cutting of strips.

Border 3
From Fabric 5 cut 4 strips 6in (15.2cm) wide and cut borders as follows:
2 borders 6in x 39in (15.2cm x 99.1cm) for the sides; and 2 borders 6in x 40in (15.2cm x 101.6cm) for the top and bottom.

Border 4
From Fabric 6 cut 5 strips 4½in (11.4cm) wide and join strips end to end. From the length, cut borders as follows:
2 borders 4½in x 50in (11.4cm x 127cm) for the sides; and 2 borders 4½in x 48in (11.4cm x 121.9cm) for the top and bottom.

Border 5
From Fabric 3 cut 7 strips 8in (20.3cm) wide and join strips end to end. From the length, cut borders as follows:
2 borders 8in x 58in (20.3cm x 147.3cm) for the sides; and 2 borders 8in x 63in (20.3cm x 160cm) for the top and bottom.

Backing
From Fabric 7, cutting lengthwise down the fabric, cut 2 lengths 81in (206cm) long, remove selvedges and sew together side to side. Trim to make a piece approx. 81in x 71in (206cm x 180cm).

Binding
From Fabric 8 cut 8 strips 2½in (6.4cm) wide. Remove selvedges and sew end to end with 45-degree seams (see page 141).

FABRIC SWATCH DIAGRAM

Patchwork Fabrics

Fabric 1
CHARLOTTE
Teal
GP186TE

Fabric 2
AGATE
Sky
PJ106SK

Fabric 3
AGATE
Turquoise
PJ106TQ

Fabric 4
SHADOW FLOWER
Teal
GP187TE

Fabric 5
AMARYLLIS
Lavender
PJ104LV

Fabric 6
SPIRAL SHELLS
Contrast
PJ073CN

Backing and Binding Fabrics

Fabric 7
JAPANESE CHRYSANTHEMUM
Magenta
PJ041MG

Fabric 8
JUMBLE
Aqua
BM053AQ

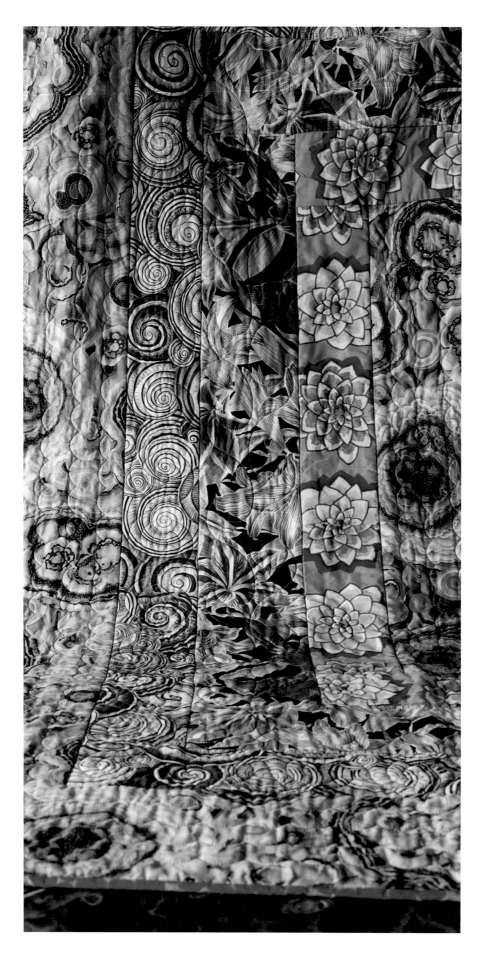

MAKING THE QUILT

Using a design wall will help to place the borders in the required layout.
Use ¼in (6mm) seams throughout.

Referring to the Quilt Assembly Diagram and quilt photograph, lay out the centre and all borders. Attach each border in sequence, starting with the innermost longer side borders, followed by the top and bottom borders. Pin each border piece in place to prevent stretching, then sew.

FINISHING THE QUILT

Press the quilt top. Layer the quilt top, batting and backing, and baste together (see page 140).
Quilt as desired.
Trim the quilt edges and attach the binding (see page 141).

QUILT ASSEMBLY DIAGRAM

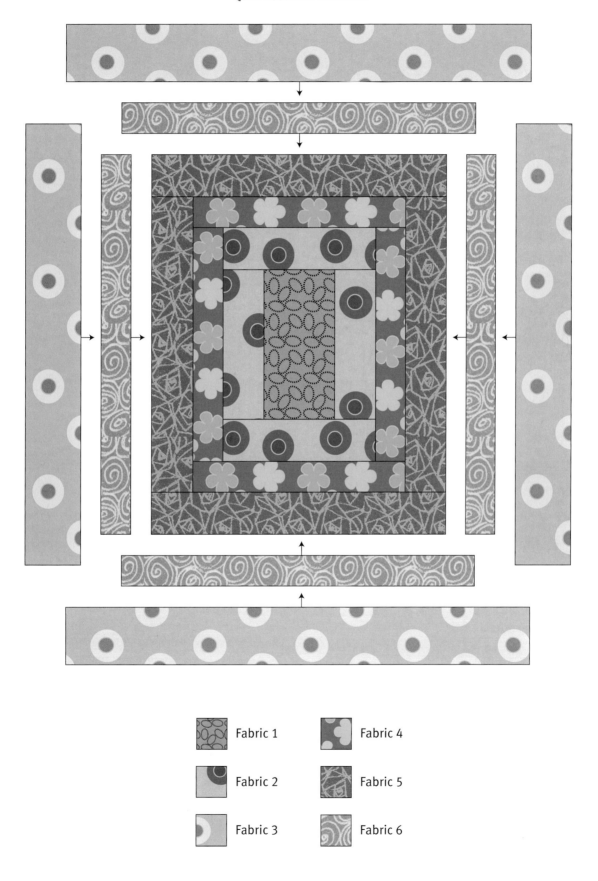

Fabric 1

Fabric 2

Fabric 3

Fabric 4

Fabric 5

Fabric 6

cobweb *

Kaffe Fassett

A simple, pastel quilt of sashed square feature fabrics. The sashing is made with sashing squares making this quilt easy to put together.

SIZE OF FINISHED QUILT
58in x 50in (147cm x 127cm)

FABRICS
Fabrics have been calculated at a maximum width of 40in (102cm). Fabrics have been given a number – see Fabric Swatch Diagram for details.

Patchwork Fabrics
AMAZE
| Fabric 1 | White | 1½yd (1.4m) |

* See also Binding Fabric
KOI POLLOI
| Fabric 2 | Delft | ¼yd (25cm) |

FLOWER NET
Fabric 3	Blue	¼yd (25cm)
Fabric 4	Green	¼yd (25cm)
Fabric 5	Grey	¼yd (25cm)

HOKUSAI'S MUMS
| Fabric 6 | Grey | ⅜yd (40cm) |

CALADIUMS
| Fabric 7 | Pastel | ¼yd (25cm) |
| Fabric 8 | Bright | ¼yd (25cm) |

CLIMBING GERANIUMS
| Fabric 9 | Green | ¼yd (25cm) |
| Fabric 10 | Duck Egg | ¼yd (25cm) |

LUCY
| Fabric 11 | Grey | ¼yd (25cm) |
| Fabric 12 | Pink | ¼yd (25cm) |

Backing and Binding Fabrics
ONION RINGS extra wide backing
| Fabric 13 | Black | 1¾yd (1.7m) |

AMAZE
| Fabric 1 | White | ½yd (50cm) |

* See also Patchwork Fabrics

Batting
67in x 59in (170cm x 150cm)

PATCHES
Feature fabrics are all 6½in (16.5cm) squares, set in 7 rows of 6 with sashing and sashing squares.

CUTTING OUT
Fabric is cut across the width unless otherwise stated.

FABRIC SWATCH DIAGRAM

Patchwork Fabrics

Fabric 1
AMAZE
White
BM078WH

Fabric 2
KOI POLLOI
Delft
BM079DF

Fabric 3
FLOWER NET
Blue
BM081BL

Fabric 4
FLOWER NET
Green
BM081GN

Fabric 5
FLOWER NET
Grey
BM081GY

Fabric 6
HOKUSAI'S MUMS
Grey
PJ107GY

Fabric 7
CALADIUMS
Pastel
PJ108PT

Fabric 8
CALADIUMS
Bright
PJ108BH

Fabric 9
CLIMBING GERANIUMS
Green
PJ110GN

Fabric 10
CLIMBING GERANIUMS
Duck Egg
PJ110DE

Fabric 11
LUCY
Grey
PJ112GY

Fabric 12
LUCY
Pink
PJ112PK

Backing and Binding Fabrics

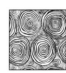
Fabric 13
ONION RINGS
Black
QB001BK

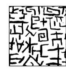
Fabric 1
AMAZE
White
BM078WH

Feature Squares
Cut strips 6½in (16.5cm) wide and cross cut squares at 6½in (16.5cm). Each strip will yield 6 squares.
Cut a total of 42 squares from fabrics as follows:
Fabric 2 (1 strip) 3 squares;
Fabric 3 (1 strip) 4 squares;
Fabric 4 (1 strip) 5 squares;
Fabric 5 (1 strip) 6 squares;
Fabric 6 (2 strips) 7 squares;
Fabric 7 (1 strip) 3 squares;
Fabric 8 (1 strip) 3 squares;
Fabric 9 (1 strip) 4 squares;
Fabric 10 (1 strip) 2 squares;
Fabric 11 (1 strip) 2 squares;
Fabric 12 (1 strip) 3 squares.

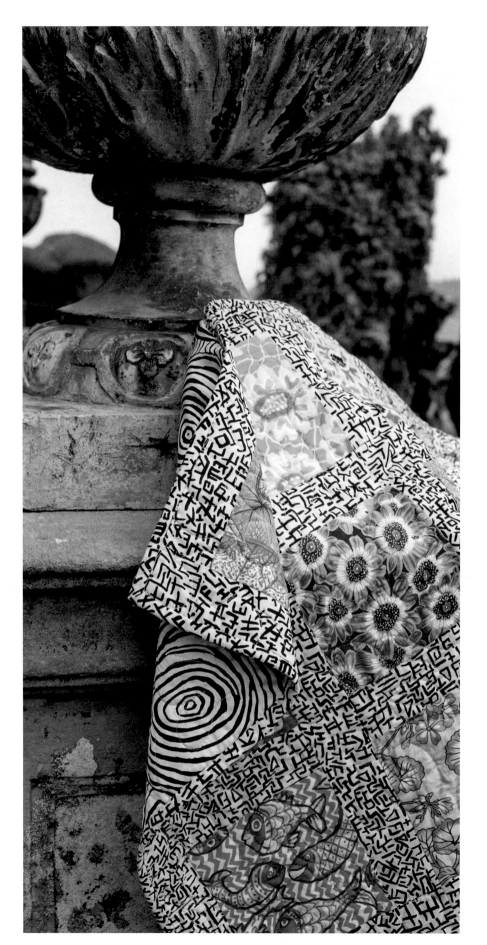

Sashing
From Fabric 1 cut 6 strips 6½in (16.5cm) wide and cross cut 96 rectangles 6½in x 2½in (16.5cm x 6.4cm). Each strip will yield 16 rectangles.

Sashing Squares
From the remaining Fabric 1 cut 4 strips 2½in (6.4cm) wide and cross cut 1 rectangle 6½in x 2½in (16.5cm x 6.4cm) for sashing and 56 squares at 2½in (6.4cm). Each strip will yield 16 squares.

Binding
From the remaining Fabric 1 cut 6 strips 2½in (6.4cm) wide. Remove selvedges and sew end to end with 45-degree seams (see page 141).

Backing
Trim Fabric 13 to 67in x 59in (170cm x 150cm).

MAKING THE QUILT
Using a design wall will help to place patches in the required layout.
Use ¼in (6mm) seams throughout.

Centre
Referring to the Quilt Assembly Diagram and the quilt photograph, lay out the feature squares in 7 rows of 6. Sew vertical sashing strips between each square and at each end of the rows to make 7 rows of sashed squares. Press seams towards the sashing strips.
Make 8 horizontal rows of sashing, each alternating 7 sashing squares with 6 sashing rectangles. Press seams towards the sashing strips.
Add the sashing rows to the layout. Sew together one row at a time and press seams towards the sashing strips.

FINISHING THE QUILT
Press the quilt top. Layer the quilt top, batting and backing, and baste together (see page 140).
Quilt as desired.
Trim the quilt edges and attach the binding (see page 141).

QUILT ASSEMBLY DIAGRAM

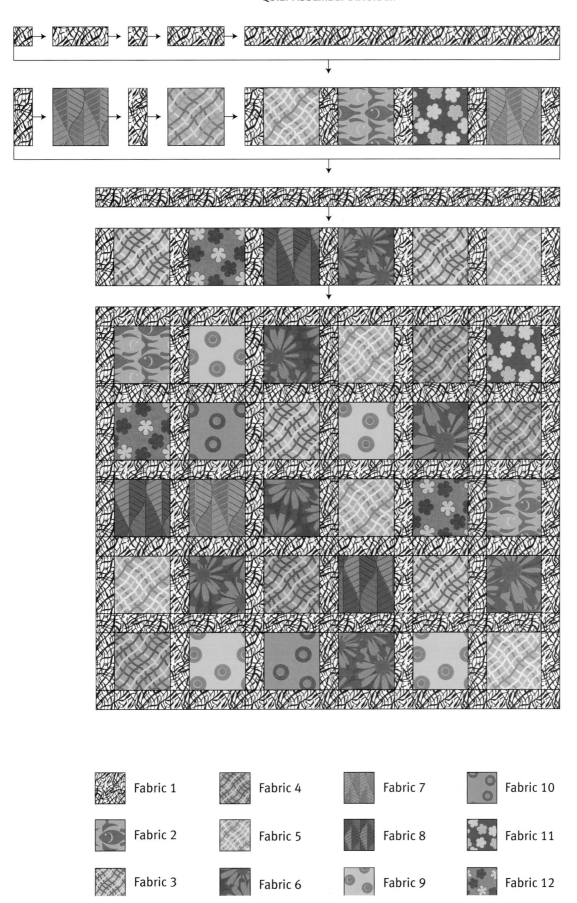

Fabric 1
Fabric 2
Fabric 3
Fabric 4
Fabric 5
Fabric 6
Fabric 7
Fabric 8
Fabric 9
Fabric 10
Fabric 11
Fabric 12

bubbly *

Kaffe Fassett

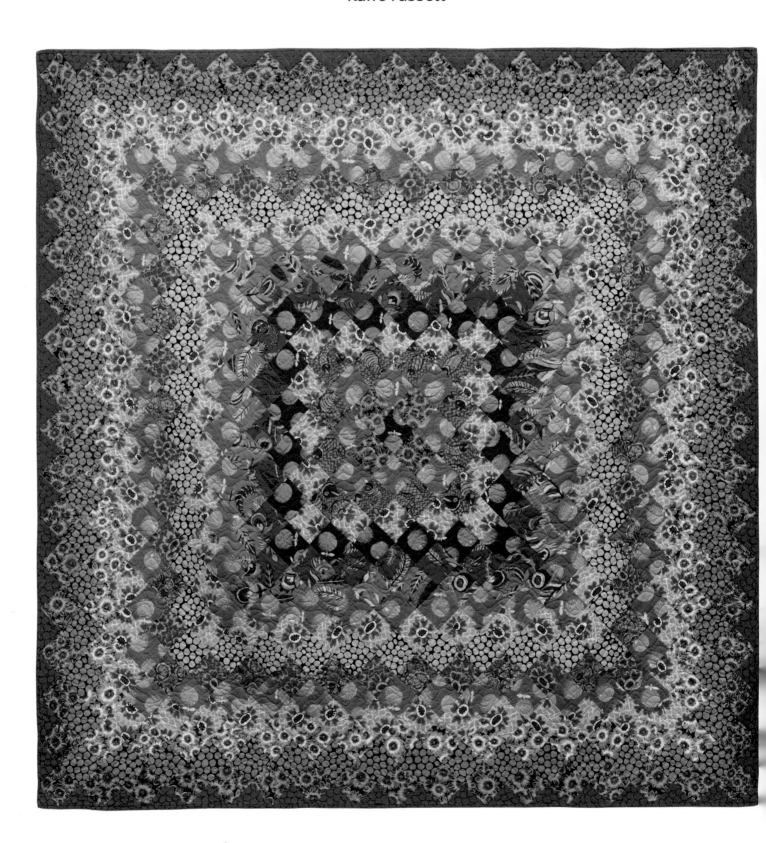

The square patches in this traditional 'Round the World' quilt are set on point and are sewn together in diagonal rows. With the predominance of circular and spot print fabrics in hot pinks, it certainly makes a bold statement.

SIZE OF FINISHED QUILT
83in x 83in (211cm x 211cm)

FABRICS
Fabrics have been calculated at a maximum width of 40in (102 cm). Fabrics have been given a number – see Fabric Swatch Diagram for details.

Patchwork Fabrics
ORANGES
Fabric 1	Maroon	⅜yd (40cm)

LUCY
Fabric 2	Magenta	⅞yd (85cm)

ORANGES
Fabric 3	Pink	1⅛yd (1.1m)

KOI POLLOI
Fabric 4	Orange	¼yd 25cm)

FLOWER NET
Fabric 5	Blue	1⅜yd (1.3m)

TICKLE MY FANCY
Fabric 6	Red	⅜yd (40cm)
Fabric 7	Orange	⅜yd (40cm)

JUMBLE
Fabric 8	Rose	½yd (50cm)

FLOWER NET
Fabric 9	Red	⅜yd (40cm)

CLIMBING GERANIUMS
Fabric 10	Red	⅜yd (40cm)

LUCY
Fabric 11	Pink	¾yd (70cm)

JUMBLE
Fabric 12	Bubblegum	¾yd (70cm)
Fabric 13	Rust	⅝yd (60cm)

* see also Binding Fabric

Backing and Binding Fabrics
MILLEFIORE
Fabric 14	Tomato	6yd (5.5m)

JUMBLE
Fabric 13	Rust	¾yd (70cm)

* see also Patchwork Fabrics

Batting
92in x 92in (234cm x 234cm)

PATCHES
The patches are 4in (10.2cm) squares, set on point in 16 rounds encircling a centre square.

FABRIC SWATCH DIAGRAM

Patchwork Fabrics

Fabric 1
ORANGES
Maroon
GP177MM

Fabric 2
LUCY
Magenta
PJ112MG

Fabric 3
ORANGES
Pink
GP177PK

Fabric 4
KOI POLLOI
Orange
BM079OR

Fabric 5
FLOWER NET
Blue
BM081BL

Fabric 6
TICKLE MY FANCY
Red
BM080RD

Fabric 7
TICKLE MY FANCY
Orange
BM080OR

Fabric 8
JUMBLE
Rose
BM053RO

Fabric 9
FLOWER NET
Red
BM081RD

Fabric 10
CLIMBING GERANIUMS
Red
PJ110RD

Fabric 11
LUCY
Pink
PJ112PK

Fabric 12
JUMBLE
Bubblegum
BM053BB

Fabric 13
JUMBLE
Rust
BM053RU

Backing and Binding Fabrics

Fabric 14
MILLEFIORE
Tomato
GP092TM

Fabric 13
JUMBLE
Rust
BM053RU

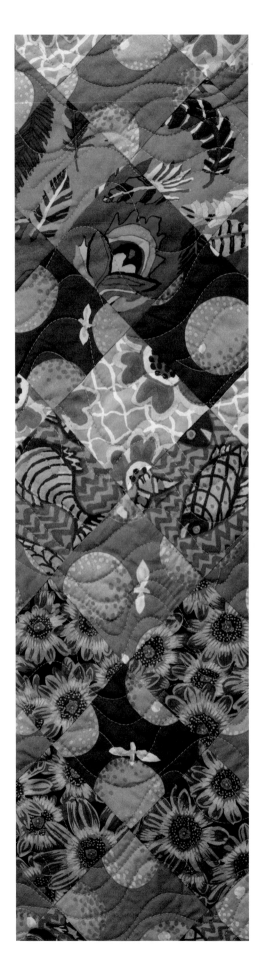

CUTTING OUT

Fabric is cut across the width unless otherwise stated.

Patches

Cut strips 4in (10.2cm) wide and cross cut squares at 4in (10.2cm). Each strip will yield 10 squares.
Cut a total of 545 squares from fabrics as follows:
Fabric 1 (3 strips) 21 squares;
Fabric 2 (7 strips) 68 squares;
Fabric 3 (9 strips) 88 squares;
Fabric 4 (2 strips) 12 squares;
Fabric 5 (11 strips) 104 squares;
Fabric 6 (3 strips) 24 squares;
Fabric 7 (3 strips) 28 squares;
Fabric 8 (4 strips) 40 squares;
Fabric 9 (3 strips) 22 squares;
Fabric 10 (3 strips) 22 squares;
Fabric 11 (6 strips) 56 squares;
Fabric 12 (6 strips) 60 squares.

Setting Triangles and Corners

For the setting triangles, from Fabric 13 cut 3 strips 6¼in (15.9cm) and cross cut 16 squares at 6 ¼in (15.9cm). Each strip will yield 6 squares. Cut each square diagonally twice to make 4 quarter-square triangles from each square – 64 quarter-square triangles in total.

For the corner triangles, trim the remaining third strip of Fabric 13 to 3½in (8.9cm) wide and cross cut 2 squares at 3½in (8.9cm). Cut each square diagonally once to make 2 half-square triangles from each square – 4 half-square triangles in total.

Backing

From Fabric 14 cut 2 pieces 92in x 40in (234cm x 101.6cm) and 1 piece 32in x 40in (81.3cm x 101.6cm).

Binding

From the remaining Fabric 13 cut 9 strips 2½in (6.4cm) wide. Remove selvedges and sew end to end with 45-degree seams (see page 141).

MAKING THE QUILT

Using a design wall will help to place patches in the required layout.
Use ¼in (6mm) seams throughout.

Assembling the Quilt

Lay out the blocks referring to the Quilt Assembly Diagram and quilt photograph, starting with the centre block in Fabric 1, adding each round of squares in the following sequence:
Centre: Fabric 1;
Round 1: Fabric 2;
Round 2: Fabric 3;
Round 3: Fabric 4;
Round 4: Fabric 5;
Round 5: Fabric 1;
Round 6: Fabric 6;
Round 7: Fabric 7;
Round 8: Fabric 3;
Round 9: Fabric 5;
Round 10: Fabric 8;
Round 11: alternating Fabric 9 and Fabric 10;
Round 12: Fabric 3;
Round 13: Fabric 5;
Round 14: Fabric 11;
Round 15: Fabric 12;
Round 16: Fabric 2.

Add the Fabric 13 setting triangles around the edge of the layout and complete the corners with the 4 half-square triangles. Check the layout before sewing together.

Referring to the Quilt Assembly Diagram, sew the rows together in diagonal rows, one row at a time, pressing seams in opposite directions on alternate rows – odd rows to the left, even rows to the right – to allow the finished seams to lie flat. Sew the rows together, carefully aligning crossing seams.

FINISHING THE QUILT

Remove selvedges from the Fabric 14 backing pieces. Cut the shorter piece **down the length** into 3 rectangles 32in x 13in (81.3cm x 33cm) and sew them together, short end to short end, to make a piece 92in x 13in (234cm x 33cm). Sew the 3 sections together down their lengths to form a backing 92in x 92in (234cm x 234cm).

Press the quilt top. Layer the quilt top, batting and backing, and baste together (see page 140).
Quilt as desired.
Trim the quilt edges and attach the binding (see page 141).

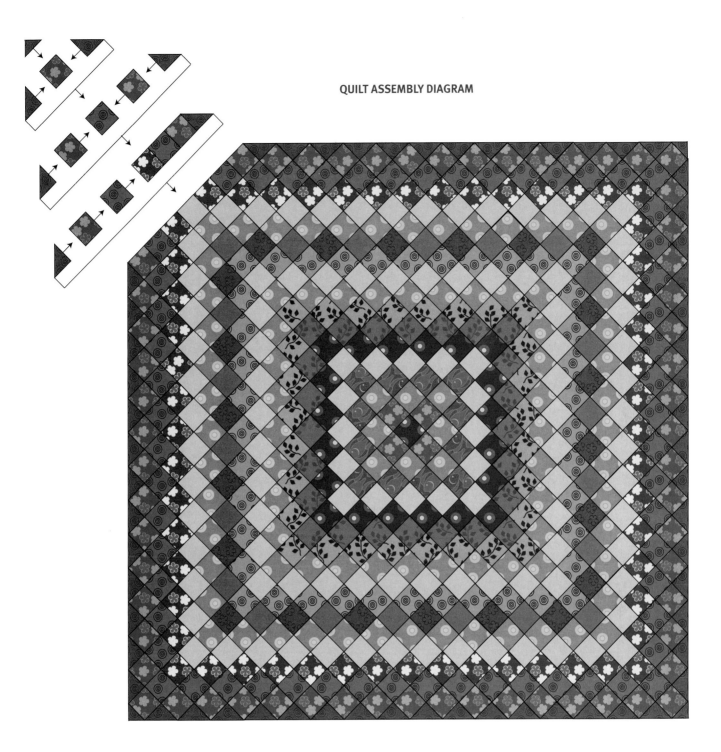

	Fabric 1		Fabric 6		Fabric 11
	Fabric 2		Fabric 7		Fabric 12
	Fabric 3		Fabric 8		Fabric 13
	Fabric 4		Fabric 9		
	Fabric 5		Fabric 10		

lavender and sage *

Kaffe Fassett

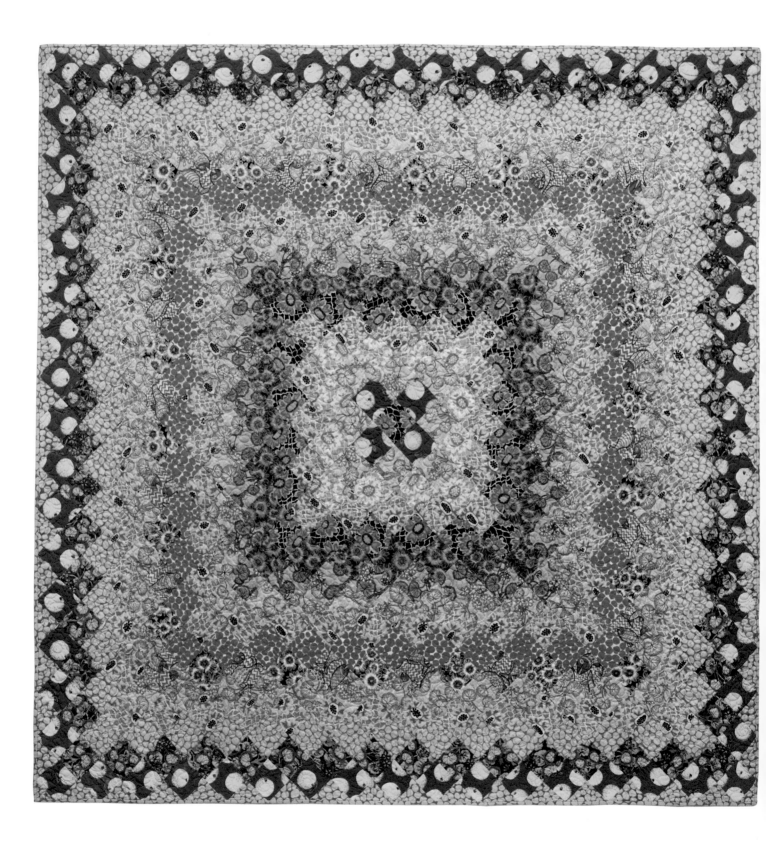

This cool version of *Bubbly* also features mostly circular motifs and spotty fabrics. Use the instructions and layout for *Bubbly* on pages 116–119 but replace fabrics with the following, referring to the Quilt Assembly Diagram overleaf.

SIZE OF FINISHED QUILT
83in x 83in (211cm x 211cm)

FABRICS
Fabrics have been calculated at a maximum width of 40in (102cm). Fabrics have been given a number – see Fabric Swatch Diagram for details.

Patchwork Fabrics
FLOWER NET
Fabric 1	Black	³⁄₈ yd (40cm)

ORANGES
Fabric 2	Lavender	⁷⁄₈ yd (85cm)

CLIMBING GERANIUMS
Fabric 3	Green	1¹⁄₈ yd (1.1m)

FLOWER NET
Fabric 4	Green	¹⁄₄ yd (25cm)
Fabric 5	Grey	1³⁄₈ yd (1.3m)

LUCY
Fabric 6	Lavender	³⁄₈ yd (40cm)

CLIMBING GERANIUMS
Fabric 7	Duck Egg	³⁄₈ yd (40cm)

JUMBLE
Fabric 8	Cobalt	¹⁄₂ yd (50cm)

KOI POLLOI
Fabric 9	Delft	³⁄₈ yd (40cm)

LUCY
Fabric 10	Grey	³⁄₈ yd (40cm)

JUMBLE
Fabric 11	Turquoise	³⁄₄ yd (70cm)

CLIMBING GERANIUMS
Fabric 12	Purple	³⁄₄ yd (70cm)

JUMBLE
Fabric 13	Moss	⁵⁄₈ yd (60cm)

* see also Binding Fabric

Backing and Binding Fabrics
MILLEFIORE extra wide backing
Fabric 14	Pastel	2⁵⁄₈ yd (2.45m)

JUMBLE
Fabric 13	Moss	³⁄₄ yd (70cm)

* see also Patchwork Fabrics

Batting
92in x 92in (234cm x 234cm)

FABRIC SWATCH DIAGRAM

Patchwork Fabrics

Fabric 1
FLOWER NET
Black
BM081BK

Fabric 2
ORANGES
Lavender
GP177LV

Fabric 3
CLIMBING GERANIUMS
Green
PJ110GN

Fabric 4
FLOWER NET
Green
BM081GN

Fabric 5
FLOWER NET
Grey
BM081GY

Fabric 6
LUCY
Lavender
PJ112LV

Fabric 7
CLIMBING GERANIUMS
Duck Egg
PJ110DE

Fabric 8
JUMBLE
Cobalt
BM053CB

Fabric 9
KOI POLLOI
Delft
BM079DF

Fabric 10
LUCY
Grey
PJ112GY

Fabric 11
JUMBLE
Turquoise
BM053TQ

Fabric 12
CLIMBING GERANIUMS
Purple
PJ110PU

Fabric 13
JUMBLE
Moss
BM053MS

Backing and Binding Fabrics

Fabric 14
MILLEFIORE
Pastel
QB006PT

Fabric 13
JUMBLE
Moss
BM053MS

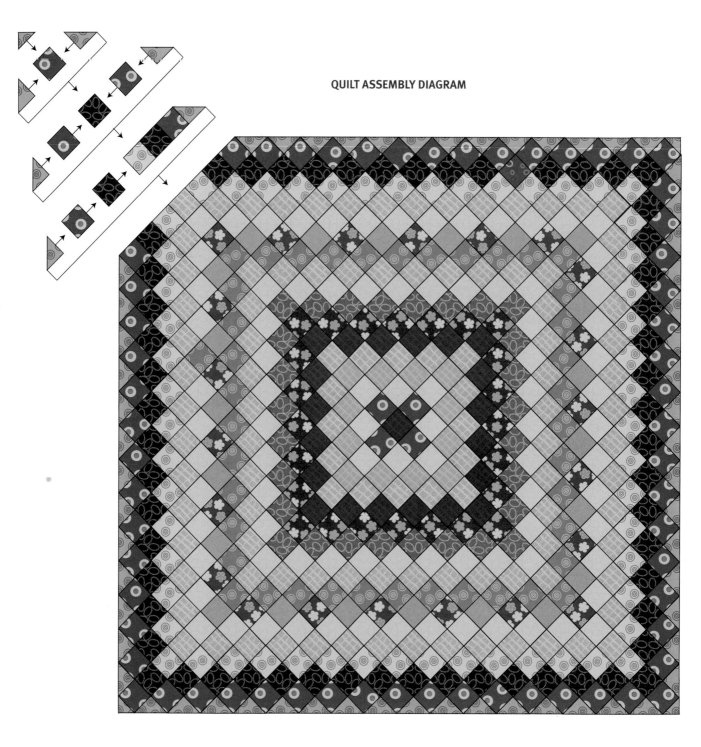

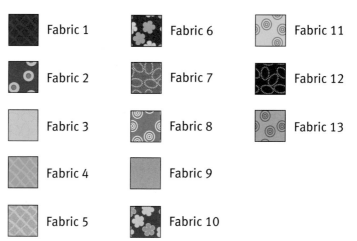

Fabric 1	Fabric 6	Fabric 11	
Fabric 2	Fabric 7	Fabric 12	
Fabric 3	Fabric 8	Fabric 13	
Fabric 4	Fabric 9		
Fabric 5	Fabric 10		

checkerboard of checkerboards *

Kaffe Fassett

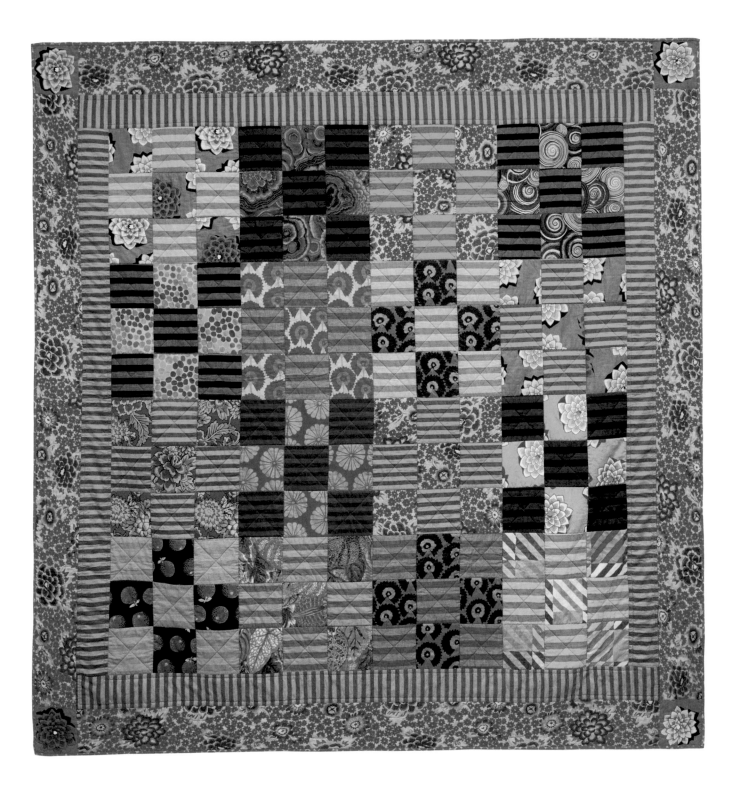

This cool quilt uses Shot Stripes to great effect in four rows of four checkerboard 9-square blocks, framed by a border of stripes and finished with a floral border with fussy-cut flower corner squares.

SIZE OF FINISHED QUILT
86in x 86in (218cm x 218cm)

FABRICS
Fabrics have been calculated at a maximum width of 40in (102cm). Fabrics have been given a number – see Fabric Swatch Diagram for details.

Patchwork Fabrics
FLOWER DOT
Fabric 1 Blue ¼yd (25cm)
CLOISONNE
Fabric 2 Blue ¼yd (25cm)
ORANGES
Fabric 3 Purple ¼yd (25cm)
DAMASK FLOWER
Fabric 4 Blue ¼yd (25cm)
CHARLOTTE
Fabric 5 Blue 2yd (1.9m)
SHADOW FLOWER
Fabric 6 Teal ¼yd (25cm)
Fabric 7 Blue ¾yd (70cm)
REGAL FANS
Fabric 8 Blue ¼yd (25cm)
Fabric 9 Dark ⅜yd (40cm)
REGIMENTAL TIES
Fabric 10 Blue ¼yd (25cm)
COLEUS
Fabric 11 Blue ¼yd (25cm)
SPIRAL SHELLS
Fabric 12 Multi ¼yd (25cm)
AGATE
Fabric 13 Blue ¼yd (25cm)
WIDE STRIPE
Fabric 14 Blueberry ⅝yd (60cm)
Fabric 15 Heather ¼yd (25cm)
Fabric 16 Seaweed ⅜yd (40cm)
Fabric 17 Embers ⅜yd (40cm)
Fabric 18 Fjord ⅜yd (40cm)
Fabric 19 Kiwi ⅜yd (40cm)
NARROW STRIPE
Fabric 20 Mallard 1½yd (1.4m)
Fabric 21 Midnight ¼yd (25cm)

Backing and Binding Fabrics
JUMBLE
Fabric 22 Blue 6¾yd (6.2m)
Fabric 23 Aqua ⅞yd (85cm)

Batting
95in x 95in (241cm x 241cm)

PATCHES
Patches are 6in (15.2cm) squares, set in 9-square blocks with alternating stripes, all lying horizontally. There are 4 rows of 4 blocks, surrounded by a striped border cut 4½in (11.4cm) wide, which is surrounded by a wider 6½in (16.5cm) border, with corner squares.

CUTTING OUT
Fabric is cut across the width unless otherwise stated. When required strips are longer than 40in (102cm) – the usable width of the fabric – remove selvedges and join strips end to end to obtain the required length. Use ¼in (6mm) seams and press seams open. When cutting different pieces from the same fabric, always cut the larger pieces first.

Border 1
From Fabric 20 cut 8 strips 4½in (11.4cm) wide. Remove selvedges and sew end to end, matching the stripes so they look continuous. Use ¼in (6mm) seams and press seams open. From the length, cut 2 border pieces 74½in (189.2cm) long for the top and bottom and 2 border pieces 66½in (168.9cm) long for the sides.

Border 2
From Fabric 5 cut 8 strips 6½in (16.5cm) wide. Remove selvedges and sew 2 pieces together end to end for each of the 4 border pieces. Use ¼in (6mm) seams and press seams open. Trim the 4 border pieces to 74½in (189.2cm) long. From Fabric 7 fussy cut 4 flower motifs into 6½in (16.5cm) squares for the corner squares.

Centre Blocks
Cut strips 6in (15.2cm) wide and cross cut squares 6in (15.2cm). Each strip will yield 6 squares.
Cut a total of 144 squares from fabrics as follows:
Fabric 1 (1 strip) 4 squares;
Fabric 2 (1 strip) 5 squares;
Fabric 3 (1 strip) 4 squares;
Fabric 4 (1 strip) 4 squares;
Fabric 5 (2 strips) 10 squares;
Fabric 6 (1 strip) 4 squares;
Fabric 7 (2 strips) 10 squares;
Fabric 8 (1 strip) 5 squares;
Fabric 9 (2 strips) 8 squares;
Fabric 10 (1 strip) 5 squares;
Fabric 11 (1 strip) 5 squares;
Fabric 12 (1 strip) 4 squares;
Fabric 13 (1 strip) 4 squares;
Fabric 14 (3 strips) 13 squares;
Fabric 15 (1 strip) 5 squares;
Fabric 16 (2 strips) 9 squares;
Fabric 17 (2 strips) 8 squares;
Fabric 18 (2 strips) 10 squares;
Fabric 19 (2 strips) 10 squares;
Fabric 20 (2 strips) 12 squares;
Fabric 21 (1 strip) 5 squares.

Backing
From Fabric 22 cut 2 pieces 40in x 95in (101.6cm x 241cm) and from the remaining fabric cut 2 pieces 16in x 47¾in (40.6cm x 121.3cm).

Binding
From Fabric 23 cut 10 strips 2½in (6.4cm) wide. Remove selvedges and sew end to end with 45-degree seams (see page 141).

MAKING THE QUILT
Using a design wall will help to place patches in the required layout.
Use ¼in (6mm) seams throughout.

Making the Blocks
Referring to the Block Assembly Diagram and Quilt Assembly Diagram for fabric placement, make 16 9-square blocks. Arrange the 9 squares with all stripes lying horizontally. Sew each row of 3 squares together, pressing seams in opposite directions on alternate rows – odd rows to the left, even rows to the right – to allow the finished seams to lie flat. Sew the 3 rows together matching crossing seams.

Centre
Lay out the 16 blocks in 4 rows of 4, referring to the Quilt Assembly Diagram and quilt photograph. Sew together one row at a time, pressing seams in opposite directions on alternate rows – odd rows to the left, even rows to the right – to allow the finished seams to lie flat.

FABRIC SWATCH DIAGRAM

Patchwork Fabrics

Fabric 1
FLOWER DOT
Blue
BM077BL

Fabric 2
CLOISONNE
Blue
GP046BL

Fabric 3
ORANGES
Purple
GP177PU

Fabric 4
DAMASK FLOWER
Blue
GP183BL

Fabric 5
CHARLOTTE
Blue
GP186BL

Fabric 6
SHADOW FLOWER
Teal
GP187TE

Fabric 7
SHADOW FLOWER
Blue
GP187BL

Fabric 8
REGAL FANS
Blue
GP188BL

Fabric 9
REGAL FANS
Dark
GP188DK

Fabric 10
REGIMENTAL TIES
Blue
GP189BL

Fabric 11
COLEUS
Blue
PJ030BL

Fabric 12
SPIRAL SHELLS
Multi
PJ073MU

Fabric 13
AGATE
Blue
PJ106BL

Fabric 14
WIDE STRIPE
Blueberry
SS001BV

Fabric 15
WIDE STRIPE
Heather
SS001HE

Fabric 16
WIDE STRIPE
Seaweed
SS001SW

Fabric 17
WIDE STRIPE
Embers
SS001EB

Fabric 18
WIDE STRIPE
Fjord
SS001FJ

Fabric 19
WIDE STRIPE
KIWI
SS001KI

Fabric 20
NARROW STRIPE
Mallard
SS002ML

Fabric 21
NARROW STRIPE
Midnight
SS002MD

Backing and Binding Fabrics

Fabric 22
JUMBLE
Blue
BM053BL

Fabric 23
JUMBLE
Aqua
BM053AQ

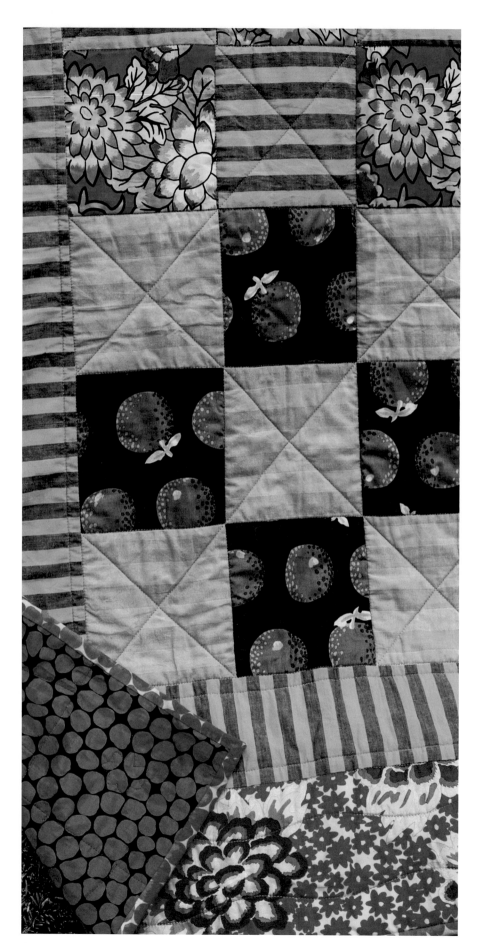

BLOCK ASSEMBLY DIAGRAM

Border 1
Pin (to prevent stretching the borders) then sew the shorter Fabric 20 side borders to the quilt centre. Press seams towards the border, then pin and sew the longer top and bottom borders.

Border 2
Pin, then sew a Fabric 5 border to each side and press seams towards Border 2. Sew a Fabric 7 fussy-cut corner square to each end of the top and bottom borders, and press seams towards the corner squares.
Pin, then sew, the top and bottom borders, matching the crossing seams.

FINISHING THE QUILT
Remove selvedges and sew the shorter Fabric 22 backing pieces together along the short edge to make a long narrow piece 16in x 95in (40.6cm x 241cm). Sew the longer 2 backing pieces and the narrow piece together along their sides to form a piece 95in x 95in (241cm x 241cm).

Press the quilt top. Layer the quilt top, batting and backing, and baste together (see page 140).
Quilt as desired.
Trim the quilt edges and attach the binding (see page 141).

QUILT ASSEMBLY DIAGRAM

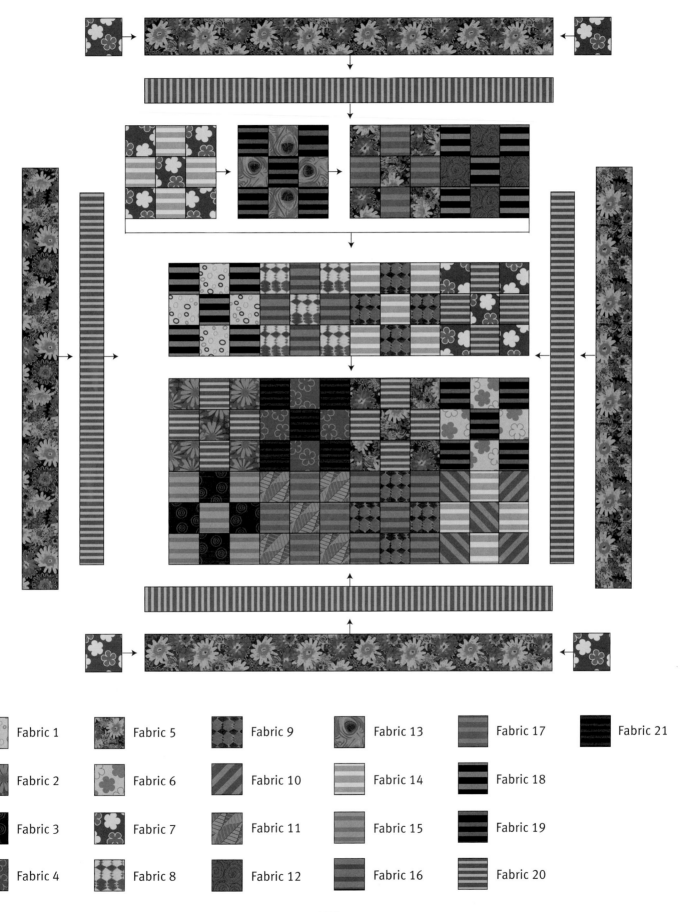

Fabric 1

Fabric 2

Fabric 3

Fabric 4

Fabric 5

Fabric 6

Fabric 7

Fabric 8

Fabric 9

Fabric 10

Fabric 11

Fabric 12

Fabric 13

Fabric 14

Fabric 15

Fabric 16

Fabric 17

Fabric 18

Fabric 19

Fabric 20

Fabric 21

sunflower checkerboard *

Kaffe Fassett

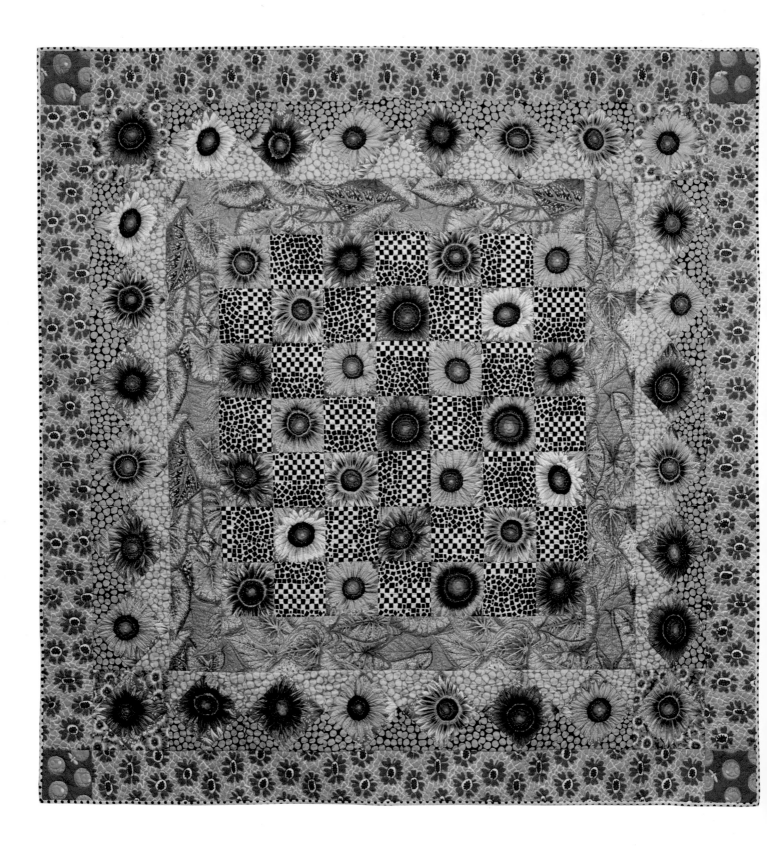

This medallion quilt makes great use of Philip's Van Gogh sunflower fabric, both in the checkerboard centre and in the square-in-square blocks of the pieced second border.

SIZE OF FINISHED QUILT
84in x 84in (213cm x 213cm)

FABRICS
Fabrics have been calculated at a maximum width of 40in (102cm). Fabrics have been given a number – see Fabric Swatch Diagram for details.

Patchwork Fabrics
VAN GOGH

Fabric 1	Bright	3yd (2.8m)
CHIPS		
Fabric 2	White	⅞yd (85cm)
CALADIUMS		
Fabric 3	Pastel	1⅝yd (1.5m)
JUMBLE		
Fabric 4	Turquoise	⅝yd (60cm)
Fabric 5	Rose	⅝yd (60cm)
LUCY		
Fabric 6	Pink	⅜yd (40cm)
FLOWER NET		
Fabric 7	Blue	2⅛yd (2m)
ORANGES		
Fabric 8	Pink	¼yd (25cm)

Backing and Binding Fabrics
LOTUS LEAF extra wide backing

Fabric 9	Jade	2⅝yd (2.45m)
SPOT		
Fabric 10	White	¾yd (70cm)

Batting
93in x 93in (236cm x 236cm)

PATCHES
The fussy-cut Fabric 1 sunflower squares in the Border 2 square-in-square blocks are larger than the sunflower squares in the centre. Do not try to fussy cut the sunflowers on the grain, or centre each blossom exactly, as they are mostly positioned just off-centre and, in many cases, cut slightly diagonally so as to cut as many flowers as possible from the fabric. Extra fabric has been allowed for fussy cutting.

CUTTING OUT
Fabric is cut across the width unless otherwise stated. Fabric 3 and Fabric 7 borders are cut lengthways. When cutting different pieces from the same fabric, always cut the larger pieces first.

Border 2 Feature Squares
From Fabric 1 fussy cut 28 squares 6⅞in x 6⅞in (17.5cm x 17.5cm). To make the best choices for fussy cutting, referring to Patches (below left), cut squares of paper the required size and move them around on the fabric to find the best placement.

Feature Squares
From the remaining Fabric 1 fussy cut 25 squares at 6½in (16.5cm). To make the best choices for fussy cutting, referring to Patches (below left), cut squares of paper the required size and move them around on the fabric to find the best placement.

Centre Squares
From Fabric 2 cut 4 strips 6½in (16.5cm) wide and cross cut 24 squares at 6½in (16.5cm). Each strip will yield 6 squares.

Border 1
From Fabric 3 cut 4 strips **down the length** of the fabric 6½in (16.5cm) wide. Cut 2 lengths 54½in (138.4cm) long for the side borders, and cut 2 lengths 42½in (108cm) long for the top and bottom borders.

Border 2 Setting Triangles
From each of Fabric 4 and Fabric 5 cut 4 strips 5⅜in (13.7cm) wide and cross cut 24 squares at 5⅜in (13.7cm) from each. Each strip will yield 7 squares. Cut each square in half diagonally once to make 48 half-square triangles from each fabric.

Border 2 Corner Blocks
From Fabric 6 cut 2 strips 5⅜in (13.7cm) wide and cross cut 8 squares at 5⅜in (13.7cm). Each strip will yield 7 squares. Cut each square in half diagonally once to make 16 half-square triangles for the corner blocks of Border 2.

Border 3
From Fabric 7 cut 4 strips **down the length** of the fabric 6½in (16.5cm) wide and 72½in (184.2cm) long.

FABRIC SWATCH DIAGRAM

Patchwork Fabrics

Fabric 1
VAN GOGH
Bright
PJ111BH

Fabric 2
CHIPS
White
BM073WH

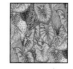
Fabric 3
CALADIUMS
Pastel
PJ108PT

Fabric 4
JUMBLE
TURQUOISE
BM053TQ

Fabric 5
JUMBLE
Rose
BM053RO

Fabric 6
LUCY
Pink
PJ112PK

Fabric 7
FLOWER NET
Blue
BM081BL

Fabric 8
ORANGES
Pink
GP177PK

Backing and Binding Fabrics

Fabric 9
LOTUS LEAF
Jade
QB007JA

Fabric 10
SPOT
White
GP070WH

SQUARE-IN-SQUARE BLOCK ASSEMBLY DIAGRAMS

 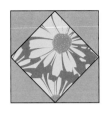 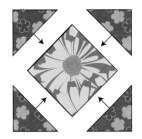 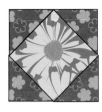

Border Square-in-square Blocks Corner Square-in-square Blocks

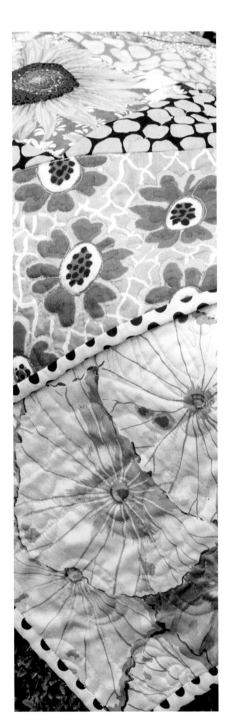

For the corner squares, from Fabric 8 cut 1 strip 6½in (16.5cm) wide and cross cut 4 squares at 6½in (16.5cm).

Backing
Trim Fabric 9 to 93in x 93in (236cm x 236cm).

Binding
From Fabric 10 cut 9 strips 2½in (6.4cm) wide. Remove selvedges and sew end to end with 45-degree seams (see page 141).

MAKING THE QUILT
Using a design wall will help to place patches in the required layout.
Use ¼in (6mm) seams throughout.

Centre
Referring to the Quilt Assembly Diagram and quilt photograph, lay out the Fabric 1 centre feature squares and Fabric 2 squares, alternating the fabrics to form a checkerboard centre of 7 rows of 7 squares, with Fabric 1 squares in all 4 corners. Sew together one row at a time, pressing seams in opposite directions on alternate rows – odd rows to the left, even rows to the right – to allow the finished seams to lie flat.

Border 1
Pin, then sew the shorter Fabric 3 border strips to the top and bottom of the centre. Press seams to towards the border, then sew the longer Fabric 3 border strips to the sides of the centre.

Border 2
Square-in-square blocks Referring to the Square-in-square Block Assembly Diagram, make 24 square-in-square blocks, with a Fabric 1 square, 2 adjacent Fabric 4 setting triangles and 2 adjacent Fabric 5 setting triangles.
Similarly, make 4 corner square-in-square blocks with a Fabric 1 square and 4 Fabric 6 setting triangles for each block.

Assembling the border Referring to the Quilt Assembly Diagram and quilt photograph, arrange 6 border square-in-square blocks along each of the 4 sides of the quilt centre, positioning the Fabric 4 setting triangles on the inside of each border and the Fabric 5 setting triangles on the outside of each border. Sew each set of 6 blocks together. Sew a corner square-in-square block to each end of the top and bottom borders.
Sew the side Border 2 pieces to the quilt centre. Press seams towards Border 1, then pin and sew the top and bottom Border 2 pieces to the centre.

Border 3
Pin and sew a Border 3 piece to each side of the quilt and press seams towards Border 3. Sew a Fabric 8 square to each end of the top and bottom Border 3 pieces. Press, then pin and sew the top and bottom Border 3 pieces to complete the quilt top.

FINISHING THE QUILT
Press the quilt top. Layer the quilt top, batting and backing, and baste together (see page 140).
Quilt as desired.
Trim the quilt edges and attach the binding (see page 141).

QUILT ASSEMBLY DIAGRAM

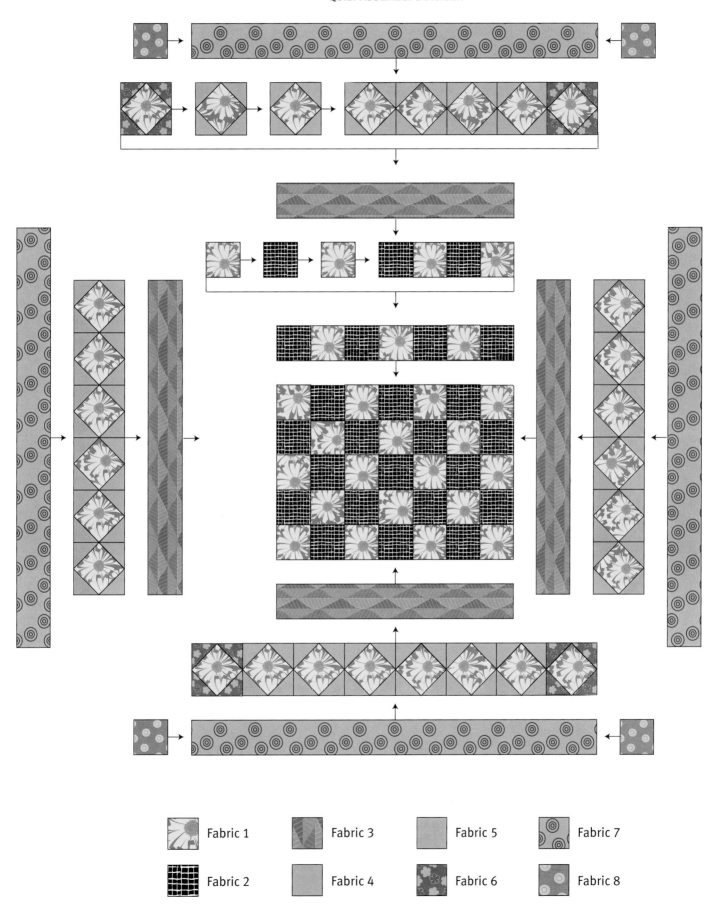

Fabric 1

Fabric 2

Fabric 3

Fabric 4

Fabric 5

Fabric 6

Fabric 7

Fabric 8

stripy strips *

Kaffe Fassett

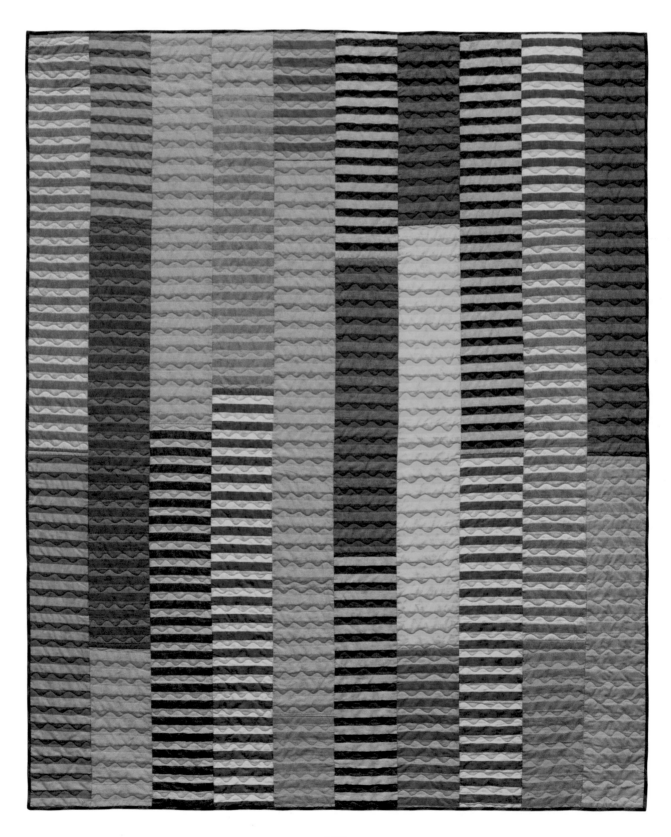

This simple design of strips in my current collection of Shot Cotton Stripes has a naïve, rustic look that lets the stripes sing. I have purposely not lined up the stripes when joining the strips. The wavy quilting gives the stripes some extra movement.

SIZE OF FINISHED QUILT
72in x 60in (183cm x 152cm)

FABRICS
Fabrics have been calculated at a maximum width of 40in (102cm). Fabrics have been given a number – see Fabric Swatch Diagram for details.

Patchwork Fabrics
WIDE STRIPE
Fabric 1	Aloe	¼yd (25cm)
Fabric 2	Apple	⅜yd (40cm)
Fabric 3	Blueberry	⅝yd (60cm)
Fabric 4	Burn	⅞yd (85cm)
Fabric 5	Cantaloupe	⅜yd (40cm)
Fabric 6	Salmon	⅞yd (85cm)
Fabric 7	Shell	⅞yd (85cm)
Fabric 8	Watermelon	⅝yd (60cm)

Backing and Binding Fabrics
MILLEFIORE
Fabric 9	Green	3⅞yd (3.6m)

WIDE STRIPE
Fabric 10	Moss	⅝yd (60cm)

Batting
80in x 69in (203cm x 175cm)

PATCHES
Patches are strips, all cut 6½in (16.5cm) wide but in varying lengths. Strips are laid out and sewn into 10 columns, then the columns are sewn together.

CUTTING OUT
Fabric is cut across the width unless otherwise stated. When cutting different pieces from the same fabric, always cut the larger pieces first. Stripes are to be cut as straight as possible, but not perfect – straightish will do fine. To achieve this, we recommend using spray starch before cutting.

Strips
Cut strips 6½in (16.5cm) wide and cross cut lengths of each fabric as follows:
Fabric 1 (1 strip) 1 piece 39½in (100.3cm).
Fabric 2 (2 strips) 2 pieces 39½in (100.3cm).
Fabric 3 (3 strips) 4 pieces:
a. 33½in (85.1cm);
b. 18½in (47cm);
c. 15½in (39.4cm);
d. 12½in (31.8cm).
Fabric 4 (4 strips) 4 pieces:
a. 39½in (100.3cm);
b. 39½in (100.3cm);
c. 27½inn (69.9cm);
d. 18½in (47cm).
Fabric 5 (2 strips) 3 pieces:
a. 27½in (69.9cm);
b. 15½in (39.4cm);
c. 9½in (24.1cm).
Fabric 6 (4 strips) 6 pieces:
a. 39½in (100.3cm);
b. 36½in (92.7cm);
c. 33½in (85.1cm);
d. 15½in (39.4cm);
e. 12½in (31.8cm);
f. 6½in (16.5cm).
Fabric 7 (4 strips) 4 pieces:
a. 39½in (100.3cm);
b. 36½in (92.7cm);
c. 24½in (62.2cm);
d. 21½in (54.6cm).
Fabric 8 (3 strips) 3 pieces:
a. 39½in (100.3cm);
b. 33½in (85.1cm);
c. 18½in (47cm).

Backing
From Fabric 9 cut 2 pieces 69in x 40in (175.3cm x 101.6cm), remove selvedges and sew together to form a piece approximately 80in x 69in (203cm x 175cm).

Binding
Binding is cut on the bias to create the diagonal stripe. From Fabric 10 cut enough bias strips 2½in (6.4cm) wide to make 274in (696cm) of bias binding (see page 141).

FABRIC SWATCH DIAGRAM

Patchwork Fabrics

Fabric 1
WIDE STRIPE
Aloe
SS001AO

Fabric 2
WIDE STRIPE
Apple
SS001AL

Fabric 3
WIDE STRIPE
Blueberry
SS001BV

Fabric 4
WIDE STRIPE
Burn
SS001BU

Fabric 5
WIDE STRIPE
Cantaloupe
SS001CA

Fabric 6
WIDE STRIPE
Salmon
SS001SL

Fabric 7
WIDE STRIPE
Shell
SS001SH

Fabric 8
WIDE STRIPE
Watermelon
SS001WL

Backing and Binding Fabrics

Fabric 9
MILLEFIORE
Green
GP092 GN

Fabric 10
WIDE STRIPE
Moss
SS001MS

FABRIC PLACEMENT TABLE

Column 1	Column 2	Column 3	Column 4	Column 5	Column 6	Column 7	Column 8	Column 9	Column 10
2	3b	6b	6f	3d	7d	4d	7a	8c	4b
3a	4a	7b	5a	6a	4c	1	8b	2	6c
	6d		8a	6e	7c	3c		5b	
				5c					

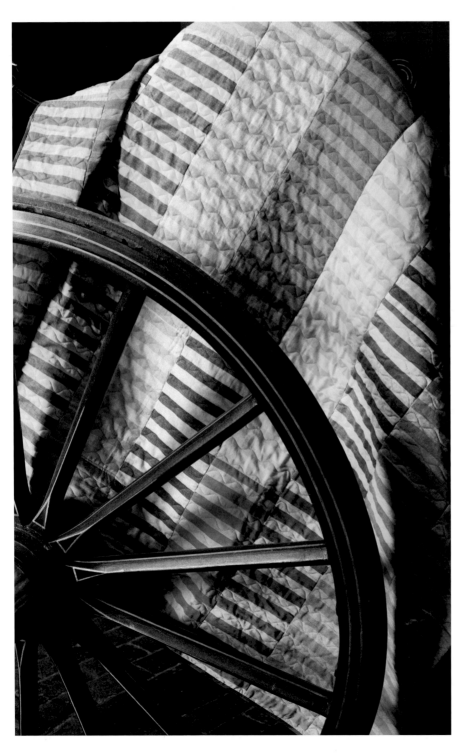

MAKING THE QUILT

Using a design wall will help to place patches in the required layout.
Use ¼in (6mm) seams throughout.

Assembling the Quilt

The Fabric Placement Table above shows where to position each piece. Referring to the Quilt Assembly Diagram and quilt photograph, lay out the strips in columns. Sew together one column at a time and press seams. Pin (to prevent stretching), then sew the columns together to complete the quilt top.

FINISHING THE QUILT

Press the quilt top. Layer the quilt top, batting and backing, and baste together (see page 140).
Quilt as desired.
Trim the quilt edges and attach the binding (see page 141).

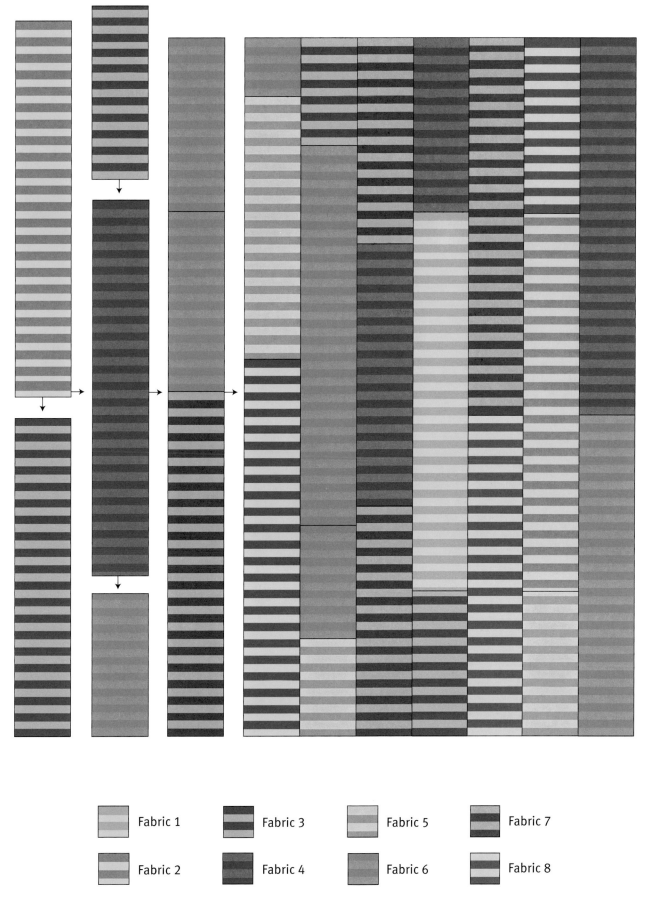

Fabric 1
Fabric 2
Fabric 3
Fabric 4
Fabric 5
Fabric 6
Fabric 7
Fabric 8

template

In this book only one quilt (Marble Tiles on page 69) requires a template for the patches. When positioning a template on the fabric, make sure the grain line arrows shown on it are lined up with the straight grain of the fabric; in other words, either in line with the selvedge or at 90 degrees to it. This will avoid creating bias edges, as they tend to stretch, causing distortion to the quilt.

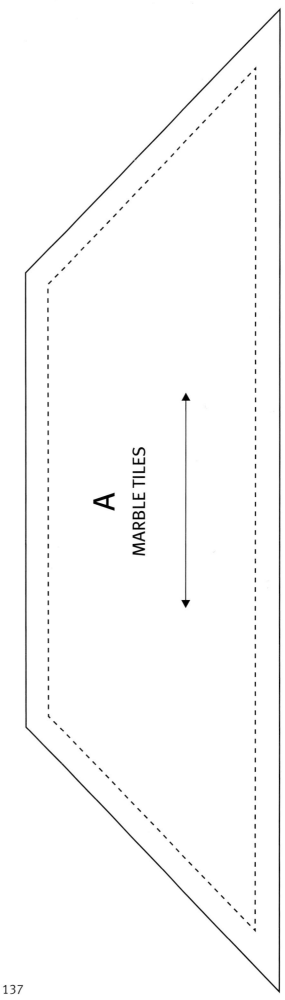

A

MARBLE TILES

patchwork and quilting know-how

These instructions are intended for the novice quilt maker, providing the basic information needed to make the projects in this book, along with some useful tips.

EXPERIENCE RATINGS
* Easy, straightforward, suitable for a beginner.
** Suitable for the average patchworker and quilter.
*** For the more experienced patchworker and quilter.

ABOUT THE FABRICS
The fabrics used for the quilts in this book are mainly from Kaffe Fassett Collective: **GP** is the code for Kaffe Fassett's designs, **PJ** for Philip Jacobs' and **BM** for Brandon Mably's. The other fabrics used are Shot Cottons and Stripes with SC or SS prefixes as well as wide backing fabrics with QB prefixes.

PREPARING THE FABRIC
Prewash all new fabrics before you begin, to ensure that there will be no uneven shrinkage and no bleeding of colours when the finished quilt is laundered. Press the fabric whilst it is still damp to return crispness to it. All fabric requirements in this book are calculated on a 40in (102cm) usable fabric width, to allow for shrinkage and selvedge removal.

MAKING TEMPLATES
Transparent template plastic is the best material to use: it is durable and allows you to see the fabric and select certain motifs. You can also use tracing paper and thin stiff cardboard.

Templates for machine piecing
1 Trace off the actual-sized template provided either directly on to template plastic, or on to tracing paper and then on to thin cardboard. Use a ruler to help you trace off the straight cutting line, dotted seam line and grain lines.

Sometimes templates are too large to print complete. Transfer the template on to the fold of a large sheet of paper, cut out and open out for the full template. Some templates are printed at a reduced size and need to be scaled up on a photocopier.
2 Cut out the traced off template using a craft knife, a ruler and a self-healing cutting mat.
3 Punch holes in the corners of the template, at each point on the seam line, using a hole punch.

Templates for hand piecing
• Make a template as for machine piecing, but do not trace off the cutting line. Use the dotted seam line as the outer edge of the template.

• This template allows you to draw the seam lines directly on to the fabric. The seam allowances can then be cut by eye around the patch.

CUTTING THE FABRIC
On the individual instructions for each project, you will find a summary of all the patch shapes used.

Always mark and cut out any border and binding strips first, followed by the largest patch shapes and finally the smallest ones, to make the most efficient use of your fabric. The border and binding strips are best cut using a rotary cutter.

Rotary cutting
Rotary cut strips are usually cut across the fabric from selvedge to selvedge, but some projects may vary, so please read through all the instructions before you start cutting the fabrics.

1 Before beginning to cut, press out any folds or creases in the fabric. If you are cutting a large piece of fabric, you will need to fold it several times to fit the cutting mat. When there is only a single fold, place the fold facing you. If the fabric is too wide to be folded only once, fold it concertina-style until it fits your mat. A small rotary cutter with a sharp blade will cut up to six layers of fabric; a large cutter up to eight layers.

2 To ensure that your cut strips are straight and even, the folds must be placed exactly parallel to the straight edges of the fabric and along a line on the cutting mat.

3 Place a rotary ruler over the raw edge of the fabric, overlapping it about ½in (1.25cm). Make sure that the ruler is at right angles to both the straight edges and the fold to ensure that you cut along the straight grain. Press down on the ruler and wheel the cutter away from you along the edge of the ruler.

4 Open out the fabric to check the edge. Don't worry if it's not perfectly straight – a little wiggle will not show when the quilt is stitched together. Re-fold the fabric, then place the ruler over the trimmed edge, aligning the edge with the markings on the ruler that match the correct strip width. Cut strip along the edge of the ruler.

USING TEMPLATES
The most efficient way to cut out templates is by first rotary cutting a strip of fabric to the width stated for your template, and then marking off your templates along the strip, edge to edge at the required angle. This method leaves hardly any waste and gives a random effect to your patches.

A less efficient method is to fussy cut them, where the templates are cut individually by placing them on particular motifs or stripes, to create special effects. Although this method is more wasteful, it yields very interesting results.

1 Place the template face down, on the wrong side of the fabric, with the grain-line arrow following the straight grain of the fabric, if indicated. Be careful though – check with your individual instructions, as some instructions may ask you to cut patches on varying grains.

2 Hold the template firmly in place and draw around it with a sharp pencil or crayon, marking in the corner dots or seam lines. To save fabric, position patches close together or even touching. Don't worry if outlines positioned on the straight grain when drawn on striped fabrics do not always match the stripes when cut – this will add a degree of visual excitement to the patchwork!

3 Once you've drawn all the pieces needed, you are ready to cut the fabric, with either a rotary cutter and ruler or a pair of sharp sewing scissors.

BASIC HAND AND MACHINE PIECING
Patches can be stitched together by hand or machine. Machine stitching is quicker, but hand assembly allows you to carry your patches around with you and work on them in every spare moment. The choice is yours. For techniques that are new to you, practise on scrap pieces of fabric until you feel confident.

Hand piecing

1 Pin two patches with right sides together, so that the marked seam lines are facing outwards.

2 Using a single strand of strong thread, secure the corner of a seam line with a couple of back stitches.

3 Sew running stitches along the marked line, working 8–10 stitches per inch (2.5cm) and ending at the opposite seam line corner with a few back stitches. When hand piecing never stitch over the seam allowances.

4 Press the seams to one side, as shown in machine piecing (Step 2).

Machine piecing

Follow the quilt instructions for the order in which to piece the individual patchwork blocks and then assemble the blocks together in rows.

1 Seam lines are not marked on the fabric for simple shapes, so stitch ¼in (6mm) seams using the machine needle plate, a ¼in (6mm) wide machine foot, or tape stuck to the machine as a guide. Pin two patches with right sides together, matching edges.

For some shapes, particularly diamonds, you need to match the sewing lines, not the fabric edges. Place 2 diamonds right sides together but offset so that the sewing lines intersect at the correct position. Use pins to secure for sewing.

Set your machine at 10–12 stitches per inch (2.5cm) and stitch seams from edge to edge, removing pins as you feed the fabric through the machine.

2 Press the seams of each patchwork block to one side before attempting to join it to another block. When joining diamond shaped blocks you will need to offset the blocks in the same way as diamond shaped patches, matching the sewing lines, not the fabric edges.

3 When joining rows of blocks, make sure that adjacent seam allowances are pressed in opposite directions to reduce bulk and make matching easier. Pin pieces together directly through the stitch line and to the right and left of the seam. Remove pins as you sew. Continue pressing seams to one side as you work.

Inset (Y) seams

When 3 or more patches have seams that come together without making a rectangle (i.e. in a Y-shape), an inset seam is needed. As shown in the diagram, with RS together, first sew the A–B seam. Then, starting from an inner point to an outer point, sew the A–C seam, and finally the A–D seam. Make sure you start and finish each ¼in (6mm) seam exactly at the beginning and end (as marked by dots on the diagram) and do not stitch into the seam allowance.

MACHINE APPLIQUÉ WITH ADHESIVE WEB

To make appliqué very easy you can use adhesive web (which comes attached to a paper backing sheet) to bond the motifs to the background fabric. There are two types of web available: the first keeps the pieces in place while they are stitched, the second permanently attaches the pieces so that no sewing is required. Follow steps 1 and 2 for the non-sew type and steps 1–3 for the type that requires sewing.

1 Trace the reversed appliqué design onto the paper side of the adhesive web, leaving a ¼in (6mm) gap between all the shapes. Roughly cut out the motifs ⅛in (3mm) outside your drawn line.

2 Bond the motifs to the reverse of your chosen fabrics. Cut out on the drawn line with very sharp scissors. Remove the backing paper by scoring the centre of the motif carefully with a scissor point and peeling the paper away from the centre out (to prevent damage to the edges). Place the motifs onto the background, noting any which may be layered. Cover with a clean cloth and bond with a hot iron (check instructions for temperature setting as adhesive web can vary depending on the manufacturer).

3 Using a contrasting or toning coloured thread in your machine, work small close zig zag stitches (or a blanket stitch if your machine has one) around the edge of the motifs; the majority of the stitching should sit on the appliqué shape. When stitching up to points, stop with the machine needle in the down position, lift the foot of your machine, pivot the work, lower the foot and continue to stitch. Make sure all the raw edges are stitched.

HAND APPLIQUÉ

Good preparation is essential for speedy and accurate hand appliqué. The finger-pressing method is suitable for needle-turning application, used for simple shapes like leaves and flowers. Using a card template is the best method for bold simple motifs such as circles.

Finger-pressing method

1 To make your template, transfer the appliqué design using carbon paper on to stiff card, and cut out the template. Trace around the outline of your appliquéd shape on to the right side of your fabric using a well sharpened pencil. Cut out shapes, adding by eye a ¼in (6mm) seam allowance all around.

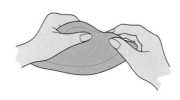

2 Hold the shape right side up and fold under the seam, turning along your drawn line, pinch to form a crease. Dampening the fabric makes this very easy. When using shapes with points such as leaves, turn in the seam allowance at the point first, as shown in the diagram. Then continue all round the shape. If your shapes have sharp curves, you can snip the seam allowance to ease the curve. Take care not to stretch the appliqué shapes as you work.

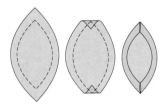

Straight stems

Place fabric face down and simply press over the ¼in (6mm) seam allowance along each edge. You don't need to finish the ends of stems that are layered under other appliqué shapes. Where the end of the stem is visible, simply tuck under the end and finish neatly.

Needle-turning application

Take the appliqué shape and pin in position. Stroke the seam allowance under with the tip of the needle as far as the creased pencil line, and hold securely in place with your thumb. Using a matching thread, bring the needle up from the back of the block into the edge of the shape and proceed to blind-hem in place. (This stitch allows the motifs to appear to be held on invisibly.) To do this, bring the thread out from below through the folded edge of the motif, never on the top. The stitches must be small, even and close together to prevent the seam allowance from unfolding and from frayed edges appearing. Try to avoid pulling the stitches too tight, as this will cause the motifs to pucker up. Work around the whole shape, stroking under each small section before sewing.

QUILTING

When you have finished piecing your patchwork and added any borders, press it carefully. It is now ready for quilting.

Marking quilting designs and motifs

Many tools are available for marking quilting patterns, check the manufacturer's instructions for use and test on scraps of fabric from your project. Use an acrylic ruler for marking straight lines.

Stencils

Some designs require stencils; these can be made at home, by transferring the designs on to template plastic, or stiff cardboard. The design is then cut away in the form of long dashes, to act as guides for both internal and external lines. These stencils are a quick method for producing an identical set of repeated designs.

BACKING FABRIC

The quilts in this book use two different widths of backing fabric – the standard width of 44in (112cm) and a wider one of 108in (274cm). If you can't find (or don't want to use) the wider fabric then select a standard-width fabric instead and adjust the amount accordingly. For most of the quilts in the book, using a standard-width fabric will probably mean joins in the fabric. The material list for each quilt assumes that an extra 4in of backing fabric is needed all round (8in in total) when making up the quilt sandwich, to allow for long-arm quilting if needed. We have assumed a usable width of 40in (102cm), to allow for selvedge removal and possible shrinkage after washing.

Preparing the backing and batting

• Remove the selvedges and piece together the backing fabric to form a backing at least 4in (10cm) larger all around than the patchwork top.

• Choose a fairly thin batting, preferably pure cotton, to give your quilt a flat appearance. If your batting has been rolled up, unroll it and let it rest before cutting it to the same size as the backing.

• For a large quilt it may be necessary to join two pieces of batting to fit. Lay the pieces of batting on a flat surface so that they overlap by around 8in (20cm). Cut a curved line through both layers.

overlap wadding

• Carefully peel away the two narrow pieces and discard. Butt the curved cut edges back together. Stitch the two pieces together using a large herringbone stitch.

BASTING THE LAYERS TOGETHER

1 On the floor or on a large work surface, lay out the backing with wrong side uppermost. Use weights along the edges to keep it taut.

2 Lay the batting on the backing and smooth it out gently. Next lay the patchwork top, right side up, on top of the batting and smooth gently until there are no wrinkles. Pin at the corners and at the midpoints of each side, close to the edges.

3 Beginning at the centre, baste diagonal lines outwards to the corners, making your stitches about 3in (7.5cm) long. Then, again starting at the centre, baste horizontal and vertical lines out to the edges. Continue basting until you have basted a grid of lines about 4in (10cm) apart over the entire quilt.

4 For speed, when machine quilting, some quilters prefer to baste their quilt sandwich layers together using rust-proof safety pins, spaced at 4in (10cm) intervals over the entire quilt.

HAND QUILTING

This is best done with the quilt mounted on a quilting frame or hoop, but as long as you have basted the quilt well, a frame is not essential. With the quilt top facing upwards, begin at the centre of the quilt and make even running stitches following the design. It is more important to make even stitches on both sides of the quilt than to make small ones. Start and finish your stitching with back stitches and bury the ends of your threads in the batting.

TIED QUILTING

If you prefer you could use tied quilting rather than machine quilting. For tied quilting, use a strong thread that will withstand being pulled through the quilt layers and tied in a knot. You can tie with the knot on the front of the quilt or the back, as preferred. Leaving tufts of thread gives an attractive, rustic look.

Thread a needle with a suitable thread, using the number of strands noted in the project. Put the needle and thread through from the front of the work, leaving a long tail. Go through to the back of the quilt, make a small stitch and then come back through to the front. Tie the threads together using a reef knot and trim the thread ends to the desired

length. For extra security, you could tie a double knot or add a spot of fabric glue on the knot.

MACHINE QUILTING

- For a flat looking quilt, always use a walking foot on your machine for stitching straight lines, and a darning foot for free-motion quilting.

- It is best to start your quilting at the centre of the quilt and work out towards the borders, doing the straight quilting lines first (stitch-in-the-ditch) followed by the free-motion quilting.

- When free-motion quilting, stitch in a loose meandering style as shown in the diagrams. Do not stitch too closely as this will make the quilt feel stiff when finished. If you wish you can include floral themes or follow shapes on the printed fabrics for added interest.

- Make it easier for yourself by handling the quilt properly. Roll up the excess quilt neatly to fit under your sewing machine arm, and use a table or chair to help support the weight of the quilt that hangs down the other side.

FINISHING
Preparing to bind the edges
Once you have quilted or tied your quilt sandwich together, remove all the basting stitches. Then, baste around the outer edge of the quilt ¼in (6mm) from the edge of the top patchwork layer. Trim the back and batting to the edge of the patchwork and straighten the edge of the patchwork if necessary.

Binding and 45-degree seams
1 Cut bias or straight grain strips the width required for your binding, making sure the grain-line is running the correct way on your straight grain strips. Cut enough strips until you have the required length to go around the edge of your quilt.

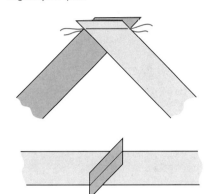

2 To join strips together, the two ends that are to be joined must be cut at a 45-degree angle, as above. Stitch right sides together, trim turnings and press seam open.

Binding the edges

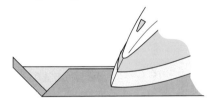

1 Cut the starting end of binding strip at a 45-degree angle, fold a ¼in (6mm) turning to wrong side along cut edge and press in place. With wrong sides together, fold strip in half lengthways, keeping raw edges level, and press.

2 Starting at the centre of one of the long edges, place the doubled binding on to the right side of the quilt keeping raw edges level. Stitch the binding in place. starting ¼in (6mm) in from the diagonal folded edge. Reverse stitch to secure, and work ¼in (6mm) in from edge of the quilt towards first corner of quilt. Stop ¼in (6mm) in from corner and work a few reverse stitches.

3 Fold the loose end of the binding up, making a 45-degree angle (see A). Keeping the diagonal fold in place, fold the binding back down, aligning the raw edges with the next side of the quilt. Starting at the point where the last stitch ended, stitch down the next side (see B).

4 Continue to stitch the binding in place around all the quilt edges in this way, tucking the finishing end of the binding inside the diagonal starting section.

5 Turn the folded edge of the binding on to the back of the quilt. Hand stitch the folded edge in place just covering binding machine stitches, and folding a mitre at each corner.

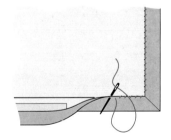

glossary of terms

Adhesive or fusible web This comes attached to a paper-backed sheet and is used to bond appliqué motifs to a background fabric. There are 2 types of web available, the first keeps the pieces in place whilst they are stitched, the second permanently attaches the pieces so that no sewing is required.

Appliqué The technique of stitching fabric shapes on to a background to create a design. It can be applied either by hand or machine with a decorative embroidery stitch, such as buttonhole, or satin stitch.

Backing The bottom layer of a quilt sandwich. It is made of fabric pieced to the size of the quilt top with the addition of about 4in (10cm) all around to allow for quilting take-up.

Basting or tacking This is a means of holding two fabric layers or the layers of a quilt sandwich together temporarily with large hand stitches or pins.

Batting or wadding This is the middle layer, or padding in a quilt. It can be made of cotton, wool, silk or synthetic fibres.

Bias The diagonal grain of a fabric. This is the direction which has the most give or stretch, making it ideal for bindings, especially on curved edges.

Binding A narrow strip of fabric used to finish off the edges of quilts or projects; it can be cut on the straight grain of a fabric or on the bias.

Block A single design unit that when stitched together with other blocks create the quilt top. It is most often a square, hexagon, or rectangle, but it can be any shape. It can be pieced or plain.

Border A frame of fabric stitched to the outer edges of the quilt top. Borders can be narrow or wide, pieced or plain. As well as making the quilt larger, they unify the overall design and draw attention to the central area.

Chalk pencils Available in various colours, they are used for marking lines or spots on fabric.

Cutting mat Designed for use with a rotary cutter, it is made from a special self-healing material that keeps your cutting blade sharp. Cutting mats come in various sizes and are usually marked with a grid to help you line up the edges of fabric and cut out larger pieces.

Design wall Used for laying out fabric patches before sewing. A large wall or folding board covered with flannel fabric or cotton batting in a neutral shade (dull beige or grey work well) will hold fabric in place so that an overall view can be taken of the placement.

Free-motion quilting Curved wavy quilting lines stitched in a random manner. Stitching diagrams are often given for you to follow as a loose guide.

Fussy cutting This is when a template is placed on a particular motif, or stripe, to obtain interesting effects. This method is not as efficient as strip cutting, but yields very interesting results.

Grain The direction in which the threads run in a woven fabric. In a vertical direction it is called the lengthwise grain, which has very little stretch. The horizontal direction, or crosswise grain is slightly stretchy, but diagonally the fabric has a lot of stretch. This grain is called the bias. Wherever possible the grain of a fabric should run in the same direction on a quilt block and borders.

Grain lines These are arrows printed on templates which should be aligned with the fabric grain.

Inset seams or setting-in A patchwork technique whereby one patch (or block) is stitched into a Y shape formed by the joining of two other patches (or blocks).

Patch A small shaped piece of fabric used in the making of a patchwork pattern.

Patchwork The technique of stitching small pieces of fabric (patches) together to create a larger piece of fabric, usually forming a design.

Pieced quilt A quilt composed of patches.

Quilting Traditionally done by hand with running stitches, but for speed modern quilts are often stitched by machine. The stitches are sewn through the top, wadding and backing to hold the three layers together. Quilting stitches are usually worked in some form of design, but they can be random.

Quilting hoop Consists of two wooden circular or oval rings with a screw adjuster on the outer ring. It stabilises the quilt layers, helping to create an even tension.

Reducing glass Used for viewing the complete composition of a quilt at a glance. It works like a magnifier in reverse. A useful tool for checking fabric placement before piecing a quilt.

Rotary cutter A sharp circular blade attached to a handle for quick, accurate cutting. It is a device that can be used to cut several layers of fabric at one time. It must be used in conjunction with a self-healing cutting mat and a thick plastic ruler.

Rotary ruler A thick, clear plastic ruler marked with lines in imperial or metric measurements. Sometimes they also have diagonal lines indicating 45 and 60 degree angles. A rotary ruler is used as a guide when cutting out fabric pieces using a rotary cutter.

Sashing A piece or pieced sections of fabric interspaced between blocks.

Sashing posts When blocks have sashing between them the corner squares are known as sashing posts.

Selvedges Also known as selvages, these are the firmly woven edges down each side of a fabric length. Selvedges should be trimmed off before cutting out your fabric, as they are more liable to shrink when the fabric is washed.

Stitch-in-the-ditch or Ditch quilting Also known as quilting-in-the-ditch. The quilting stitches are worked along the actual seam lines to give a pieced quilt texture.

Template A pattern piece used as a guide for marking and cutting out fabric patches, or marking a quilting, or appliqué design. Usually made from plastic or strong card that can be reused many times. Templates for cutting fabric usually have marked grain lines which should be aligned with the fabric grain.

Threads One hundred percent cotton or cotton-covered polyester is best for hand and machine piecing. Choose a colour that matches your fabric. When sewing different colours and patterns together, choose a medium to light neutral colour, such as grey or ecru. Specialist quilting threads are available for hand and machine quilting.

Walking foot or Quilting foot This is a sewing machine foot with dual feed control. It is very helpful when quilting, as the fabric layers are fed evenly from the top and below, reducing the risk of slippage and puckering.

Yo-Yos A circle of fabric double the size of the finished puff is gathered up into a rosette shape.

Y seams See Inset seams.

ACKNOWLEDGMENTS

I have a small team of makers who patiently sew, quilt and write the instructions for these books, including Liza Prior Lucy, our trusted friend and loyal colleague in the US, with her team of Bobbi Penniman, Sally Davis and Judy Baldwin, plus Judy Irish for quilting. In the UK I have the marvellous Janet Haigh of Heart Space Studios, and her team of Ilaria Padovani and Julie Harvey, plus Mary-Jane Hutchinson for quilting. Thanks to them all. Were it not for them, these books would not be possible. Thanks to Bundle Backhouse for taking on the enormous responsibility of the technical editing of the instructions and also for her organizational skills at the Kaffe Fassett Studio; to Anne Wilson for her graphic eye and for her attention to detail on the book layouts; to Steve Jacobson for the technical illustrations and Steven Wooster for the quilt flat shot photography; and to our publishing consultant, Susan Berry of Berry & Co, for managing this series through the process to print, alongside Peter Chapman, our executive editor at Taunton Press.

Highest praise goes to the National Trust for keeping the magic of Powis Castle going for us all to enjoy and to the team who run Powis Castle, who were so helpful to us on our shoot.

Particular thanks to our ever-trusted friend and photographer, Debbie Patterson, who shares not only a similar vision but also our sense of humour. She puts up with Brandon's and my temperamental moods at our photography shoots to arrive at just the magic we were aiming for. And, last but not least, to Brandon, who not only manages the studio, and co-designs with me, but carries the pressure of whirlwind photo shoots in various locations – so glad you hang in there, ensuring the output is of consistently high quality.

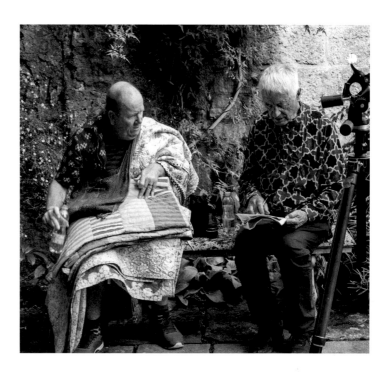

The quilts were made and quilted by the following (the quilter's name is in *italics*).

Toast and Marmalade Julie Harvey, *Mary-Jane Hutchinson*
Cobweb Sally Davis, *Judy Irish*
Blue Tiles Ilaria Padovani, *Mary-Jane Hutchinson*
Sassy Baby Liza Prior Lucy, *Judy Irish*
Vintage Library Julie Harvey, *Mary-Jane Hutchinson*
Saturated Red Ilaria Padovani, *Mary-Jane Hutchinson*
Marble Tiles Liza Prior Lucy, *Judy Irish*
Golden Squares Liza Prior Lucy, *Kaffe Fassett*
Stripy Strips Liza Prior Lucy, *Judy Irish*
Sweet Baby Liza Prior Lucy, *Judy Irish*
Cold Frames Ilaria Padovani, *Mary-Jane Hutchinson*
Hot Frames Ilaria Padovani, *Mary-Jane Hutchinson*
Jumping Jacks Julie Harvey, *Mary-Jane Hutchinson*
Checkerboard of Checkerboards Ilaria Padovani, *Mary-Jane Hutchinson*
Sunflower Checkerboard Bobbi Penniman, *Judy Irish*
Turquoise Dream Julie Harvey, *Mary-Jane Hutchinson*
Plums and Ginger Liza Prior Lucy, *Judy Irish*
Topiary Julie Harvey, *Mary-Jane Hutchinson*
Lavender and Sage Liza Prior Lucy, *Judy Irish*
Bubbly Judy Baldwin, *Judy Irish*

OTHER TAUNTON TITLES AVAILABLE

Kaffe Fassett's Quilt Romance
Kaffe Fassett's Quilts en Provence
Kaffe Fassett's Quilts in Sweden
Kaffe Quilts Again
Kaffe Fassett's Quilt Grandeur
Kaffe Fassett's Quilts in Morocco
Kaffe Fassett's Heritage Quilts
Kaffe Fassett's Quilts in Italy
Kaffe Fassett's Quilts in Ireland
Kaffe Fassett's Quilts in America
Kaffe Fassett's Quilts in the Cotswolds
Kaffe Fassett's Quilts in Burano
Kaffe Fassett's Quilts in an English Village

The fabric collection can be viewed online at
www.freespiritfabrics.com

KAFFE FASSETT

— for —

FreeSpirit

FreeSpirit Fabrics
Carmel Park II
11121 Carmel Commons Blvd, Ste 280
Charlotte, NC 28226
Tel: (001) 866 907 3305
Email: info@freespiritfabrics.com

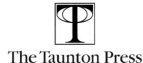

The Taunton Press
Inspiration for hands-on living®

The Taunton Press, Inc., 63 South Main Street,
Newtown, CT 06470
Tel: 800-888-8286 • Email: tp@taunton.com
www.tauntonstore.com

foreign distributors and stockists

To find a retailer in the USA and Canada for the fabrics used in this book please go to www.freespiritfabrics.com/where-to-buy/

For any countries/territories not listed below, contact www.freespiritfabrics.com.

For the following countries/territories see contact information below:

AUSTRALIA
XLN Fabrics
2/21 Binney Rd,
Kings Park
NSW 2148
www.xln.com.au
email: allanmurphy@xln.com.au

DENMARK
Industrial Textiles A/S
Engholm Parkvej 1
Alleroed 3450
www.indutex.dk
email: maria@indutex.dk

JAPAN
Kiyohara & Co Ltd
4-5-2 Minamikyuhoji-machi
Chuo-ku, Osaka 541-8506
www.kiyohara.co.jp

Mitsuharu Kanda
1-14-10 Nihonbashi Bakuro
Chuo-Ku, Tokyo 103-002
www. kanda.o.oo7.jp/2_1.htm
email: kandacom@nifty.com

Nippon Chuko
1-9-7 Minsmikyuhoji-Machi
Osaka 541-0058
www.nippon-chuko.co.jp
email: k.sanada@nippon-chuko.co.jp

Yamachu-Mengyo Co Ltd
1-10-8 Edobori, Nishi-Ku
Osaka 550-0002
www.yamachu-mengyo.co.jp

NEW ZEALAND
Fabco Ltd
Unit 18, 23 Bristol Place,
Te Rapa, Hamilton 3200
www.fabco.co.nz
email: joe@fabco.co.nz

SINGAPORE
Sing Mui Heng Pte Ltd
315 Outram Road
Singapore 169074
www.smhcraft.com
email: mkt@singmuiheng.com

SOUTH AFRICA
Arthur Bales Pty Ltd
62 4th Avenue
Johannesburg 2103
www.arthurbales.co.za
email: nicci@arthurbales.co.za

SOUTH KOREA
J Enterprise Co Ltd
Daerung Techno Town3
115, Gasan Digital 2Ro unit #1008
Geumcheon-Gu, Seoul 08505
www.enjoyquilt.co.kr
email: JinHan@enjoyquilt.co.kr

SPAIN
J. Pujol Maq Conf SA
c/Industria 5
Montgat, Barcelona
www.jpujol.com
email: jpujol@jpujol.com

Jose Rosas Taberner SA
c/o Trafalgar 60
Barcelona
www.castelltort.com
email: info@castelltort.com

UK/EUROPE
Rhinetex BV
Maagdenburgstraat 24
ZC Deventer 7421
Netherlands
www.rhinetex.com
email: info@rhinetex.com
Stof Fabrics
Hammershusvej 2 c
Herning 7400
Denmark
www.stoffabrics.com
email: stof@stof.dk

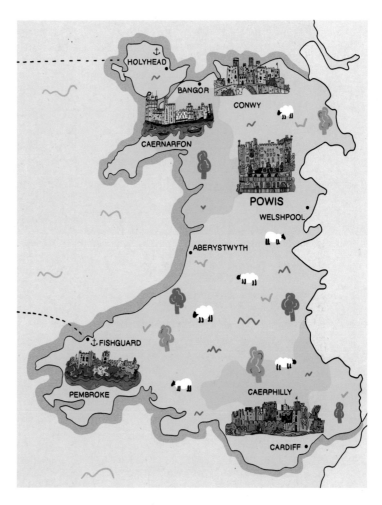

Location of Powis Castle (a National Trust property) in Wales